THE NEW ART
OF COOKING

'If the divine creator has taken the pains
to give us delicious and exquisite things
to eat, the least we can do is prepare them
well and serve them with ceremony.'
Fernand Point, *Ma Gastronomie* (1969)

THE NEW ART OF COOKING

a modern guide to
 preparing and styling
delicious food

Frankie
 Unsworth

BLOOMSBURY PUBLISHING
LONDON · OXFORD · NEW YORK · NEW DELHI · SYDNEY

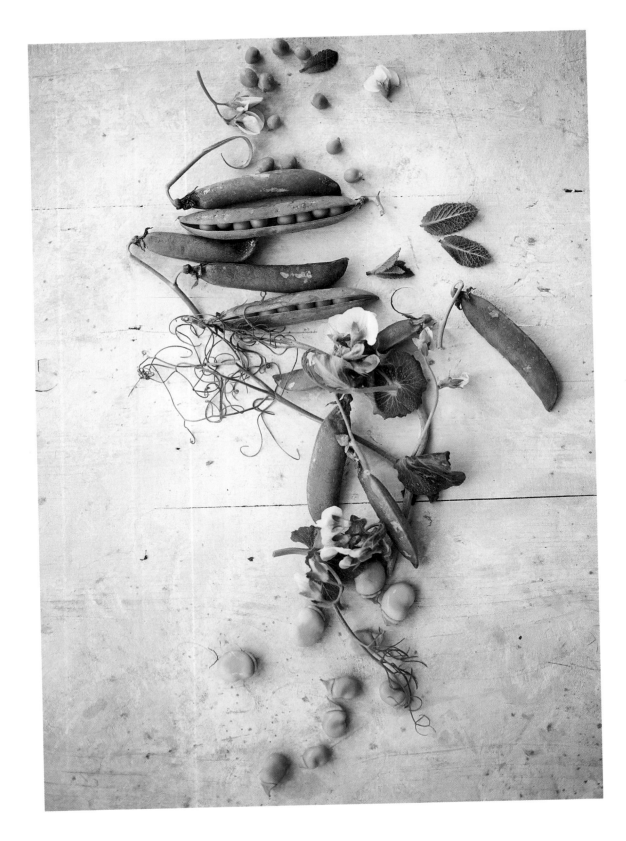

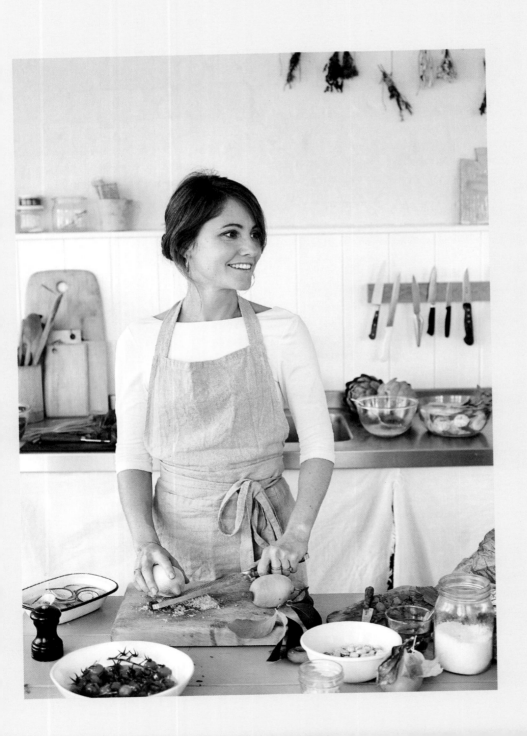

Being a Food Stylist

When I was on the set of a global ad campaign recently, watching a male hand model's cuticles being touched up with foundation by a specialist hand make-up artist, I thought to myself 'that's a weird job'. After this brief contemplative pause, I returned to the task at hand: inserting a chicken salad sandwich into the model's now-pristine clutches, positioning cocktail sticks to secure the filling, grabbing my tweezers to tease out the prettiest leaves and then taking a tiny paintbrush to distribute mayonnaise across the underside of the bread. The rest of the crew looked on in bewilderment. Welcome to the world of 'food styling'.

Styling food for photo shoots varies from the tweezer-toting precision of advertising jobs, where detail is paramount lest that sandwich be blown up on the side of a bus, to inspiring home cooks with atmospheric images for cookbooks, where natural lighting and realism make for the most delicious photographs. Food styling is both my profession and my obsession, but it's the more natural side of it, focussing on flaunting the beauty of the ingredients themselves in a creative way, that truly inspires and informs my cooking at home.

A plate can act as a canvas and the layers and components of the food come together to form a whole picture through a play of colours, textures and forms. By paying more attention to how we buy, cook and eat our food, we can turn an everyday practicality into one of life's affordable luxuries. Eating is a multisensory experience after all, enriched by the bright colours of the season's pickings, the weight of a fork in your hand or the evocative smell of garlic slowly sweated in butter.

Spending most of my working day in a kitchen means that my style of cooking isn't fussy at home; it makes the most of a few well-prepared ingredients and usually requires little hands-on cooking time. It is led by a love of good produce, colour and clever flavour combinations. The recipes that follow are a collection of things I most want to eat, dishes that make the most of beautiful ingredients but don't take hours to prepare.

Working as a food stylist comes with a certain degree of stress. Every shoot day is different, every new kitchen has its challenges and every recipe has its intricacies. I've been through it all, from cooking in a tent without any running water to crouching over a camping stove on a pebble beach. There will always be new, unpredictable and obscure issues, but having mastered a few basics (perfect poached eggs, the crispiest fish skin and the icing you can serve on even the most sweltering day) I now have the confidence to confront all the challenges that might be thrown my way. In a nutshell, I've learned from many mistakes so that you don't have to.

This book is about lovingly crafting beautiful plates of food to be proud of, whether it's showing yourself a little tenderness with a perfect omelette for one or sharing good food and too many bottles of wine with a gathering of friends. I want to show how easy it is to cook dishes that are just as pretty as in the pictures – and how a little extra thought when it comes to prepping and presentation can make all the difference.

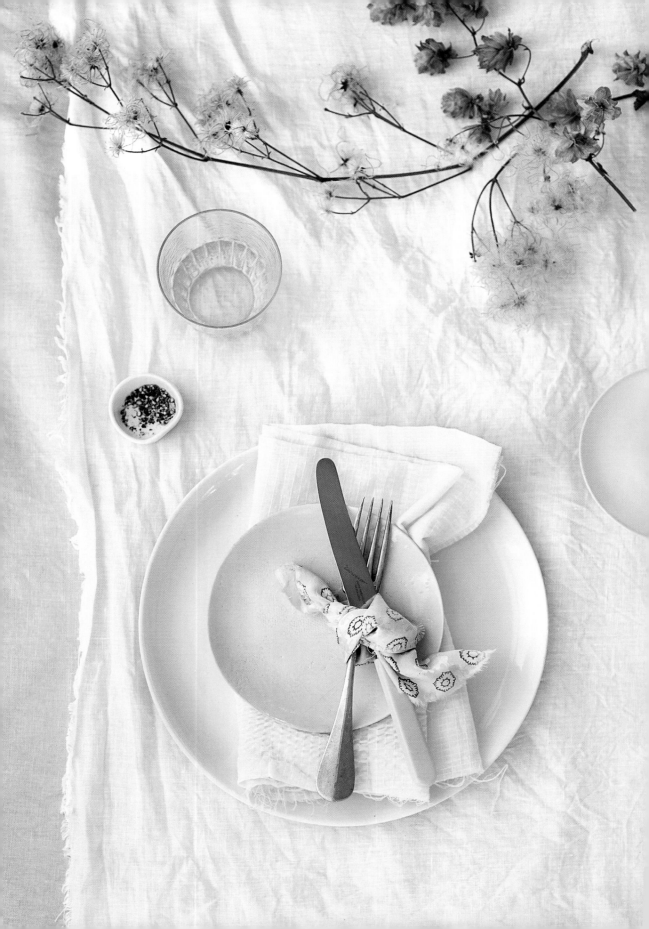

Setting
the Scene

In the world of food photography, we bring cookery to life by creating a scene that will invite the viewer to sit down and tuck in. From the plates to the table surface, 'props' create an atmosphere and enhance the real star of the show – your dinner.

The same goes at home. You don't have to take a strict and formal approach to setting the table. Sometimes it can be as simple as taking the time to choose just the right plate or light a candle or two. It's about giving your cooking a backdrop and letting it shine.

Laying the Table

Setting the table initiates a ritual that tells you it's time to set the day aside and focus on the meal you are about to dig into. Charles Spence, a professor of experimental psychology at the University of Oxford, even offers a scientific reason to take care over the presentation of food. He has studied the impact of all the aspects surrounding mealtimes, from the weight of cutlery (the heavier the cutlery, the more people are willing to pay for the food in a restaurant) to the colour of a plate (strawberries taste sweeter on a white plate), and how they influence our perceptions of quality and taste. In other words, if you light candles, lay down a tablecloth and pull out your best glassware, you're already on your way to a good meal.

One of the easiest ways to create ambience is through considered lighting. Low lighting, ideally not from overhead, makes for a soft and sometimes even sumptuous setting. Candlelight and table lamps offer a subtle diffused light that is kind on the food and on your friends. If you have strong spotlights in your dining area, bring in lamps from other rooms and go heavy on the candlelight. I keep a stash of pillar candles handy, as well as tea lights, which I pop in small glasses, jars or pinch pots. When I am feeling romantic, I whip out the tapered dinner candles in candlesticks for some old-world elegance. Fairy lights wrapped around a tree or a bush in the garden can add a magical touch. I also have a few long lengths of festoon lights to illuminate the back of my house on those rare nights when the pesky English summer allows for outdoor entertaining.

Laying the table for a dinner party is best done in advance of the cooking – that way even if you are feeling frazzled in the final stages of preparing the food, at least the table will be presentable and give an impression of organisation when guests arrive. Your table-setting need not be overly formal; try putting the cutlery in jars or old mustard pots and popping them in the centre of the table for people to help themselves. This is a good solution if you don't have room for everyone to sit down. And if you've limited space, you can put a folded napkin on each plate with cutlery on top instead of on either side. That way everyone can see how tightly they need to squeeze in.

At the risk of sounding old-fashioned, sometimes a small amount of formality can be fun and seating plans make excellent work of mixing up the chat and making tactical pairings. Try using postage tags as place names and flex your calligraphy skills. Tie the tags around napkins with butcher's twine, ribbons or even fabric offcuts torn to encourage a frayed edge. Vintage clothes pegs or attractive heavy paper clips also do a good job. I have a vast collection of Japanese washi tape (see Stockists, page 332), a fancy thin version of masking tape, which I use for sticking things down, whether it's a pressed flower to a menu card or some garden foliage to a place name.

If I am serving bread, a breadboard with a scattering of salt and a swipe of whipped butter (see page 108) gets plonked on the table. With other condiments, such as mustard, gravy or pickles, either take the lids off the jars and centre them on a nice saucer with a spoon, or decant them into a jug or bowl.

I often fill jugs or carafes with ice and make simple infusions that both add colour and offer refreshment. Try strips of cucumber and rounds of lime; watermelon chunks with mint or basil sprigs; or pink grapefruit and tufts of rosemary. (Don't let the citrus steep for longer than about 3 hours as it has a tendency to turn bitter.)

Choosing crockery and cutlery is of course a question of personal taste, but opposite are a few pointers that you may find helpful.

Crockery and Cutlery

Curating a small selection of crockery and cutlery that you treasure goes a long way in elevating your eating experience. My personal collection is an eclectic mix of hand-made plates from one-man-band ceramicists, vintage French flea-market finds, curious patterned bowls from car boot sales and family hand-me-downs. Nothing matches, nothing stacks well, but there's something to turn to for every occasion, and each one is unique, each with its own story.

When it comes to setting the table with such a diverse array of crockery and cutlery, I usually go by colour or tone, and you'll see that the same logic applies to the images throughout this book. Objects that are, on the face of it, very diverse in style can be surprisingly complementary if you find a unifying element. So if you find harmony in colour, working with a few pale pinks say, then stick with the pastels. Likewise, if you have a few dark plates, you could contrast them with white for a monochrome look.

Pattern can be beautiful but sometimes too much detail will compete with your food. Having said that, some patterns are a playful nod to the style of food on offer, such as a stripe of maritime blue running around the rim of a white plate for seafood, or an ornate vintage cake stand for a Victoria sponge.

I am constantly on the lookout for wooden boards with interesting surfaces, as the different textures and forms add character to a display of cheese and charcuterie, or can be used as a breadboard. If you are feeling particularly crafty, drill a hole into a spare piece of wood and thread a nice lenth of rope or leather through it, then hang your new board proudly on display. I find the more worn a board gets the better, so I have stopped trying to keep mine pristine. As they weather and age those scars and stains all tell a story. Turmeric, on the other hand, is the one exception to this rule, and should be kept well away from wood unless you want its orange pigment to stay there forever more.

When it comes to dinner plates, I prefer to use mid-sized for serving food and I don't overcrowd the plate; you can always have a second helping if you are still hungry. I buy a lot of vintage dinner plates and hunt down unique pieces from emerging ceramicists, as the price of modern designer plates has inflated to unreasonable proportions. If you are serving food on large dinner plates, however, consider leaving space to let each element of the dish sing. Try not to fill the plate more than two thirds full.

From a composition point of view, serving a meal attractively is easier in a bowl than on a plate, and I've gone so far as to include a whole chapter on the subject of 'bowl food'. The high edges allow you to pile upwards, displaying the different elements of the food, and play with the colours. Consider using bowls rather than plates for stews and casseroles, as they will keep the

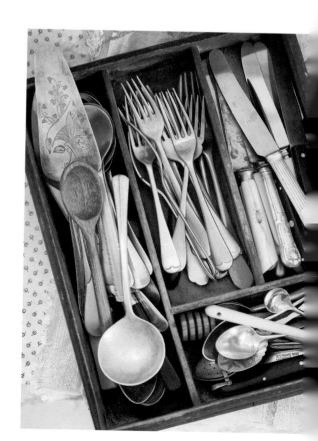

the Confit garlic ajo blanco (see page 174), which I want to embellish with plenty of edible accessories.

Large serving platters work well for relaxed meals – you can pile salads in abundance for people to serve themselves or use one to display a slow-cooked joint of meat. I have a mix of sizes and shapes at home, but one or two will suffice. And of course, platters are also useful for serving nibbles.

Falcon enamelware is handy as it's cheap, stackable and comes in many shapes, from pie tin to baking tray; it also looks good enough to bring to the table and it ages gracefully.

For a special cake, the height of a lovely cake stand will always make your creation look that little bit more celebratory. I also favour a snug 20cm cake stand for things like Panettone torrone Alaska or Ultimate chocolate cake (see pages 308 and 310). If you invest in a stand that's at least 27cm then you can be sure that most cakes will fit on it (including the wedding cake on page 312). You can always adorn the bare edges with some draped foliage or fresh flowers if you would like to.

Brand new, good-quality cutlery can be expensive so I tend to turn to flea markets or charity shops for the elegant bone-handled knives I've collected over a number of years or other interesting second-hand treasures. Sharp wooden-handled knifes such as Opinels are my go-to steak knives and are a worthwhile investment until I can afford a set of Perceval 9.47s, the Rolls-Royce of steak knives.

liquid neatly contained. I like shallow bowls for pasta and risotto, allowing plenty of space for a fine veil of Parmesan or some crisped herbs, and lovely deep earthenware bowls for curling up on the sofa with soup and a blanket.

It's useful to have a broad range of vessels for serving soup, in fact: dainty little Japanese lacquer bowls, rustic chipped enamel mugs, delicate fine glasses for chilled soups or very shallow bowls that allow you to play with the ratio of liquid to solid. The bowl will make a huge difference to how you taste and enjoy your soup: the depth of the bowl will dictate how much of the topping you will get in each spoonful (the deeper the bowl, the less space there is for garnishes) and the width of the rim will influence the temperature. Deep bowls work well for rustic warming soups, while I would choose a shallow soup plate with a narrow rim for more delicate soups like

Glasses

My mismatched collection of glasses is the
result of charity and flea-market finds mostly,
with the odd modern wine glass thrown in
to appease wine aficionados. Tumblers wide
enough to keep a large chunk of ice in place
are a must for me, essential for water, whiskey
and late-night negronis, as are everyday small
sturdy tumblers. Don't be afraid to serve wine
in these, or double them up as water glasses.
Cut-crystal tumblers also make an appearance
when I want to look fancy.

I favour a coupe over a flute for champagne
or short cocktails, as they feel just that little
bit more elegant.

When entertaining, it's a good idea
to welcome your guests in with an inviting
selection of glasses and drinks; you'll find
that people congregate around them, allowing
you to get on with the cooking. Ice buckets
can also be perched by the drinks if you have
an open chilled bottle on the go.

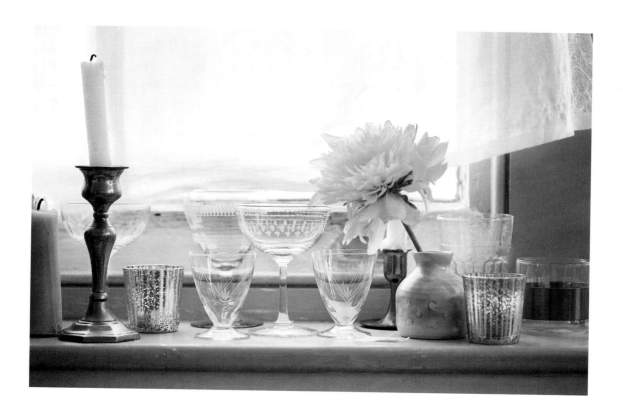

Fabric and Flowers

While some like to channel their energy into styling themselves in well-thoughtout accessories, I spend a disproportionate amount of time considering how to dress my dinner table.

Tablecloths aren't just for fine dining or having your granny over for tea; for me they transform my everyday table into an eating occasion. A good tablecloth goes a long way towards turning a basic garden table or trestle table into an elegant tablescape to flaunt your dinner.

Cloth shops allow you to buy fabric by the metre, presenting a cheaper alternative to ready-made tablecloths, and allowing you to collect an eclectic mix. You might sew up the ends (if you don't the threads will pull after a couple of spins in the washing machine), though I think a few threads here and there add charm.

For the crumpled textured effect stylists covet, which you'll see in the pages of this book, line-dry your linens or play up the creases and folds by ironing the cloth folded so the table looks effortlessly elegant but not too formal.

Overlapping multiple cloths is a pretty way of layering textures and tones on a table, and also useful if your cloth isn't large enough to cover the whole thing. If you have pulled a few tables together to make one, this is also a good way of unifying them. Table runners down the centre are useful for marking the area where the food and flowers will sit.

From utilitarian tea towels to sun-bleached curtains and scraps of old cloth torn to size, nothing is safe from being called a napkin when I'm about. A collection of linen napkins are a treat, but these days there are some heavier paper napkins (see Stockists, page 332) doing a great job of emulating them, and when there's a crowd to feed, these are infinitely more practical. You don't have to iron linen napkins; try them a little crumpled, tied with string and with a sprig of lavender or rosemary tucked in. If you have herbs or flowers to spare, nestling a sprig of rosemary, a twig of bay or a few strands of lavender in each napkin can be a thoughtful nod to the season.

Ribbons, nice string or scraps of linen can also double up as napkin ties. If you have linen napkins, try tying them in a loose knot. Knots in napkins give the excellent message that you've made a little effort but you haven't got too much spare time on your hands (unlike, say, an origami swan).

Fresh flowers are instant table enhancers, but don't feel you need to go overboard investing in some big blowsy bouquet. I tend to buy stems individually rather than pre-bundled at the florist; this way you can spend as much or as little as you want and pick your favourite blooms. Small bud vases are handy for displaying single flowers, but bottles and jars with the labels steamed off also do the trick, and can be spread out down the table without getting in the way of conversation or jostling for space with the food. Seasonality usually dictates which flowers I go for, but think about tones that will suit your tablecloth or the occasion – an autumnal gathering can be complemented by warm colours, while a summer evening might call for a pale white-washed palette.

Centrepieces needn't be limited to flowers and candles; consider paying homage to the season or setting, whether it's a foraged piece of beach driftwood, a scattering of seashells, an autumnal selection of bulbous squash or some festive pine cones sprayed with gold.

Preparing Ingredients Beautifully

The process of styling food begins well before it hits the plate. The key is to source sparklingly fresh produce and prepare it with care.

Local, seasonal and organic is the winning formula for buying flavoursome and good-looking produce that will be easy to turn into beautiful, enticing food at home. I am always seeking out intriguing varieties of fruit and veg: crimson blood oranges, green tomatoes or candy-striped beetroot. For pairing ingredients (and wine, for that matter) I often come back to the old adage, 'what grows together, goes together'. Flavours you'll find in season at the same time often complement one another: tomatoes and raspberries share a common sweet acidity, and bitter winter leaves are livened up by a spritz of citrus.

When it comes to storage and preparation there are a few classic techniques and tricks of the trade that will have a disproportionate effect on the finished dish.

Herbs

The use of herbs in food styling (and eating generally) has been turned on its head over the last few decades. Circa 1970, curly-leaf parsley was king and solitary sprigs hovered over every plate. Fast-forward to today and going curly is the ultimate foodie faux pas (along with the word 'foodie', for that matter). Clippings of coriander or delicate dill fronds now reign supreme. The best rule of thumb – for home cooks and professional stylists alike – is to garnish with a herb only if it is adding flavour or aroma to the finished dish.

Growing and buying herbs

Planting a variety of herbs in a window box or patio bed is the best way to ensure you always have the freshest looking herbs to hand, guaranteed to be more fragrant to the nose and perkier on the palate than shop-bought. If space doesn't allow it, or they have hibernated for the winter, I tend to buy whole potted herb plants from the supermarket, which are a world above the limp clusters under plastic; they will last you a good week and are only marginally more expensive and bouncingly fresh, as they should be.

Growing your own herbs at home also opens up the world of flowering herbs. When my thyme develops sweet little pink flowers, my chives boast purple tufts or my borage flowers come out en masse, nothing is safe from a scattering of edible garden confetti. See page 25 for more on this.

Storing herbs

If you have bought a bunch of delicate herbs like dill, mint or coriander and the ends are looking dry, trim these off before placing the stems in a glass filled with a little water. Store the herbs in the fridge; put a sandwich bag over the top of the glass secured with a rubber band to protect their extremities from the chill and maintain a humid environment. Be aware of the cold spots in your fridge and avoid storing herbs there, as they might freeze. I find the door of the fridge is usually the best option. If you have a large jar or container, you can simply put a little water in the base and seal the lid.

Coriander is so delicate it tends to wilt, so I always buy this on the day I am using it or buy it potted (although I still find it has a tendency to wilt more than other herbs). Potted is also a good option if you don't have space in your fridge for storage.

Keep basil at room temperature, with the stems in a glass of water and away from direct sunlight.

Hardier herbs like thyme, rosemary and sage can be wrapped in a slightly damp J-cloth then stored inside a sandwich bag or plastic container in the fridge (I also transport delicate herbs this way if I am taking them to a shoot or packing for a picnic).

If you are prepping ahead for a dinner party, you can pre-chop or pick your herbs, put them in a bowl and cover them with a damp piece of kitchen paper. They will keep like this for a good couple of hours (it is something we would do when prepping ahead for a photo shoot).

Washing herbs

Do wash your herbs before using them, but be sure to dry them thoroughly. A salad spinner makes easy work of this without damaging the herbs, or you can dab them gently with kitchen paper. Don't chop wet herbs, as they get stuck to your board and are easily bruised.

Picking the leaves

Picking leaves from their stalks is a part of cooking prep that often differentiates professionals from home cooks – it really is worth doing and is as simple as it sounds: simply use your fingers to pluck off the best-looking leaves from the stems. While this does add a little extra time to the meal prep, it's pleasant to do and can make a big difference to the look of the finished dish.

Thyme, rosemary, oregano and marjoram all have fairly small leaves and tougher stalks, which makes them easier to 'pick'. Pinch the top of the stem of the herb then run your fingers down from top to bottom to strip the leaves off. For other herbs, such as basil, sage and coriander, pinch or pluck the leaves from their stems individually, selecting only the prettiest ones.

While some stalks are chunkier and not great to eat (I'm looking at you mint), the tender tops of dill, coriander and parsley can be kept on the stalk. Coriander tops are especially stunning on a laksa (see page 184) or tacos (see page 239). Choose only the really delicate small sprigs, and let them fall naturally into place for an effortless look.

Bruising herbs

Bruising herbs is a good way of releasing their
aroma, and works especially well for rosemary
and thyme. Lightly bash them with the end
of a rolling pin on a chopping board or with
a pestle and mortar. It releases more aroma
from the herbs than just chopping with a blade.
To bruise bay leaves, I simply scrunch them
up in my hand before throwing them into the
pot or pan, rather than bashing them.

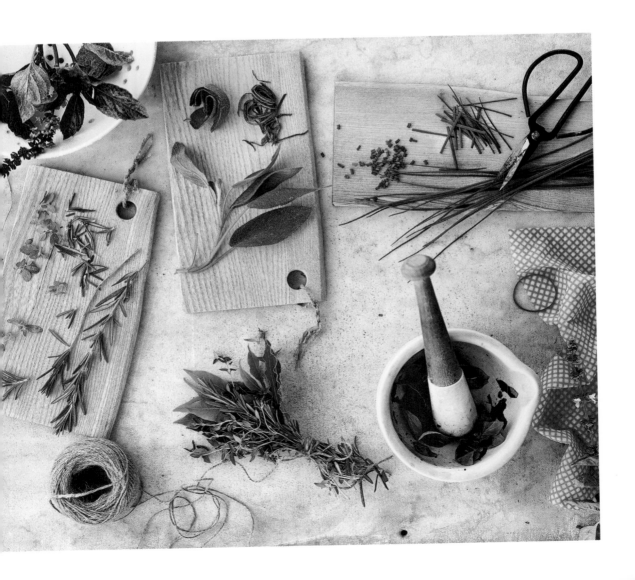

Cutting herbs

Herbs should be seen as an ingredient as much as they are a garnish. Don't be afraid to really go to town, chopping massive handfuls of parsley to stir through butter and smother over a piece of grilled fish.

Slicing is a gentle cutting approach that works well for delicate herbs like chives and dill if you want them fine for sauces or omelettes but don't like them mushing into your chopping board. Here you want to use a rocking motion with a sharp chef's knife (see page 66), clenching the bunch in place with one hand (keep your fingers tucked safely under) and working gradually along with your blade; you'll need to move the clenched hand along as you go. Scissors work a treat on chives and dill, especially for freestyle snippings, also saving you the task of cleaning your board down. You can snip directly over the plate for the ultimate natural, free-falling look.

Rigorous chopping works best on more robust herbs, such as rosemary, parsley and sage. Stack your picked herbs in a pile and start by roughly chopping them with the lower part of your blade, pinching the sides of the blunt edge of the knife with your other hand. Work your way back over the roughly chopped herbs, gathering them together again into a pile.

CHIFFONADING HERBS 'Chiffonading' is a fancy French term for cutting into ribbons, and is best used for large leafy herbs, such as basil, mint or sage. Stack a few leaves on top of one another, roll them into a tight bundle and slice crossways, rocking the knife back and forth along the bundle.

BLITZING HERBS Sometimes you might want to blitz bundles of herbs in a food processor or blender for vibrant green speedy sauces or vinaigrettes. For the record, I actually make pesto in this way too, but don't tell the Italians. It's always worth holding back a few picked herbs for garnishing at the end.

Cooking with herbs

While delicate herbs are best added towards the end of cooking to maintain their vibrancy, the flavour of hardy herbs is unlocked by heat and they can be added early to infuse and permeate a recipe. Leaving them on their stems makes it easier to fish them out once the cooking time is up.

Hardy herbs lend themselves to roasting, steeping and stewing, and they can also take on the role of utensil for a bit of extra flavour and a stylish touch. Try sturdy rosemary stalks as skewers for scallops or prawns, or tying a bundle of rosemary or thyme together and using it to brush steaks or vegetables with a little oil when barbecuing. As I say, I generally avoid cooking delicate herbs like basil, chives, dill and coriander but I am partial to fried herbs...

FRYING Frying herbs adds an extra level of texture and interest to all manner of things, from soup toppings to dressings. While this technique does work especially well for more delicate herbs like parsley and basil, as in my Crispy-herb vinaigrette (see page 228), it also transforms hardy herbs like rosemary and sage into a crunchy herb garnish. Fancy chefs might go as far as frying individual leaves for garnishing dishes, but I do them in batches. Keep sage leaves whole and snip rosemary in little clusters from their sprigs for more impact. Frying herbs in butter, as in my Sweet potato gnudi (see page 218) infuses the butter too, which can then be drizzled back over the final dish for an extra flavour hit.

Garnishing with herbs

To refresh herbs before using them as a garnish, plunge them into iced water, then dry them.

Leave it right until the last minute to scatter soft herbs on hot soup or stews, as they will wilt quickly and lose their fragrance. While some recipes in this book will call for finely chopped herbs stirred through a dish (like the potato salad on page 160), in the majority of cases the best sprigs or picked herbs are held back and added as a garnish at the end.

I also like to serve abundant piles of herbs on the side for people to help themselves, as they might in a Vietnamese restaurant. Try Vietnamese mint, coriander and Thai basil as a starting point. Lay them on a side plate, freshly washed and dried; as you add them to the dish the steam will release an aromatic waft of fresh herbs.

Crystallising herbs and edible flowers

I often crystallise herbs and edible flowers for cocktails or cakes, which gives them a frosted look and a crisp sweet texture. In a small bowl, whisk an egg white until it is just frothy and the white is no longer gloopy (add a few drops of water to help it along). Using a small paintbrush, paint the flower or herb you are crystallising, covering it with a light layer of the egg white. Sprinkle caster sugar over the top to cover the surface completely. Transfer to parchment paper, and leave in a cool, dry place to firm up for about 1½ hours.

Decorating with herbs

In table styling and floral arrangements, herbs are not to be overlooked. Not only are they easy and economical to source, but their fragrance is an excellent addition to the tablescape. Lay a few sprigs over napkins and tie them with a little piece of ribbon or butcher's string. Big branches of rosemary also make for excellent additions to a traditional bouquet for added fragrance.

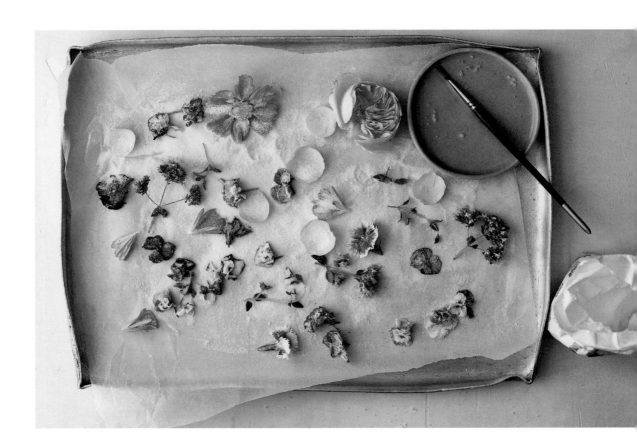

Preserving herbs

If you have leftover herbs that are looking a little tired, try drying them at home in a warm and dry place, in small string-bound bunches hung upside down. Hardy herbs lend themselves best to this treatment, so try thyme, rosemary, sage, marjoram and oregano. Once dry they can be roughly crumpled up to keep some of their shape (don't crush them to a powder), and popped into a jar. They also look far more interesting than the flaky, dusty supermarket equivalents, which tend to be tired, uniform and a bit powdery. If you have a serious glut of herbs and fancy getting creative, try making the herb oil below for vibrant green drizzling, or the flavoured butter on page 221. You can also make simple herb butters in ice-cube trays: line the trays with a layer of finely chopped herbs then pour over some melted butter that you've allowed to cool a little.

> HERB OIL Pick the leaves from a large bunch of parsley or other herb of your choice – you want about 50g in total – and roughly chop. Put a combination of water and ice into a large bowl and set a smaller bowl inside it. Blend the herbs with 200ml light olive oil for 1 minute or until well blended. Heat a pan over a medium heat and once the pan is hot, pour the oil in and stir vigorously. Cook for 15 seconds, then immediately pour into the bowl suspended over ice and stir until cool. Pour through a coffee filter or a muslin-lined sieve to strain away the bits – you'll be left with a bright verdant oil that will keep for 1 week in a jar in the fridge.

Edible flowers, microherbs and microgreens

Introducing edible flowers and microherbs or microgreens (the small seedlings of herbs and vegetables) into your cooking is one of the easiest and quickest ways of making something look stunning with just a few little sprinkles. They might look a little pretentious, but once in a while, why not? Use them sparsely and always with the intention of adding substance as well as style to the plate.

I try and grow a few plants or herbs with edible flowers each year so I have a little collection over the summer months to pretty up desserts, cakes and salads. Nasturtiums are almost *too* easy to grow; they basically behaved like weeds when I planted them in the patio bed and created a tangled overspill. I would suggest planting them in big pots and letting them tumble over the sides gracefully instead. The leaves are peppery and delicate, and the yellow and red flowers are a delight for garnishing salads.

If you are decorating a big celebration cake with fresh flowers, be diligent about where you source them from, especially if you plan to crystallise them for eating. Buy unsprayed or organic flowers (see Stockists, page 333) or advise people that they are purely decorative if you are unsure.

Dried rose petals and cornflowers are handy to have in the cupboard – do use these in moderation or risk your dinner looking and tasting like potpourri.

Vegetables

In an ideal world, we would of course all be plucking homegrown vegetables from our vegetable plots, but in reality sourcing top-notch vegetables isn't quite as *The Good Life* as we might want it to be. As a rule, however, eating seasonal produce is the easiest way to ensure you are buying the best quality for your money, and you'll taste, feel and see the difference.

Establishing a relationship with a supplier is one of the most rewarding ways of shopping for your veg. Try to buy your produce from a greengrocer, farmer's market or seasonal box scheme (ideally a busy one as a quick turnover means fresher produce) to get the best possible greens, fruits and roots. At its simplest, cooking with these ingredients requires little work bar a good rinse and maybe a refreshing plunge in a bath of icy water, plus a little seasoning. It's also substantially cheaper than going to the supermarket, if you shop sensibly.

Vegetables that haven't been pre-prepared are on the whole a lot tastier and fresher, and buying this way allows you to control the shape and the size of what you are chopping. This also means you can take a nose-to-tail approach, eating the many parts of the vegetable that often get trimmed away before hitting the shelves; celery leaves (great for salads), beetroot stalks (excellent in frittatas), cauliflower leaves (sneak them into a cauliflower cheese) and radish leaves (try them in pesto). As a rule I avoid buying things in bags – you inevitably create waste by buying more than you need and there's all that packaging. Buying this way also gives you the option to (gently) feel your produce.

These days baby vegetables, such as carrots, beetroot, turnips and sweetcorn, are widely available. They work well for salads and crudités especially, as you can get away with leaving them whole or simply halving them.

Storing veg

Vegetables fall into two camps: those that require humidity and those that don't. If you consider what wilts quickly, that will give you a good idea of what should be a) used up first and b) given a little humidity assistance.

Greens such as chard and cavolo nero, as well as celery, bunches of carrots and courgettes, need humidity to stay fresh for longer. Do keep them in the designated drawer in the fridge if you have room – sometimes know as the 'crisper' this is the most humid spot in the fridge. I keep a stash of J-cloths and stray tea towels which I run under a cold tap then squeeze dry and wrap around these vegetables, or the tops of beetroots and radishes so they stay super fresh as they tend to wilt really quickly.

Mushrooms are best stored in a paper bag, loosely closed to allow some air to circulate.

Vegetables like potatoes, onions, winter squash and tomatoes (until fully ripened) should be stored separately in a cool and dry place but out of the fridge.

Much of the supermarket packaging has perforated holes in it, allowing the veg to breathe so you can wrap a damp J-cloth around leafy greens and return them to their bags, or leave longer-lasting vegetable such as carrots and parsnips in this packaging.

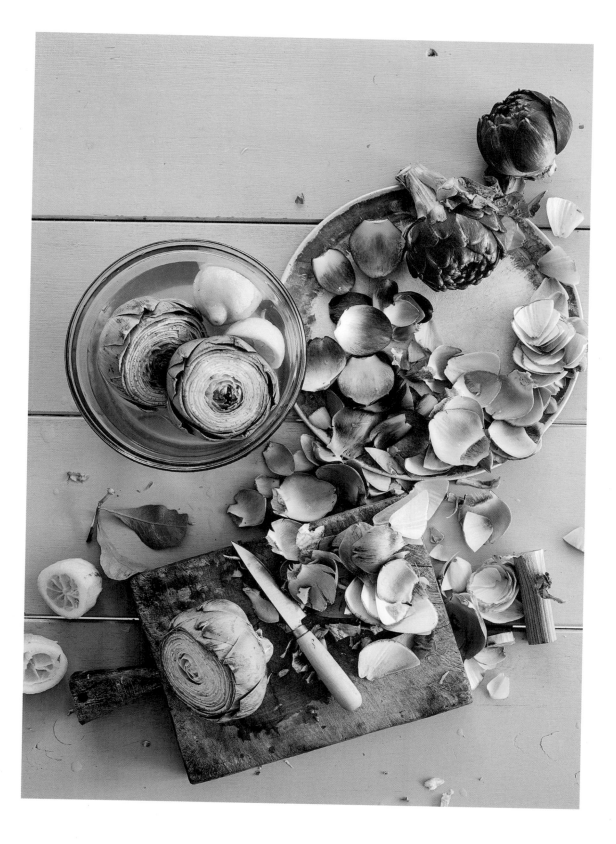

Preparing veg

As a rule of thumb, when I prepare vegetables I try to keep their shapes looking as much like their natural incarnation as possible. This reminder of Mother Nature evokes an idea of freshness that makes your vegetables all the more appealing. For example, trim all but a centimetre or so off carrot tops (use the tops for pestos or wilt them to make a side). Leave more on beetroot tops (around 3cm); scrape any excess dirt off the skin with a paring knife and leave the skinny tail on (not everyone would approve but I think it adds character!). When it comes to mushrooms, I don't cut the smaller ones, and the larger ones, I always slice through the head to maintain the shape of the cap and stem. Always use a toothbrush or special mushroom brush to clean mushrooms but avoid washing them with water at all costs as they absorb it like a sponge and will then seep liquid as they cook instead of getting a golden glaze.

Instead of cutting the florets off cauliflower or broccoli heads using a knife, which would leave a sharp edge, start with the underside of where the 'core' is and use a paring knife to cut this out. You can then use your hands to pull away the individual florets, which look like tiny little bouquets. Don't throw away the core – make cauliflower or broccoli rice by chopping it then pulsing it in a food processor until it has the texture of fine breadcrumbs.

If you are peeling and chopping ahead of time, store your veg in bowls or Tupperware with damp kitchen paper or J-cloths over them.

FRESHENING UP VEG Dunking fresh vegetables into a bowl of iced water crisps and firms them up, and it's also a good method for reviving some of the more tired looking vegetables in your fridge. This is the perfect way to make sure vegetables are really crunchy when serving them as crudités.

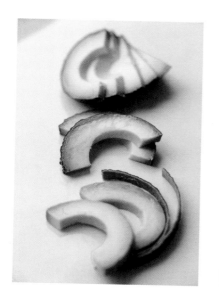

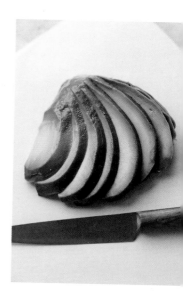

PREPARING AVOCADO There's more than one way to prepare avocado. Sometimes it suits being scooped out and mashed onto toast with a fork, maybe running the fork over the top in a criss-cross pattern – this is especially good when you have a particularly ripe one; while at other times it deserves more special treatment. Either way, remember to give it a good spritz of lemon juice to stop it discolouring. Here are the methods I use to prepare avocado:

1) For super-clean slices of avocado, cut around the stone lengthways and twist to separate the two halves. Carefully stab the heel of your knife blade into the stone and twist to remove it. Leave the skin on and slice either lengthways or into half moons horizontally, then peel the skin off the individual slices. This works well if you have an avocado that is just slightly overripe but you want to produce neat slices.

2) For fine slices, to top something like the Tuna and crispy kale rice bowls on page 190, use a large spoon to scoop the flesh out of the halved stoned fruit, trying to run it as close to the shell as possible so as not to lose too much of the flesh. Place the shelled avocado cut-side down on a board and slice into 2mm slices widthways. To keep the slices held together, use a palette knife to transfer them to a bowl or onto a piece of toast.

3) To slice an avocado fan, take your stoned avocado half and peel away the skin. Place the shelled avocado cut-side down on your board. Leaving about 2cm at the top, cut it into 1cm slices lengthways. Gently press the top of the avocado down and to one side to fan it out. Your avocado will need to be just on the point of ripeness for this method to be successful.

Cooking veg

With the exception of slow-cooked vegetables adding depth to the base of stews and roast trays, the longer you cook vegetables the more flavour, nutritional value and colour will be lost, so I err on the side of caution when it comes to cooking times.

BLANCH AND SHOCK The blanch and shock method maintains the brilliant green of fresh vegetables and the best texture. Get a large pan of salted water (not only does the salt add flavour to the vegetables, but it also helps to speed up the softening before the chlorophyll, which keeps them green, has time to dissipate) and bring to a rolling boil. It's important to use a large pan if you are blanching a high volume of vegetables, as the temperature of the water will lower when you add them. Plunge the veg into the water. If you are blanching several different veg, group the ones with a similar cooking time together. Blanch the vegetables until they are just tender but still al dente. Small things like peas and broad beans can be scooped out quickly with a sieve when they reach the perfect colour. I use tongs to fish out larger, sturdier vegetables, such as broccoli florets and asparagus.

Have a large bowl of iced water at the ready. If you are blanching many vegetables at a time, fill your sink with water and ice so there's plenty of space for them.

GRILLING AND GRIDDLING VEG Grilling and griddling are great ways to fast-cook vegetables – charred edges add smoky character and flavour. Courgettes cut into long strips, asparagus, aubergines and romaine lettuce all cook really well on a griddle. Use a pastry brush to coat them with a nice even layer of oil before laying them in the smoking hot griddle pan. Don't move them once they are in the pan. Be patient before turning, waiting to smell the 'burning' before flipping them over.

When you are griddling in batches, be careful to maintain the distinct grill marks by lying the cooked vegetables flat on a tray without overlapping them. If you run out of room, lay a piece of parchment paper between them.

Open fires and smouldering embers represent a return to our primal cooking roots – a satisfying and theatrical way to use the barbecue embers when they are at that perfect glowing point. Some vegetables, such as corn in husks or onions, can be cooked whole in their skins. Try this with aubergines for a smoky take on baba ganoush.

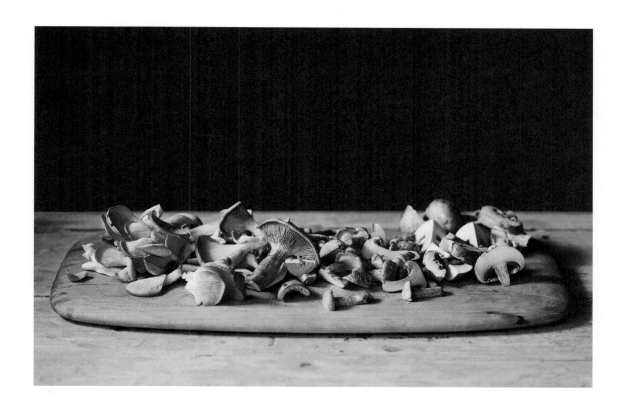

ROASTING VEG The key to roasting is to allow a decent amount of space between your vegetables – this gets the outsides crispy and golden. You could pretty things up with whole sprigs of herbs, crushed garlic cloves or whole bulbs of garlic sliced around the circumference. Not only will the cooked vegetables look picture-perfect, they will taste even better too.

PURÉED VEG Professional-looking purées really aren't that hard to achieve, and they are brilliant for trapping sauce in a neat little area on the plate. Vegetable purées will offset really punchy flavours with their mellow and creamy notes, as well as offering the opportunity to get playful with colours. Carrots, peas and cauliflower (which happens to contain natural pectins, resulting in the creamiest of emulsions) all respond extremely well to puréeing.

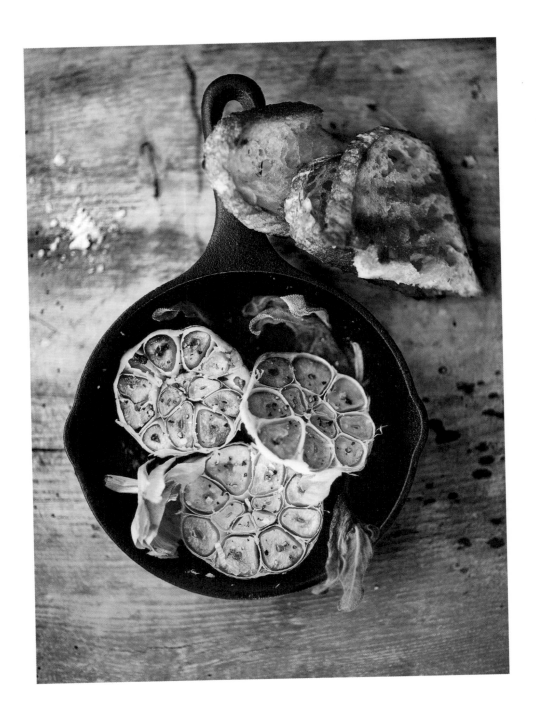

Garlic

Garlic is usually dried and sold in whole bulbs, which are sometimes woven into a branch – an enticing ornament to hang in the kitchen. Garlic has the capacity to permeate other vegetables and fruit if stored close to them, so it is best kept to itself in a garlic cellar or a little ceramic pot with holes in it, as it likes to breathe.

Preparing garlic

If there are green sprouts inside your garlic cloves, remove them before cooking, as they can be somewhat bitter.

SEPARATING THE CLOVES To separate the cloves of a garlic bulb, put the palm of your hand on the top of the bulb and use your body weight to lean on it.

MINCING GARLIC For finely minced garlic, you can crush and peel the cloves, then mince them with a knife, but a Microplane grater does the job at twice the speed and you can grate them straight into dressings or onto gently sweating onions.

SLICING GARLIC If I want my garlic to have a little more visual impact or texture I will go to the effort of trimming the tough end off each clove then cut it into 1mm slices crossways.

BLANCHING GARLIC When using raw, peeled garlic for dips or soups, you can take the edge off the flavour with a 30-second blanch in boiling water. Strain, pat dry and use as you would raw.

Cooking garlic

Garlic has a prominent place in my kitchen, acting as a soft and mellow base for soups, such as the Confit garlic ajo blanco on page 174, or as a fresh garnish – as in the gremolata that fragrances the chicken broth on page 188. Here are a few ideas for making the most of this kitchen stalwart:

ROASTED GARLIC If I have a whole bulb of garlic going spare I will often pop it in a tray with chicken or vegetables to roast, then squeeze out the resulting pulp and add it to a sauce or dressing, or mix it into softened butter.

To roast garlic on its own, cut a bulb in half around the circumference, drizzle the cut surface with oil and sprinkle with a little salt, then roast at 200°C/Fan 180°C/Gas 6 on a baking tray for 30-40 minutes.

For an elegant way of serving garlic bread DIY-style, pop some roasted bulb halves on a board with a pile of flaky sea salt and some griddled sourdough and whipped butter (see page 108).

GARLIC OIL AND GARLIC CHIPS You can quickly infuse olive oil with garlic by following the method on page 223. Not only will you end up with some lovely garlic oil for drizzling, but also crispy chips for garnishing soups, stews and salads.

CONFIT GARLIC This sounds fancy, but in actual fact it's just a way of slow-cooking whole cloves submerged in olive oil - see page 174 for the cooking method. You could go on to use it in the Confit garlic ajo blanco, or simply smear it on toast and sprinkle with flaky sea salt.

Onions

Alliums are an essential in every kitchen, and how you prepare them can have more of an impact than you might think. Raw and very finely diced, they give a potato salad or creamy dip an uplifting pepperiness, while thicker slices lend themselves to low and slow caramelisation. Red onions are my staple allium, as good raw as they are slowly caramelised; they also bring a pop of purple to a dish and maintain their shape. Brown onions are my preferred choice for sweating into sticky sweetness, for slow cooking and for soups.

Cutting onions

Dices, slices, rounds... there are a myriad of ways to cut an onion. Here are my favourites:

RINGS Peel the onion, then slice it widthways into rounds about 2mm thick. I use rounds in classics like a Greek, Niçoise or tomato salad, when a little precision goes a long way. This style of cutting works well with banana shallots, as you'll see in the caprese salad on page 144.

PETALS Peel the onion then halve it from tip to root. Halve lengthways again, then trim the root off and pull away all the individual 'petals' from the outside all the way to the centre. This is a good method to use for pickling, as the onions turn an elegant shade of pinky-red as they pickle.

VERTICAL SLICES Peel the onion and slice it in half from root to stem. Lay the onion cut-side down on your board, then thinly slice from root to tip, in the same direction as when you halved it (keep the root on to help you, and then trim it off afterwards). I like to use vertical slices on pizzas or tarts, where you can fan them out to make shapes. They also work well if you are slowly sweating or caramelising your onions.

HALF MOONS Peel the onion, and trim off the tip and root. Cut the onion in half lengthways, then slice it widthways into half moons. This gives you a sharper flavour than the vertical slices above (it breaks down the cells, releasing more of those tear-inducing vapours), which is good when you want to add some punchy flavour to a salad.

FINELY DICED Place a peeled onion half cut-side down on your board. With the knife parallel to the board, make finely spaced cuts into the onion towards the root, making sure not to cut all the way through to the root – you want to leave a section of the root intact to hold the onion together. Slice from root to tip, then slice in the other direction.

Mellowing onions

For anyone with an aversion to raw onion, a great way to temper the taste is to soak the chopped onion in some cold water for 15 minutes before serving. You could also soak it in something acidic, such as lemon or lime juice (for a ceviche perhaps), or red wine vinegar mixed with a pinch of caster sugar (for a quick pickle). This also brings out the colour of red onions.

Cooking onions

As a rule of thumb, the slower you cook your onions, the softer and stickier they will be, but sometimes a bit of bite on a quickly cooked tart (see page 116) is nice, adding a nice crunch and peppery flavour.

CARAMELISING ONIONS Few of us cook our caramelising onions low and slow enough. Fact. Try cooking them over a low heat for 30-40 minutes, with a splash of oil, a pinch of salt (which draws out the moisture) and a knob of butter. Caramelised onions are perfect with hot dogs, on top of a warm salad or scattered over soups - they look temptingly gooey.

ROASTING ONIONS If I'm throwing a roast in the oven, I'll add some onions to the roasting tray too. I peel and quarter them, leaving the root intact so that they keep their shape. They will be soft and sweet after 45 minutes but depending on the roasting time I will leave them for up to 4 hours or so to make them sticky.

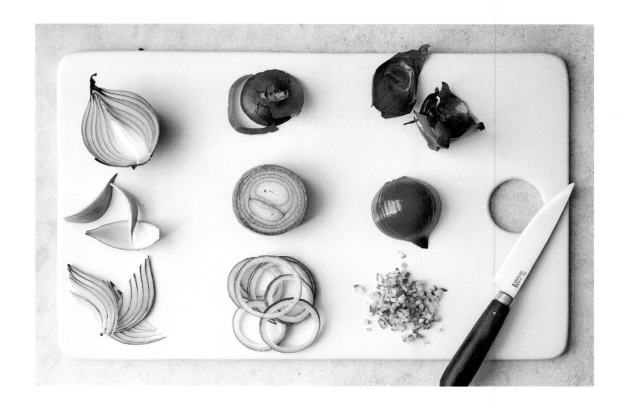

Fruit

These days we can get most things throughout the year, but on the whole it's not ideal from a flavour or aesthetic point of view. Seasonal bounty comes in a host of vibrant colours and varieties for cooks to experiment with, so do try and buy what's in season when you can. When it comes to dried fruit, goji berries, barberries and dried cranberries all have brilliant bold colours and can be substituted for raisins or sultanas if you want to speckle a recipe with something a bit different.

Preparing fruit

When cutting fruit, think about its natural shape. Respect the fruit and emphasise its highlights: anything from the little star centre you find when you slice an apple through its equator, to the elegant curves of a plump fig with its little hat of a stem. Most fruits shouldn't be cut much in advance of serving, unless it's for macerating. If you are preparing apples or pears ahead, keep a bowl of water with lemon halves squeezed into it nearby, and rub the cut fruit with the lemony water.

I like to use a melon baller for scooping out the core if I'm poaching apples and pears – that way you can retain the elegant shape of the fruit. The scooped-out centre also catches sauces and juices when you serve them (see my Crunchy caramel apples on page 262).

A fellow food stylist friend asked me recently if I had ever polished blueberries. I must admit that in my opinion life is too short for this – unless you find it therapeutic, in which case knock yourself out.

CUTTING OR TEARING The choice of whether to cut or tear fruit will have an impact on how it looks and how it behaves when dressed. Take figs for example: tearing gives them an interesting texture and allows whatever partner you opt for, be it honey or olive oil, to cling on and permeate the flesh. On the other hand, sometimes a straight edge is exactly what you need - perhaps for daintily arranging fig quarters on top of a tartelette. If you are cutting, always save the juices left on your board and return them to the fruit or use them to drizzle over the dish at the end.

LEAVING ON STEMS While they might not all be edible, I adopt a creative licence over leaving fruit stems on for visual impact, especially when it comes to poached pears, cherries, small strawberries, redcurrants and apples.

MACERATING This is the fruit version of a light marinade. Tossing cut fruit with a little sugar and a splash of acid (lemon juice or even vinegar) and leaving it to rest breaks down its texture, releasing lovely syrupy juices that are perfect for splodging and drizzling over dishes.

Cooking fruit

I love fresh fruit so much that I am often reluctant to cook it, and I think this is probably reflected in the way I like to style it too. I tend to use older fruit for cooking and save the perfect fresh pieces for munching on, for making up breakfast bowls with yoghurt or to top porridge.

ROASTING FRUIT Rhubarb, pineapple and apricots are my favourite fruits to roast. I use semi-ripe fruits; overly ripe will not maintain their shape when cooked. Toss rhubarb chunks, pineapple wedges or halved, stoned apricots in sugar, honey, or another sweetener – or try vinegar for a savoury pairing. A little butter, water or a splash of dessert wine will get the juices going, though it is not strictly necessary. Roast at 200°C/Fan 180°C/Gas 6 for about 20 minutes depending on the size of your fruit.

GRIDDLING FRUIT You need to use juicy but not overly ripe fruit for this, so they don't disintegrate. Try stone fruits, watermelon, pears and pineapple slices. Slice and core the fruit. Place a griddle pan over a high heat and, once hot, add the fruit cut-side down and cook, without moving it, until charred.

COMPOTES AND PURÉES Plums, rhubarb, summer berries and apples all work brilliantly. Prepare your fruit, put it into a pan with a touch of sugar and a splash of water, add any spices or herbs you fancy, and leave to simmer with the pan covered. After 5 minutes or so the fruit should be softened, and can be mashed, puréed or kept chunky.

Freezing fruit

Frozen berries are your best freezer-dwelling friend, especially in the depths of winter when fruity inspiration is sparse. I like to freeze my own berries in the summer months when they are cheaper and at their peak. Redcurrants are a particular favourite, as you can keep them on their stems for a pretty draped effect, and serve them still frozen with hot white chocolate sauce for a striking but simple dessert.

To freeze fruit, line a tray that fits in your freezer with cling film and spread the fruit out (fruit other than berries should be peeled and sliced or chopped). Freeze until solid then bundle them into freezer bags to store. This way you can keep their shape intact and they won't cluster together as they freeze.

Citrus fruit

Lemons, limes, grapefruit and oranges are endlessly inspiring ingredients. Whether thin slices are added to salads, segments are candied in a syrup or a strip of zest is rubbed around the edge of a glass of negroni, they are one of a food stylist's great joys.

I always buy unwaxed organic lemons, as this means you can use the zest and skin, but note that they don't keep as well. I also try to buy them with leaves on as this looks dreamy in a fruit bowl.

SEGMENTING CITRUS FRUIT Often referred to as 'supreming', this handy technique removes the membrane from citrus fruit, leaving perfect little segments like the tinned ones you might remember from your youth. First, trim 0.5mm off the very top and bottom of the fruit with a sharp knife. Next, set the fruit down on its base and carefully run the knife down between the flesh and the skin, beginning at the top and following the curves down to remove all the white pith too. Carefully cut out each section by inserting the blade of the knife between the flesh and the membrane and slicing each side to make a triangular cut. Remove the wedges, leaving only the membrane intact. Once all the segments are done, squeeze the membrane and save the juice for drizzling over whatever you are eating.

ZESTING I have a number of go-to tools for zesting. I use a Microplane grater for grating fine sprinkles of zest directly over food I'm about to serve, or for creamy sauces.

For very fine strips of zest, I use a 'stripper'-style zester (see image opposite), which you run down the side of the fruit to create dainty curls.

Long, thin strips for candying can be made using a Y-shaped peeler, then cut with a knife into fine lengths.

For cocktails, when you want to release some of the zest's oils, I use a Y-shaped peeler, then bruise the zest by folding it between my fingers to express the oils, then run it around the rim and pop it in the glass. To take this up a level, use a knife to straighten the sides, slice the ends on a diagonal and twist this around your finger a few times – the curl should remain.

Not an essential but a nifty zesting tool nonetheless, a 'canelle knife' has sharp V-shaped grooves which you can dig into the skin and scrape around the citrus to achieve a slick curl.

CUTTING CITRUS FRUIT Anything goes when you're cutting citrus fruit; here are some of the methods I turn to when styling and serving.

Cutting the fruit in half around its 'waist' reveals its beautiful symmetrical shape, but also allows the pips to escape. I tend to cut lemons this way if I am serving a plate of seafood. For a sweet way of serving them, cut a small square of muslin and wrap it around the cut flesh. Twist the other end and tie it tightly with a piece of butcher's string in a little bow.

An elegant alternative to lemon wedges is to present lemon 'cheeks'. Slice a section off the side of the lemon avoiding the central membrane and therefore the pips.

For the rustic feel of a trattoria in Puglia, I favour a segment of lemon with a little of the branch still on, cut in half lengthways then in half again leaving the stem intact.

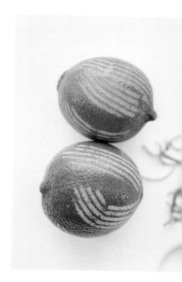
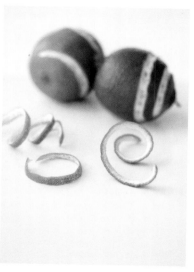
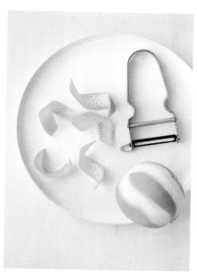

CANDYING CITRUS FRUIT Making home-
made candied citrus couldn't be simpler,
turning rounds of multicoloured citrus
into almost translucent slices to be
used for garnishing cocktails, dipping
in chocolate and topping cakes.

Slice your fruit (2 small oranges,
1 grapefruit or 2 limes) into 3mm rounds.
Place in a small pan with enough cold
water to cover and bring up to a slow
boil. Discard the water and refill with
cold water, being careful not to pour
water directly onto the orange, as this
will ruin the shape. Repeat the process
(this removes some of the bitterness
from the pith), then drain the slices.
Add 150ml fresh water to the pan, along
with 300g caster sugar, carefully
replace the fruit slices and bring the
liquid to a slow boil, then simmer for
8-10 minutes. Gently remove the syrupy
citrus slices. Preheat your oven to
100°C/Fan 80°C/Gas ¼. Spread the slices
out on a baking tray lined with baking
parchment and bake for 1-1¼ hours,
or until the slices have dried out
but not coloured. The candied citrus
fruit will keep for up to 4 weeks in
a sealed container.

CANDYING ORANGE ZEST A good use for
unwanted peel, these fine ribbons of
zest are a delicious decoration for
the tops of cakes or the Every occasion
lemon biscuits on page 320.

Remove the zest from the orange in
long strips using a Y-shaped peeler. Cut
lengthways into fine matchsticks using
a sharp knife. Place the zest in a small
heat-resistant bowl and pour over
enough boiling water to cover. Let stand
for 30 minutes before draining through
a sieve. Now heat 120g caster sugar and
60ml cold water in a small saucepan and
bring to a simmer so the sugar dissolves.
Add the orange zest and simmer for
10 minutes. Remove the zest from the
syrup with a slotted spoon, then spread
out on a parchment-lined tray. Coat
with more caster sugar if you like. The
zest is ready to be used immediately.
The candied zest can be kept in a sealed
container in a cool, dark place for up
to 6 weeks.

BURNING OR GRILLING CITRUS FRUIT
Burning or grilling citrus is not only
a way of adding a caramelised and
concentrated flavour to it (it makes it
intensely sweet and almost a bit jammy),
but adds an interesting aesthetic to
flaunt alongside your seafood or
grilled piece of fish. You can do this
quickly on a griddle pan or slowly in
an oven if you are roasting something
else at the same time. Cut in half and
place flesh-side down on a sizzling
hot griddle or frying pan. If roasting,
just put the halves into your tray with
whatever veg or meat you are cooking.
Cook until golden, sticky and sweet.

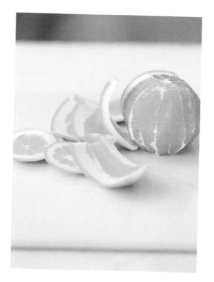 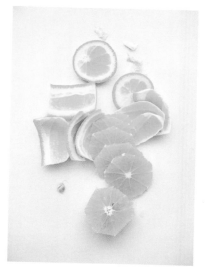 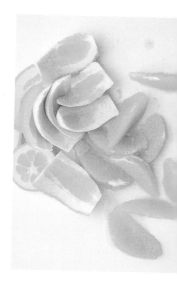

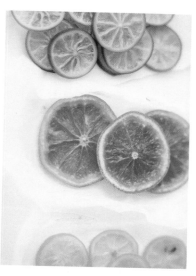

Meat

There are no hard and fast rules for cooking and styling meat, but one of the most important things for me is doing justice to the animal, and if it's cooked perfectly it will invariably look as delicious as it tastes. Pay a higher price and treat meat as a special treat and you'll reap the rewards when it comes to cooking and enjoying it. Thanks to the revival of the local butcher, sourcing high-welfare, excellent-quality meat has never been easier.

Buying meat

Shopping at a butcher or from a butcher's counter gives you the opportunity to get the perfect portion size or cut. You want to allow about 250g per person for larger cuts or fattier joints, but do check the recipe for portion sizing, as it will vary depending on the animal and fat content.

When I'm buying my meat, I don't tend to opt for the most expensive cuts – I prefer the better-value butcher's favourites like a good skirt steak, with its almost offal-like depth of flavour. Tougher cuts that require slow cooking are generally the best value and easy to make delicious if you can spare the time to simmer them over the day. Beef or pig cheeks are a great choice when it comes to slow-cooked stews; they hold their shape well and are good for feeding a crowd.

Cooking meat

I know this is a kitchen and not a science lab, but a digital meat thermometer is essential for anyone wanting to take their cooking seriously. While I tend to use intuition with many cuts and roasts, when it comes to an expensive rib of beef, I rely on the thermometer to avoid any dramas. Probe the meat in a few places for accuracy, and when checking a roast chicken be sure to probe the thickest part – the back of the leg nearest the carcass.

RESTING TIME Resting is essential for roasted and grilled meat, giving the fibres time to relax and the juices to be redistributed. As a rule, allow at least 15-30 minutes of resting time for joints and 5 minutes for steaks. To rest meat, put it on the board you're planning to use for carving, loosely covered with foil, so it stays warm but doesn't sweat. An important factor to take into consideration is that when meat is resting, it will continue to cook because the internal temperature carries on rising. The temperature increase will depend on the size of the joint or cut, whether it has a bone (the bone conducts heat) and the temperature it was cooked at. I usually allow for a 3-5°C increase during resting, but it can be as much as 5-10°C for a very large joint from a hot oven. Note that this rule doesn't apply to roast chicken, as the hollow cavity dissipates the heat quickly. These are the temperatures you are aiming for after the meat has rested:

Pork: 63°C for medium (for lean cuts); 71°C for well-done
Beef and lamb: 52°C for rare, 55°C for medium-rare, 60°C for medium
Chicken: 74°C (no temperature increase during resting)

Skin and crackling

Not everyone loves skin I know, but if it's perfectly crisped or puffy and crackled, few can resist. Moisture is the enemy here, whether it's fish skin, chicken skin or pork crackling.

CRISPY CHICKEN-SKIN CROUTONS Remove the skin from the chicken, pat dry and scatter with salt on a baking tray. Cut it to the size you want, but bear in mind it will shrink as it cooks. Bake in the oven at 200°C/Fan 180°C/Gas 6 for 20 minutes. These are great on salads and for using up any unwanted skin.

PORK CRACKLING For crispy pork crackling when you're roasting a joint, follow the method on pages 246-7.

DUCK SKIN When cooking duck breast, score the skin lightly in diagonal motions across the width. Season. Start with an unheated heavy-based non-stick pan and place skin-side down over a medium heat. You want to render (draw out) as much fat as possible, then slowly start to raise the heat. After about 8-10 minutes, once the skin is golden and crisp, flip the breast over and sear the other side. Depending on how thick it is, you may need to finish cooking the duck in an oven preheated oven to 200°C/Fan 180°C/Gas 6. Leave to rest for 5 minutes before slicing to serve.

Browning meat

It is a common misconception that searing meat seals the juices in. But don't feel silly about having cared so much about browning that meat for your stew or getting a good caramel crust on your steak: searing meat is an essential part of adding flavour to a recipe, as well as making it look delicious. The 'Maillard reaction' (the chemical process that creates the depth of flavour in darkened meat) is the basis of a great pan sauce and creates a delicious crust on your meat.

HOW TO SEAR A STEAK You'll find that quality steaks are often 'dry-aged' to draw out the moisture, concentrating the flavour and allowing them to develop a dryer, dark exterior, making a good crust easier to achieve when it comes to searing a steak.

If your steak isn't dry-aged, you can cheat this a little by starting to prepare your meat the day before. Season the steak with a little flaky sea salt, place it on a wire rack set inside a baking tray and leave in the fridge overnight, uncovered so that the air circulates around it and dries the outside.

Pat your meat dry with kitchen paper and bring it back to room temperature before you cook it, then season again with plenty of salt (I add pepper at the end so it doesn't burn). Get your pan searingly hot. I use a heavy-based well-seasoned cast-iron pan for the job as it maintains heat and place it in a hot oven for 10 minutes. Remove from the oven and place over a high heat, add a thin layer of oil, then add the meat.

If you are cooking a few steaks, do them in batches (crowding the pan means the temperature will drop and the meat will steam rather than brown and turn grey rather than caramelise). Even if this means the steak will hang around for longer, it's crucial that you don't lose pan heat – warm your serving plates instead. You must rest your meat. This gives the proteins a chance to relax and the juices to distribute themselves through the meat.

Fish and shellfish

I have my local fishmonger Danny on speed dial. His fish counter stocks a glistening display of fish fresh off the boat. I might go in there with a list of things in mind but end up leaving with something totally different simply because I can't resist his haul. Buying fish from a fishmonger will generally get you higher quality fish, with firmer flesh and glistening skin, making it both easier to cook and better to eat. If you buy fish from a packet at the supermarket, remove it before cooking and give the fish a rinse and a pat dry, as it can be a bit pungent.

I tend to buy all my fish whole for better value (unless we are talking about a massive expensive cod, in which case fillets are the way to go). Buying whole also allows you to inspect the freshness of the fish. You are looking for shiny and clear eyes (as opposed to cloudy), not sunken, and glistening scales. Really fresh fish will also have bright red gills.

Storing fish

Keeping fish and shellfish fresh is important for preparing dishes like ceviche (see page 182), where the fish is 'cooked' in citrus juice, rather than heated. Rinse the fish in cold water, then pat dry and place in freezer bags. Store the bags in the coldest part of your fridge – usually right at the back. Set them on a tray of ice if you want to be extra diligent.

Poaching fish

Cooking on the bone is a great way of keeping a piece of fish intact and stopping it from flaking if you are poaching it. Ask for cross-section cuts of salmon (cut widthways straight through the bone), monkfish or hake, which all work well if you're poaching fish in a curry or soup. Cod cheeks are good too; like fish on the bone, you will find that they are easy to divide up when serving lots of people.

Cooking 'en papillote'

This delicate method of cooking fish is a bit of a favourite among food stylists – it will always produce perfectly cooked fish, whether it's whole or filleted. Cooking within sealed parcels allows you to steam the fish while also infusing it with herbs and other colourful aromatics. Place your chosen piece of fish on baking parchment large enough to be able to wrap it up like a parcel with a little room for steaming. Add any flavourings you fancy – maybe a slice of ginger and a splash of soy sauce, or a slice of citrus and a drizzle of extra virgin olive oil – then tie it with string to seal, or loosely enclose it in a layer of foil. Cook in a preheated oven at 200°C/Fan 180°C/Gas 6, allowing about 8–10 minutes for thin fillets, such as bream, and about 15 minutes for thicker fillets, such as salmon. I like letting people unwrap the parcels themselves at the table.

Crispy fish skin

Really dry skin and a very hot non-stick pan is essential for achieving crispy skin on your fish fillet. Pat the fish dry, place it skin-side up on a plate. Leave it uncovered in the fridge for an hour or so. Don't season the fish at this point as you risk curing it. Get a frying pan really hot, then pour a thin film of oil inside. Season the fish with salt and place it in the hot pan, skin-side down, pressing it down with a fish slice to keep the skin in contact with the pan. You want to virtually cook the fish through at this point. For thinner fillets, such as as red mullet or bream, I tend not to do any more than this, but for thicker fillets, you will need to put the pan in an oven set at 200°C/Fan 180°C/Gas 6 to finish cooking it, or flip it as on page 227. If serving with a sauce, put your fish onto the sauce – don't drizzle it over or you risk ruining the lovely crispy skin.

Prepping prawns

Cooking prawns in their shell is an effective way of keeping them juicy and protecting them against overcooking, which can be a risk on a barbecue or under a grill. I also prefer to cook them this way when their juices are imparting flavour, in a dish such as a laksa. While you can cook them as they are, I remove the intestinal tract. Using sharp scissors cut along the back of the prawn just deep enough to access the grey thread and use a spoon to scrape it out.

If you prefer to serve the prawns peeled, remove the head and peel off the shells up to 1cm from the end of the tail, leaving that on as it keeps the shape of the prawn nice and curved and looks better for presentation.

Serving seafood

One of the great joys of shellfish is that it comes in its own bespoke serving vessel, something us stylists and chefs like to take advantage of on both the presentation and enjoyment front (I think slurping shellfish from a shell is one of life's great pleasures). The scallops with flavoured butters (see page 221) get cooked and served in their shells, and this not only allows you to mop up the buttery juices that get trapped in the shell, but it also serves as a reminder of the scallops' just-plucked-from-the-sea freshness.

When it comes to serving clams and mussels, I like to show off the shells as much as possible, while still making them easy to eat voraciously. I might pull some out and serve the rest in their shells, for example. For the gazpacho on page 176, I take it a step further and use mussels as spoons, the bonus being you get a sweet mouthful of mussel as well as soup. Always pick the best-looking shells to flaunt.

At the risk of sounding obnoxious, shellfish platters are all about a show of abundance, so I like to add height with plenty of crushed ice and pile up the seafood (finances permitting). Using a tall bespoke metal stand, as in a Paris brasserie, is a ceremonial way of serving *fruits de mer*; a large metal tray perched on a cake stand works very well as a stand-in. Turn to page 39 for ideas on how to present the lemon; and put out some water bowls with a slice of lemon in them too, to avoid excessive mess on your napkins!

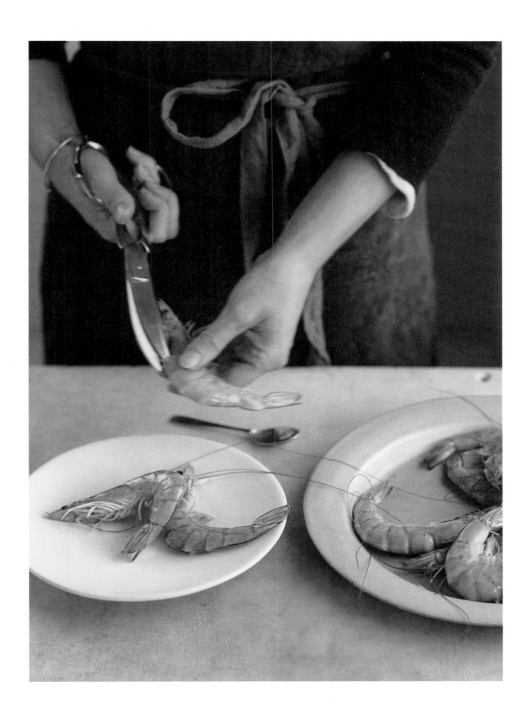

Bread

One of my pet peeves, when I flick through a magazine or a cookery book, is admiring a delicious and beautifully styled dish – then spotting a piece of sad-looking bread in its vicinity. There is a time and a place for a pre-sliced loaf of white bread (cheese toasties, cucumber sandwiches, summer pudding), but it's not on an otherwise carefully conceived table spread. Find a favourite bakery and treat yourself to a baguette or splash out on a lovely crusty sourdough loaf.

Mopping up food with bread

Our continental cousins have verbs for the basic pleasure of mopping up your sauce with your bread: *fare la scarpetta* in Italian and *saucer* in French both signify that moment when the sauce is so good, you need to devour every last drop of it.

Think of matching your bread to your food. A crusty baguette has the perfect tearability for dunking in soups, whereas some types of rye bread would crumble and go mushy. For serving cured salmon, on the other hand, a thinly sliced loaf of dark rye or pumpernickel is perfect, adding a nutty savouriness that complements the flavour of the fish.

Flatbreads

'Serve with flatbread or pitta' is a throwaway line you'll often read at the end of a recipe, a time when food stylists have to use their imagination. An anaemic piece of pre-made pitta never really gets the taste buds going, but fortunately there are plenty of pretty and tasty ways to perk up even shop-bought pitta. Try drizzling it with oil and scattering over some homemade dukkah (see page 207), or brushing it with oil and griddling it with a few sprigs of herbs and flaky sea salt as I do in the flatbread recipe on page 122.

TORTILLAS AND TACOS It's very easy to give shop-bought tortillas or tacos a facelift. If you have a gas hob, grab a pair of tongs with a long handle and char each tortilla or taco directly on the open flame of the hob – this will give you uneven charring marks that make them look like they have emerged from a street food stand in Mexico.

Char marks made using a griddle pan are another winning look. Just heat a griddle on a really high heat then press the tortilla onto it. Don't move it once it's in the pan, as you want to make the marks quite defined. Keep the tortillas warm in a nice piece of linen or a tea towel brought to the table.

Croutons

Torn or cubed, that is the question. When I look at cubed croutons, with their perfect proportions, I think back to the days of Pizza Hut all-you-can-eat buffets for kids (yes, even stylists have their blips). These days, the more rustic the better, which means tearing, crusts and all. I fry croutons in butter with a clove of crushed garlic, or bake them in a hot oven after tossing in oil and sometimes with grated Cheddar over the top. For soup; the gnarlier the croutons are the better.

Breadcrumbs

Never let stale bread go to waste. There's always a use for breadcrumbs, whether it's fine ones for coating a fillet of fish or chunky, oil-fried ones scattered over pasta. I'm a big fan of the carb-on-carb classic that is *pangrattato* pasta: toast your breadcrumbs in butter spiked with a few melted down anchovies – or just a few herbs – and scatter over your pasta. It is the ultimate in upcycling indulgence.

Eggs

The first step towards making eggs look stunning is buying great eggs. Good quality free-range organic eggs not only taste better, but they look better too. I generally go for Clarence Court for their vivid orange yolks, which are so deliciously creamy too.

Eggs are a subject to be taken very seriously and their cooking is hugely personal. As with most foods erring on the gloopier side of things (ripe bananas and soaked chia seeds also spring to mind), opinions vary over setness and wobble, which is why I advise thinking in terms of well-done or medium-rare.

My personal preference alters on a daily, even hourly, basis. Sometimes the runniest of scrambled eggs, sloppily soaking into a slice of buttery toasted sourdough, is the only way forward; at other times it's all about a dry scramble, piled on the plate with a slice of cured salmon. A poached or boiled egg with a soft jammy yolk is the most enticing accessory for a soup, while a hard-boiled egg can be grated on as a light crumbly garnish.

Testing for freshness

To test the freshness of an egg, lower it into a bowl of cold water. If it floats, then it is old and you should only scramble or hard-boil it. If it falls flat, it is very fresh, and therefore perfect for poaching. If it's lightly tipping upwards, the egg is good for all other purposes (frying, omelettes, etc.).

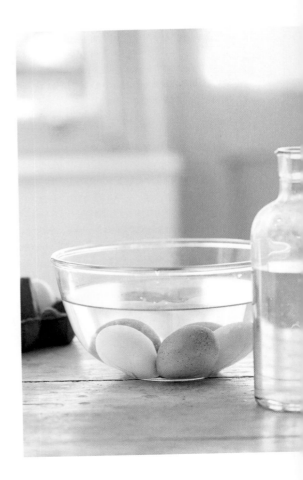

Boiling eggs

Here's how to boil medium eggs. First look at the size of each egg (even if it's labelled medium) and decide if it will be necessary to alter the boiling time by 20–30 seconds or so.

Always start with the eggs at room temperature. If you store yours in the fridge, run them under a warm tap to take the chill off. Bring a small pan of water to a rolling boil. You'll need enough water to cover the eggs by about 1cm. Carefully lower the eggs into the water, then lower the heat to a simmer and start the timer.

Time 3½ minutes for a runny centre, which is essential if you like dunking soldiers.

Time 6 minutes for medium with a squidgy-soft centre, which is best for salads where the yolk will run into the dressing, or for bowls of grains and vegetables. This is also good for ramen-style soups like the one on page 181.

Time 8 minutes for medium with a not-totally-set centre. I use these eggs with aïoli or bruschette (see pages 105 and 111).

Time 10 minutes for hard-boiled eggs, good for sandwiches and grating (see the Asparagus mimosa on page 141, or Disco dyed eggs on page 126).

PEELING BOILED EGGS If you want to peel boiled eggs, do it under running water for ease. I tend to cover the plughole with a sieve to make the tidy-up quicker. If you have used very fresh eggs, they will be harder to peel than slightly older eggs because the white albumen sticks to the inner shell more than older eggs. To make it easier, run the cooked egg under cold water, roll them on your work surface to crack the shell lightly all over, then submerge in a bowl of iced water for a few minutes before peeling them under running water.

Frying eggs

I'm a sunny-side up girl through and through, because from a styling point of view, 'over easy' is just going to conceal the enticing contrast between the white and yolk. I use my non-stick 20cm pan, though my mum prefers her 10cm blini pan for neater, perfectly circular eggs. I opt for the crispy fried eggs below when I fancy a crunchy texture, but basted fried eggs are my favourite on toast.

CRISPY FRIED EGGS Heat 1 tablespoon of olive oil in a non-stick frying pan. Leave it to heat over a medium flame for about 1 minute. Crack in the egg (avoid any oil splash) and let it sizzle in the pan, crisping at the edges. Season and cook for about 2 minutes or until set to your liking (pop a lid or plate over it if you prefer the yolk and the top of the white quite set). Crispy fried eggs are especially great doused in chilli oil or sambal, and served over vegetables or fried rice with an Asian accent.

BASTED FRIED EGGS Melt 2 tablespoons of butter in a non-stick frying pan. Once the butter is melted and foaming, crack in your egg, holding it close to the base of the pan to avoid breaking the yolk. Cook the egg over a medium-low heat. Once the edge of the white has just set, gently tilt the pan to one side and use a spoon to scoop up the melted butter and tip it over the egg. Repeat this for 3 minutes, until the egg is cooked but not crispy.

Scrambling eggs

Eaters of scrambled eggs fall into two very distinct camps. Some relish the creamy and wet variety, going as far as to cook them over a bain marie, with cream, but I'm all about the silky and firm, fast and furious option. There's a time and a place for both; here are my go-to methods (each method serves 2):

QUICK SCRAMBLING (SILKY AND FIRM)
Crack 4 eggs into a bowl, beat well and season with salt. Heat a 20cm non-stick frying pan (you'll thank me later when you aren't scrubbing the saucepan you have been using until now, plus the large surface area cooks the eggs even quicker) over a medium-low heat and add 2 tablespoons of butter. Once the butter is foaming, add the eggs and let them spread around the pan in an even layer. Leave for about 10 seconds, then use a wooden spoon or spatula to push the egg in from the sides , folding the set bits of egg into the centre of the pan a few times to create ribbons of egg - you'll end up with a mixture of set and sloppier bits. Quickly transfer the scrambled eggs to a plate, as they will keep cooking. These eggs look quite the part next to a piece of cured salmon.

SLOW SCRAMBLING (CREAMY AND WET)
Beat 4 eggs with 1 tablespoon of double cream and some salt. Set a pan of simmering water over a medium heat. Put 1 tablespoon of butter into a heatproof bowl that sits snugly in the pan without touching the water. Once the butter is melted, add the eggs and cream and stir continuously with a spatula for around 15-20 minutes until you have a runny scramble.

Omelettes

Not only are omelettes one of the cheapest and quickest plates of food you could make yourself, I hope you'll get a deep satisfaction from this simple and delicious accomplishment once you master the art. The best omelette is 'for one' because it's best eaten immediately – you don't really want to cook another one for a friend or lover while yours goes cold.

CLASSIC OMELETTE Whisk 3 eggs in a bowl and try not to incorporate too much air. Heat 1 tablespoon of butter in a 20cm non-stick frying pan over a medium-low heat. Don't let the butter brown - you want it pale and foamy. Add the eggs, season (I opt for white pepper here, so as to preserve the perfect homogenous colour) and use a spatula to move the egg constantly around the pan, as if you were scrambling it. Do this until the omelette is just set underneath but still quite wet, or slobbery, as the French say. Grate over some Parmesan (if you like - it's not included in the traditional French recipe!) and sprinkle on a few table-spoons of finely chopped herbs, such as chives, tarragon, chervil and parsley. Press the egg evenly across the base of the pan so that it sets but does not colour, then gently, using the spatula, fold up the omelette by scooping it from underneath. Flip it onto a plate. Glaze with a little extra melted butter for an extra-shiny finish, scatter a few more herbs on top and extra finely grated Parmesan, if using.

Poaching eggs

A controversial matter in the kitchen, poaching eggs comes down to one key criterion: using fresh eggs. There are two methods here, one in which you prick the shell before poaching (as championed by Julia Child), and a second in which a sieve is used to keep the egg in shape. Trim your egg whites with a pair of scissors if you want a pristine finish – but really there's no harm in a ghostly straggle of white.

 Poached eggs are great for feeding a crowd, as they can be cooked in bulk and set aside in iced water after poaching, which stops the yolk from cooking any further. When you are ready to eat, dunk them back in a shallow pan of simmering water for a few seconds then drain well on kitchen paper or a J-cloth.

IN SHELL Bring a large pan of salted water to the boil. Prick your egg with a pin, then submerge it in the water and boil for 15 seconds. Remove the egg and reduce the water to a low simmer. Crack the egg directly over the surface of the simmering water and poach for 2-3 minutes, or until the white has set. Use a slotted spoon to fish it out. Drain on kitchen paper and serve.

SIEVED Bring a large pan of salted water to the boil, then reduce the heat until the water is barely simmering. Set a sieve over a bowl and crack your egg into it. This gets rid of the excess loose white. Transfer the egg to a wine glass (it's easier to lower the egg in from a curved shape). Make a vortex in the water by stirring gently with a wooden spoon. Position the glass close to the surface of the water, then tip the egg from the glass straight into the centre of the vortex. Cook for 2-3 minutes or until the egg white is set and the yolk is still delicate and soft. Drain on kitchen paper and serve.

Curing eggs

Think of cured egg yolks as a vegetarian alternative to bottarga, the bitter salted fish roe loved by the Italians – grated, it is a brilliant addition to everything from pasta to tacos. This is a great way of using up leftover yolks from making meringue.

Combine equal parts fine salt and caster sugar, enough to fill a small Tupperware box two thirds full. Make a little nest in the mixture and gently place the yolk(s) inside it. Sprinkle the cure over the yolk, being careful not to break it, and cover it fully in the mixture. Leave for 3–4 days in the fridge, then remove from the mixture, run under cold water to rinse off the excess cure and dab dry. Place on a parchment-lined baking tray and dry in the oven on its lowest setting (or use a dehydrator if you have one), for about 3–4 hours until they feel firm. You can now grate the cured egg yolks over salads, soups or pasta – they'll keep in an airtight container in the fridge for up to 3 weeks.

Mayonnaise

My experiences with mayonnaise vary from the triumphant –'what's all the fuss about?' – to the disastrous – 'how can I call myself a cook?'. Having experimented for years, however, I've finally nailed an ideal method.

I find making mayo easiest in a clean, deep glass bowl with a balloon whisk; I've never had much luck with the food processor. Rest your bowl in a tea towel over a snug-fitting pan. (You need two hands for the job so the key is to have a stable set-up for your bowl.) A fitted pourer on your oil bottle also helps once you get going.

Crack 2 yolks at room temperature into the clean bowl. Add 1 teaspoon Dijon mustard and whisk until well combined. Now start adding 200–250ml light olive or vegetable oil in a slow and steady stream, whisking vigorously every so often. Keep pouring the oil until you are happy with the consistency. Add 1 teaspoon lemon juice or white wine vinegar at the end, and season to taste.

If your mayonnaise splits (i.e. goes from thick to liquid and you freak out), all is not lost. In another large bowl, whisk an egg yolk and gradually incorporate the split mayonnaise into the yolk.

Nuts and seeds

Having a stash of nuts or seeds in your cupboard is a gratifying investment. Not only do they add texture and, well, nuttiness, to a recipe, but they can magically unify all the components in a dish in much the same way as a well-chosen herb. Try not to buy pre-roasted or pre-chopped nuts or seeds – this will give you the flexibility to be creative and prep them yourself. They will also taste better! (I do make an exception for flaked almonds, which are impossible to slice as perfectly as the ones in a packet, but do opt for untoasted ones and toast them yourself.)

Whole walnuts, in particular, often get crushed in their bags, but if you buy walnuts in their shells, you can crush them yourself and ensure they are neat (and less dusty). Just envelop the walnuts in a tea towel and tap them with a rolling pin a few times, then pull away the shell. A nut cracker will also do the job if you have one. The goal is to try and keep the kernel as intact as possible. Whole nuts in their shells also make a pretty addition to a cheeseboard.

I generally buy pistachios as kernels rather than in their shells, for ease. If I am using them to stud a dessert like Panettone torrone Alaska (see page 308), I use vibrant green, nibbed Iranian pistachios (see Stockists, page 333). These can also adorn dishes with a Middle Eastern flavour. However, if you can't find Iranian pistachios, there's a cheat's way of getting a similar visual effect – quick-boiling standard ones. Blanch the pistachio kernels in a pan of boiling water for about 1 minute until you see some of the papery skins start to release, then plunge the kernels straight into a bowl of iced water. Leave to chill, then (this is the tedious part) peel the skins away using the tip of a paring knife.

Chopping nuts

Whether it's to get them as fine and even as possible, or to split them in half perfectly, food stylists always have an agenda when it comes to nuts. While you can buy them pre-chopped or shove them in a food processor – where's the fun in that? – I chop most nuts roughly on a board instead, using a sharp knife.

Hazelnuts have a little diamond shape in the middle of them and I get a bit of a kick out of exposing it: simply split them in half with a small paring knife from the pointy tip downwards. Almonds look best cut into shards down the longest part. Have a go at finely grating blanched pistachios for a pretty dusting on the top of a cake.

Toasting nuts and seeds

Oven toasting nuts, rather than dry-frying them in a pan, is better for getting an all-round golden look. (If you do want to use a pan, toss them regularly over a medium heat.) To use the oven, preheat it to 180°C/Fan 160°C/Gas 4, then place the nuts on a baking tray and check them every 5 minutes once they're in. Larger nuts, such as hazelnuts and walnuts, can take 5–10 minutes, while cashews will burn sooner than that. I toast pistachios for 3–4 minutes, just enough time to release some aroma, but not enough for them to colour at all.

Pine nuts have a tendency to go from beige to burnt so quickly that I usually opt for the pan-toasting method in order to have them in my sight at all times. Once they are starting to colour I don't take my eyes off them. To stop them cooking once you reach the desired colour, you need to decant them straight into another vessel.

Always roast nuts close to the time of serving, as they develop a speckle when roasted and stored for a long time (though you can refresh them with a quick outing in a hot pan).

Sometimes the skins on hazelnuts can be too papery – just roast them with the skins on then place them in a clean tea towel and rub them, and the skins will shed.

I tend to toast seeds dry in a non-stick pan over a medium–low heat. Pumpkin seeds are particularly worth toasting; you'll know when they are done, as they will start to pop. I often toast them in olive oil with a little salt as a glossy garnish for soups or toast. Seeds also make for excellent carriers of spices, sugar (when caramelising) or seasonings like soy. Once the seeds are toasted in a pan, add your seasoning to coat and cook for a further minute.

Decorating with nuts

Toasted almonds, crushed hazelnut praline and any kind of roasted nut tossed in honey while hot (see page 154 for my method) are some of my favourite additions to the tops of cakes or puddings, adding an extra texture and a visual clue as to what the eater can expect. Or for savoury dishes, toss them in a little oil to give them a sheen.

Salt and pepper

A good rule is to season often and taste all the time while you're cooking. If you worry that you have over-seasoned, you can mellow it out with a touch of acidity or sweetness. If you want to look cheffy and season evenly, sprinkle or grind on salt and pepper from a height of about 20cm.

Which salt to use

The most useful salts to have to hand are fine sea salt, which I use for seasoning pans of boiling water and in baking; flaky sea salt, for most other seasoning; and coarse salt for serving oysters or other shellfish. Flaky sea salt can give a subtle finishing touch to a recipe visually, and even the tiniest pinch can elevate a dish with its delicate crunch. Take care when opting for fine salt in lieu of flaky sea salt when using teaspoon measures. The compactness of the fine salt in a teaspoon measure means that you will be using almost twice as much salt as flakes. If a recipe has called for 1 teaspoon of fine salt, this would be the equivalent of about 2 teaspoons of flakes, and vice versa.

Try playing around with different varieties and textures, such as black lava salt, granular fleur de sel, pink Himalayan cracked with a pestle and mortar, or Murray River flakes, which have an incredibly delicate saltiness.

Pepper

Peppercorns – black, green, pink, white or Sichuan – are not to be underestimated in the kitchen. It's worth buying peppercorns whole; avoid those dusty machine-ground powders.

With a few twists of the grinder or chopped by hand with a knife, black pepper works a treat for enhancing a dish before serving. Conversely, white pepper is handy to have about when you want the heat of its flavour but are avoiding the speckles (think white sauces such as Béchamel). Sichuan peppercorns, when toasted, give a tingly heat sensation and pink peppercorns, with their little red tinges, are a pretty addition to the plate.

For grinding peppercorns quickly, you can't beat a pepper mill – many of them allow you to adjust the coarseness of the grind by untwisting the screw at the top. On a photo shoot I opt for a pestle and mortar or I use a knife to chop whole peppercorns, which gives me an extra level of control over the coarseness, particularly for the top of soups. You can also try crushing peppercorns under the weight of a heavy pan.

How to Arrange a Plate

Serving is one of the most important parts of food styling. Once you have cooked all the components of your dish it's a case of assembling it in a way that *looks* as well as smells and tastes enticing.

Just as individual style is incredibly subjective, there's no right and wrong method of assembling a plate, but with a few rules to follow, you'll be on your way to more beautiful home cooking. My personal approach is a fairly rustic one, as I think this highlights the natural beauty of the ingredients. If you like a neater style of presentation you can still follow the same basic principles, whether it's lining your asparagus spears up in lieu of tumbling them on top of one another, or slicing rather than tearing your figs for cleaner edges.

Getting organised

'Mise en place' is the fancy restaurant term for getting everything ready before you start cooking, and I would advise you to try and bring it into your way of working: organising yourself like a chef will really help make you more efficient in the kitchen.

Read every recipe all the way through before you begin, and if you are preparing multiple dishes make a list of what you can do to get ahead and tick them off as you go; feeling organised will stop you getting flustered.

Once you've read the recipe, if the ingredients include pre-chopping vegetables or making a spice paste in advance, get these ready and put them into individual vessels. This way, you'll be able to cook more quickly and smoothly.

Between each stage of the cooking process, clean and put away things you no longer need. A tidy workspace is a tidy mind.

Think about the mise en place when you serve your food too. If a soup recipe calls for a handful of picked coriander leaves, chopped and roasted hazelnuts and a sprinkling of pickled shallots, then place all the items in small bowls or line them up on your chopping board before you ladle the soup into bowls. Seeing all the components laid out like this gives you a chance to think about how the colours and shapes are going to work together and how to position them when you come to use them.

No matter how stressful the kitchen may have become, always pause and make a conscious decision about which ingredients in your dish you want to take centre stage, and which ones you don't mind concealing. Having said that, food looks at its very best fresh from the pan so work quickly when transferring your cooking from hob to table.

Before I've finished cooking I'll always pause and think about what dishes I am going to use for serving (I usually do this before any guests arrive), then I get them out of the cupboard and keep them in my sight. This way, even when you are juggling a few different recipes and trying to ensure they are all hot at the same time, you won't let down the presentation at the last minute and be tempted just to throw the centrepiece on the table in its aluminium tray (unless, of course, it's a beautiful tray and you intended to!).

Creating a composition

When you're serving up, remember the 'rule of three', which dictates that an arrangement of three will always look better than a formation of four. Overlap, create height, layer and play around with the composition – but stick to odd numbers. Asymmetry adds interest to a plate, and leaving a little room allows you to show off the shape of star ingredients, like the curve in a stalk of rainbow chard or a perfectly-griddled piece of peach.

Work with the natural shape of the food. Don't think in terms of filling the plate, but leave some negative space; smaller looks daintier and more special. Remember that you can always go back for seconds!

Hang onto a few of the prettiest elements of your dish to position them at the end. This could be the best-looking segment of orange or the curl of carrot you are most happy with. It gives you greater control over the composition of the plate and it means that all those lovely colourful elements won't get lost under a bed of spaghetti or kale.

Use a garnish to harmonise all the elements on your plate. Some picked herbs, a sprinkle of dukkah or a scattering of praline can often be the unifying element that brings a dish together. And few things aren't improved with a drizzle of extra virgin olive oil and a scattering of flaky sea salt.

Ingredients don't have to be kept whole. Whether it's a steak that you have sliced against the grain and tilted to reveal some of its perfectly cooked centre, or a fillet of salmon that you have flaked into three rough pieces to expose its pink flesh, breaking food into 'chunks' allows you to show off both the inside and the appealing outside at the same time.

Messiness is good – within reason. This can be anything from letting the crumbs from a tart case crumble on to the serving plate, or allowing some tufts of herbs to fall onto the tablecloth. However, messiness such as the spilling of stew down the rim of the bowl is not appealing so use a damp piece of kitchen paper to clean the edges of plates or bowls before serving.

Remember that dinner shouldn't look like a staged still life, but something delicious you want to dig into, so anything unnecessary or inedible shouldn't be on the plate at all.

A Cook's Toolkit

Contrary to popular belief, a food stylist's toolkit does not include expensive gadgets, a rainbow of food colourings, instant mashed potato or WD-40 (or at least mine doesn't). Here, instead, are a few of the essential tools that will help make your cooking shine.

Cutting

Blunt knives are dangerous and painfully slow to use. If you aren't confident sharpening them yourself on a steel or whetstone, look up your nearest sharpening service. I have a guy that pops by with a portable sharpening machine and does all of mine in one go.

A CHEF'S KNIFE and PARING KNIFE are my two most-used knifes, and as long as those are in good shape you can live without a full set. A sharp serrated BREAD KNIFE is also crucial for achieving decent, even bread slices, especially from a crusty loaf of sourdough, and for cutting cakes.

For trimming, snipping herbs and tying up poultry and joints of meat, you'll need both SCISSORS and STRING. (The prettier the better if you also intend to have them on display, dangling from hooks in the kitchen...)

Peeling, grating, grinding and blending

A PEELER is a food stylist's best friend, essential for creating ribbons of vegetables and flaky thin shavings of hard cheese. The simplest and most basic one, which is shaped like a 'Y', is all you need – these peelers are easy to grip, sharp and cheap as chips.

A JULIENNE PEELER and MANDOLIN are two simple, inexpensive pieces of kit that will speed up your cooking and make you look like a proper pro. I use a mandolin extensively for the recipes in this book, for thinly shaving vegetables with precision and speed.

It's also useful to have a range of GRATERS and ZESTERS. I would recommend a 'stripper'-style zester for making fine twists of citrus (see page 38); a Microplane for finely grating zest, nutmeg, ginger and garlic; and a box grater or coarse grater for grating cheese.

Spices that are toasted and ground fresh are much more flavoursome than the pre-ground sort. You can either use a COFFEE or SPICE GRINDER, or a PESTLE AND MORTAR.

When it comes to gadgets, I use a HIGH-SPEED BLENDER for making soups and purées, a FOOD PROCESSOR for blending dips and pestos, and a STAND MIXER for making buttercream light and airy, and kneading enriched doughs.

Measuring

I don't even go on holiday without DIGITAL SCALES. Precision is key when it comes to baking, in particular, and all of the recipes in this book have been created and tested with that in mind. Digital scales are probably the best culinary investment you could make and I urge you to get a set. For liquid measurements, I rely on my trusty scales as well, working on the basis that 100g water is equivalent to 100ml (for thicker liquids it varies). To weigh a liquid, put the empty container on the scales and set them to zero, then slowly add the liquid.

A small set of MEASURING SPOONS is an excellent kitchen asset for measuring spices, raising agents and dressings, and all the recipes in the book rely on a level-measured spoon.

It's also worth investing in an OVEN THERMOMETER. All ovens are different and often don't read totally accurate on the dial, so place an oven thermometer inside your oven and rest assured the edge of that tart won't catch. If you are used to your oven and trust it implicitly, ignore this, but I don't and like to keep a watchful eye.

A DIGITAL MEAT THERMOMETER is also useful for achieving a perfect roast every time (see page 43 for more detail), and I am a slave to mine. A Thermapen is one of the quickest and niftiest on the market, with an instant-read gauge and to the decimal point accuracy.

Pans

I have no intention of listing all the pots, pans and trays that a well-stocked kitchen needs, but do remember that a TRUSTY PAN will last a lifetime and longer. I do love copper pans, as the heat distribution is excellent (I have a 30cm sauté pan made of copper and a little saucepan for sauces).

CAST-IRON PANS have heavy bases that work well for browning meat and slow cooking; they also double up as serving dishes that can be plonked in the middle of the table on a heatproof mat or a trivet. My favourite Staub pans make regular appearances throughout these pages. A well-seasoned (non-stick from a protective layer of oil) CAST-IRON SKILLET or FRYING PAN is ideal because they retain heat so well. If you don't have one, a heavy non-stick pan is perfectly fine.

The ridges on a GRIDDLE PAN create attractive charred lines on meat or vegetables; which is also great if you want to make fancy-looking toast.

Other useful tools

If you married a silicone spoon and a spatula, you would get a 'SPOONULA', and since I was introduced to one a few years ago I've never looked back. They're bendy enough to scrape all around the nooks of pans, blenders and jars without scratching.

For cake decorating, a PALETTE KNIFE is an essential tool for smearing icing (buy a range of shapes and sizes, but at least one long and flat, one small and angled). The choux buns and lemon biscuits on pages 317 and 320 require PIPING BAGS and NOZZLES, which are indispensable if you want to take your pastry skills to the next level. Plastic disposable ones are useful if you don't want to invest in a full set of piping nozzles, as you can snip the opening to the desired size with scissors.

I couldn't live without a FISH SLICE for carefully turning pancakes or fish in the pan.

A PLASTIC SCRAPER makes quick work of scraping dough from bowls or dividing dough on a work surface, as well as scraping your surface down after use without damaging it.

SERVING TONGS in two sizes are another essential; I love my tiny ones for precision, when turning individual items over in a pan or twirling pasta, and longer-handled ones are useful for the barbecue.

Always have KITCHEN PAPER to hand and use it to ensure that every plate is clean before serving. For more delicate tidying put a folded piece of kitchen paper against one finger and sweep it around the edge of the bowl if you have any residual soup marks or spills. And then act all casual about it. On set we use COTTON BUDS to clean up any messes of this type.

Chefs' TWEEZERS (around 20cm long), or even ordinary tweezers, might not be the first thing you'd think of having in the kitchen, but for delicately placing herbs on a finished dish or moving a salad leaf a couple of centimetres to the left without ruining the rest of your work, give them a go.

Some things benefit from a quick blast with a BLOWTORCH before being served. A cook's blowtorch can be used to caramelise leeks, fish skin, crackling, citrus and crème brûlée tops. This little investment will transform your presentation.

For drizzling oil on a photo shoot I decant the oil into a SQUEEZE BOTTLE or insert a pourer into the top of an oil bottle. Turn the bottle upside down and quickly circle it around the plate or bowl. A squeegee bottle also works well for very small droplets.

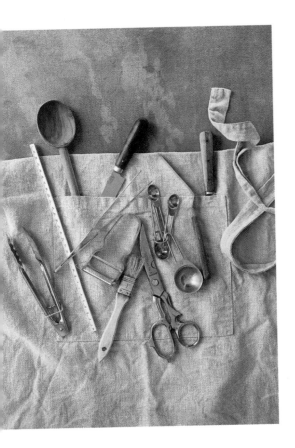

For serving soups, I use a little LADLE for accuracy, but if you are decanting into a small serving vessel, pour the soup from a jug for even greater precision.

A soft-bristled PASTRY BRUSH is essential for lightly applying egg wash to pastries and delicately dusting away any speckles when serving up.

Breakfast

To do breakfast justice I'm of the mind that you need to give it the time and attention it deserves, which is why this chapter is mostly about weekend breakfasts and brunches, when you can throw on the dressing gown, not feel silly decanting your milk into a pretty vessel (although, sad to say, I'll admit I sometimes do that midweek anyway) and take pleasure in preparing something to share. Some of these recipes, such as my Sticky figgy breakfast buns (see page 88) require a little preparation the night before, while others, like the One-pan breakfast beans on page 95, can be rustled up in the time it takes to fix a round of teas and coffees and get the weekend papers on the table.

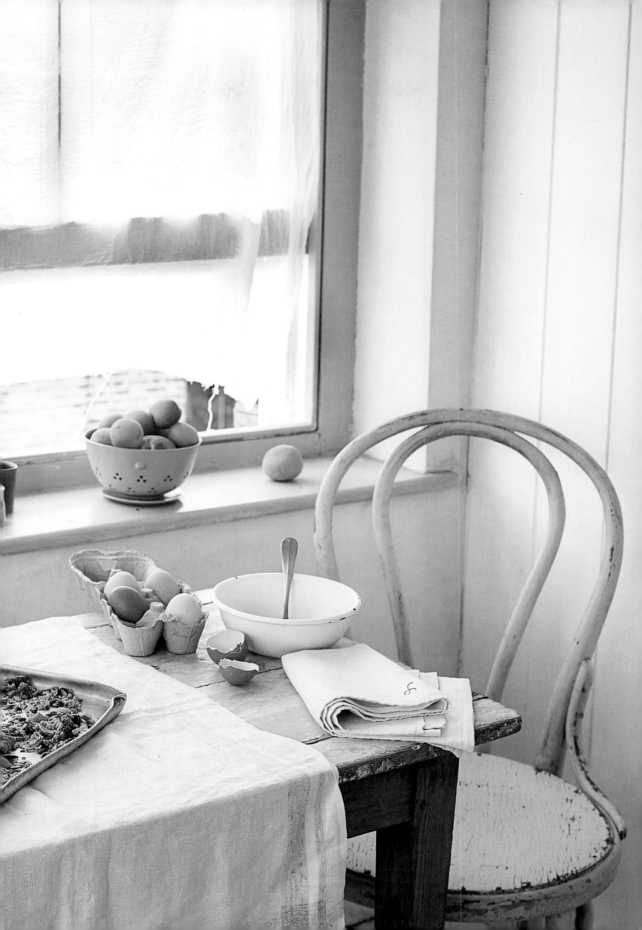

Chocolate granola shards

When I'm up early to rush off to a photo shoot I rarely have time for anything bar a strong black coffee to kick me into action. But around the mid-morning mark I love a cheeky little pick-me-up, and that was how this recipe was born. I always have a batch of granola on the go, usually made up of odds and ends left over from a shoot, so feel free to make up the quantities with what you have to hand. While it's not essential, I also add a teaspoon or two of dried cornflowers to decorate. Store the shards in the fridge to nibble on as required, or add some to a lunchbox. *Makes about 550g*

CHOOSING DRIED APRICOTS Although unsulphured apricots have become more popular in recent years, if you are keen on vibrant colours and tangier flavours, as I am, you might like to use the bright orange dried apricots for this.

GRANOLA DISCS If you want to serve this in a more elegant fashion for a post-dinner nibble with coffee, try spooning small discs of the melted chocolate onto the parchment. Stud them with a few pieces of granola.

85ml coconut oil
120ml maple syrup or honey
½ tsp vanilla extract
200g jumbo oats
100g seeds (sesame, chia, pumpkin, sunflower all work well)
150g nuts (pecans, almonds, pistachios, hazelnuts)
A pinch of fine sea salt
50g coconut flakes
60g dried fruit (apricots, goji berries, cranberries, sliced figs), chopped
300g dark or milk chocolate
1 tsp dried cornflowers, to decorate (optional)

Preheat the oven to 180°C/Fan 160°C/Gas 4. Line one large baking tray or two smaller ones with baking parchment.

Melt the coconut oil in a pan and add the maple syrup and vanilla extract. Transfer to a large mixing bowl, add the oats, seeds, nuts and salt and toss well to coat. Spread the mixture over the prepared tray (or work in batches if you have only one small one).

Bake for 30–40 minutes, or until the granola is dark golden and crunchy, adding the coconut flakes after 20 minutes. Turn it occasionally to make it brown nicely all over. Leave to cool before placing in a big jar and mixing through the dried fruit.

To make the chocolate shards, line your baking tray or trays with baking parchment. Break up the chocolate and place it in a heatproof bowl set over a pan of just-simmering water (don't let the base touch the water). Allow the chocolate to melt, then use an angled spatula to spread a thin layer (3mm) across the parchment. Sprinkle evenly with 250g of the granola and a few cornflowers, if using, then chill until set. Break the set chocolate into shards, then return to the fridge until you're ready to eat it. Store the shards, separated by parchment paper, in an airtight container.

A porridge for all seasons

Porridge is often regarded as a comforting, humble breakfast, but with a bit of care it can be beautiful too. I like to pre-soak and cook my oats really slowly (as you would a risotto, stirring regularly), allowing them the time to get really creamy while still retaining a little bite.

You can mix and match the ingredients overleaf (I've made suggestions depending on the time of year), but I always like to have some fruit, crunch, and perhaps a cooling dollop of yoghurt. *Serves 2-ish*

80g rolled oats (I use Rude
 Health sprouted oats
 which hold their texture
 nicely during cooking)
About 380ml water or milk
Fine sea salt
Brown sugar, honey or maple
 syrup, to taste (optional)

Put the oats into a saucepan, add the water or milk and leave to soak for about 10 minutes (for the spring topping option you will need to add the frozen berries to the oats while they are soaking). If you can spare the time to soak them for even longer, it will speed up the cooking time.

Place the pan over a low heat and stir for 12–15 minutes (the lower and slower the better) until thick and creamy. Season with a pinch of salt and sweeten with brown sugar, honey or maple syrup if you like a sweet porridge (though note that the autumn topping includes maple syrup so it might not need anything more). Divide between bowls, top with your chosen seasonal topping and serve.

Photographs and toppings overleaf

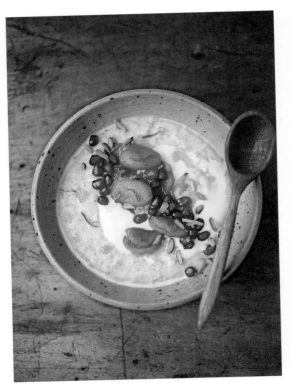

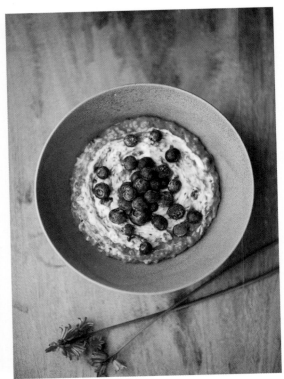

For a winter topping

160ml orange juice
50g caster sugar
A generous pinch of saffron strands
150g dried apricots, soaked in lukewarm
 water to soften
Natural yoghurt
1 tbsp pomegranate seeds
A few pistachios

Place the orange juice, sugar, saffron and apricots
in a small saucepan and simmer over a low heat
for 20 minutes, or until soft and tender. (This
topping can be made in advance and stored in
a jar in the fridge; any left over can be stored
for up to 4 days.)

Serve on top of the porridge with a dollop
of yoghurt, a sprinkling of pomegranate seeds
and a few pistachios.

For a spring topping

100g frozen blueberries, plus extra to serve
Natural yoghurt

Add the frozen berries to the oats while they
are soaking. Serve with a few frozen blueberries
on top and a swirl of yoghurt.

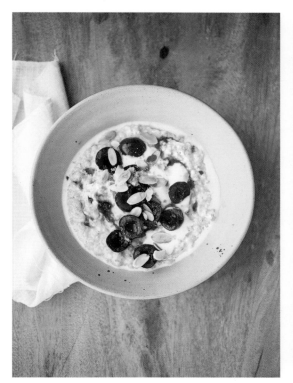

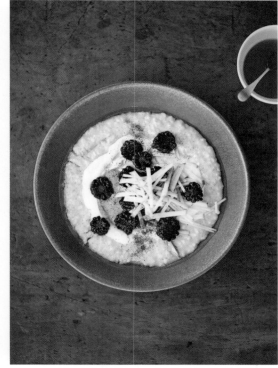

For a summer topping

1 small handful cherries, pitted
A few toasted flaked almonds

Preheat the oven to 200°C/Fan 180°C/Gas 6.

Place the cherries in a small baking tray and
roast for 10 minutes. Top the porridge with the
roasted cherries and finish with the cooking
juices and a few toasted flaked almonds.

For an autumn topping

1 tbsp nut butter
1 eating apple, cored and cut into matchsticks
50g blackberries, halved
Ground cinnamon
Maple syrup

Top each serving with nut butter, apple
matchsticks and blackberries. Sprinkle with
a pinch of cinnamon and drizzle with plenty
of maple syrup.

Breakfast

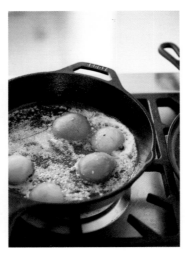

Caramelised apricots with labneh and honeycomb

I used to steer away from cooking stone fruits because their purest form seemed too perfect to alter – and juice dripping down your arm as you eat might be the pinnacle of joy. Applying a little heat, however, has some excellent advantages, caramelising the sugars, adding textural contrast and sometimes smokiness, and breaking down the flesh into soft, spoonable happiness.

Labneh is a strained yoghurt popular in Middle Eastern cooking as both a savoury and sweet accompaniment. This homemade labneh, which you'll want to start preparing the day before, is just the cold and creamy contrast these squidgy perfumed apricots need alongside a sticky square of honeycomb. *Serves 4*

RIPENING APRICOTS Juicy apricots work beautifully here, but the heat treatment is a good cheat for transforming any fruit that needs a little help to coax out its full potential: simply leave the apricots to rest in the sun if they aren't perfectly ripe. Cut them through their dimple to get a good crevasse for capturing the honey in this recipe.

500g Greek yoghurt
 (full-fat or at least
 2 per cent fat)
4 apricots
Juice of ½ lemon
4 tbsp caster sugar
1 knob butter

TO SERVE
100g comb of honey
4 tbsp pistachio nibs,
 toasted and roughly chopped

To make the labneh, line a colander with muslin or a clean tea towel, letting it hang over the sides. Tip the yoghurt into the centre and bring the corners of the cloth together to make a sack. Tie with string and suspend over a bowl in the fridge overnight. (The longer you strain the yoghurt, the firmer the labneh will be.) Transfer to an airtight plastic container to store; there will probably be a little more than you need for this recipe.

Now prepare the apricots. Cut them in half, drizzle with the lemon juice and dip in the sugar. Heat a non-stick frying pan over a medium heat. Melt the butter in the pan, then place the apricots in it, cut-side down. During the cooking, tilt your pan at an angle and use a spoon to scoop up some of the juices to baste the apricots. Add a little extra butter if required. Cook for 3–4 minutes, until soft and lightly caramelised.

Dollop the labneh onto your serving plates, using a spoon to make a shallow well, then nestle the apricots in it. Place a small piece of honeycomb alongside, then drizzle any extra honey from the comb around the edge of the plates. Scatter with the pistachios to serve.

Dark rye, banana and blueberry pancakes

Like a comforting slice of banana bread in pancake form, these pancakes have a distinct wholesomeness thanks to the nutty depth of the rye flour and natural sweetness of the banana. When I am craving something quick and nourishing, I just bung everything in the blender and have a batter in under 30 seconds. Studding the pancakes with blueberries isn't essential, but they burst and bleed into the batter adding an inimitable smudgy sweetness.

The caramelised pecans and banana slices are an addictive addition that would be good on porridge too. For an impressive stack, drippy with maple syrup, pile the pancakes high and drizzle away. *Serves 2–4 (makes about 8–10)*

SUBSTITUTING BLUEBERRIES If you haven't got any blueberries to hand, make a plain batter and use a different fruit for the glazed topping. A thin slice of apple cut through its waist looks elegant, and fig slices work a treat too, taking on a jammy quality.

3 eggs

3 ripe medium bananas (about 300g flesh), peeled and roughly chopped

75g dark rye flour

1 tsp baking powder

½ tsp vanilla bean paste

A pinch of fine sea salt

2-4 tbsp butter, for frying

100g blueberries, hold a few back for garnish

Greek yoghurt, to serve (optional)

FOR THE GLAZED TOPPING

1 tbsp butter

2 bananas, peeled and sliced about 2cm thick at an angle

20g pecan halves

2 tbsp maple syrup, plus extra to drizzle

Preheat the oven to 180°C/Fan 160°C/Gas 4. Put the eggs, banana, flour, baking powder, vanilla and salt into a blender and whizz until the ingredients are fully incorporated.

Melt 1 tablespoon of the butter in a non-stick frying pan. Once it is frothy, add separate heaped spoonfuls of the batter, making sure you leave enough space to move and flip them. (I can fit about three at a time in my pan.) Stud each pancake with a few of the blueberries. Cook over a medium heat for about 2–3 minutes on the first side, then flip and cook for 1–2 minutes on the other side. Transfer the pancakes to a baking tray and place in the oven while you repeat the process.

To make the topping, melt the butter in the empty pan. Once hot, add the banana slices and pecans and fry for 2 minutes on each side until the bananas are golden. Add the maple syrup and stir gently to coat everything. Toss the remaining blueberries in the caramel juices to make them extra glossy.

Stack the pancakes on two or four plates, depending on how sensible you're being with the portion sizes, layering banana slices between them, and yoghurt if you fancy. Place the remaining blueberries and banana on top and scatter with the pecans. Serve with more yoghurt and maple syrup on the side.

Dutch baby pancake

The love child of a crêpe and a Yorkshire pudding, a Dutch baby pancake is something I discovered only recently, but it has rapidly become a firm fixture in my recipe repertoire. It puffs up a treat in a red-hot oven, deflating slightly as it hits the table, so get it over there quickly. Season permitting, I pair mine with strawberries glazed with lemon, mint and icing sugar, roasted rhubarb or summer berry compote – and I add a very generous dusting of icing sugar or drizzle of syrup to the top. *Serves 2–4*

COOKING WITH CAST IRON It's worth investing in a heavy, well-seasoned cast-iron pan for these oven-to-table-style dishes - they retain heat extremely well and will give you an extra good puff around the sides as well as acting as an excellent serving vessel. I also use one to sear steaks and bake the Sticky figgy breakfast buns (see page 88).

60g plain flour, sifted
2 eggs
120ml whole milk,
 at room temperature
A generous pinch of fine
 sea salt
1 tsp caster sugar
3 tbsp melted butter
Icing sugar or maple syrup,
 to serve

FOR THE STRAWBERRIES
300g strawberries
Juice and zest of 1 lemon
3 tbsp icing sugar
Leaves from 2 fresh
 mint sprigs

Preheat the oven to 220°C/Fan 200°C/Gas 7.

Tip the flour into a large bowl and make a well in the centre. Crack in the eggs, then add the milk, salt, sugar and 1 tablespoon of the melted butter. Use a whisk to beat the eggs into the milk, slowly incorporating the flour, until you have a smooth batter. Set aside to rest for 15 minutes.

Meanwhile, halve the strawberries (I don't hull them as I like the look of the green tops), or quarter them if large. Toss with the lemon juice and icing sugar. Chiffonade the mint leaves (see page 21) and add them to the strawberries. Mix gently, then scatter with the lemon zest and set aside.

Heat a 26cm ovenproof frying pan over a high heat and add the remaining 2 tablespoons of melted butter. Swirl it around the pan and immediately add the batter before the butter has time to burn. Transfer immediately to the hot oven. Bake until the pancake is puffed and a deep golden colour around the edges, 16–20 minutes.

Dust generously with icing sugar or drizzle with maple syrup and quickly place the pan on a trivet or cloth in the middle of the table.

Brioche and fruit custard bake

Weekend breakfasts are a time for low-maintenance, high-sustenance feeding of family or friends and this big tray bake, bejewelled with fruit, promises just that. I vary the fruity topping to fit with what's in season. In the depths of winter when the greengrocer's shelves are sparse, I'll turn to frozen summer berries, while early autumn calls for plums and figs. This is a summer version with raspberries, peaches (or nectarines) and currants, which make beautiful bedfellows.

The key to a good bready custard bake is a mix of textures, which is where haphazard overlapping and higgledy chunks of brioche work well. The exposed bits take on extra crunch while the underneath remains creamy and custardy. I like to add extra sugar to the edges so they caramelise and get even crunchier.
Serves 8

ADDING EXTRA GLOSS I opt for a casual, rustic approach with the appearance of this breakfast bake, but if you want to serve it with a glossy sheen, heat 5 tablespoons of apricot jam in a pan until runny, then when the bake is out of the oven, use a pastry brush to brush the top of it with the warm jam.

3 tbsp soft unsalted butter, for greasing
1 × 500g brioche loaf, preferably stale, torn into large chunks
200g caster sugar
7 eggs
1 vanilla pod, halved lengthways
450ml whole milk
450ml double cream
200g raspberries
4 peaches or nectarines, stoned and sliced
2 tbsp demerara sugar
1 × 150g punnet white currants or redcurrants, or a mixture of both, to decorate
Greek yoghurt, to serve

Preheat the oven to 200°C/Fan 180°C/Gas 6. Grease a 25 × 30cm baking dish that's at least 5cm deep with the butter.

If your brioche isn't stale, place the chunks on a baking tray and toast lightly in the preheating oven until they dry out, about 5–10 minutes.

Put the sugar and eggs into a bowl, scrape in the vanilla seeds, then whisk together with a balloon whisk until really smooth.

Put the milk and cream into a pan and bring to just below boiling point. Pour a small amount over the egg mixture and whisk vigorously – this tempers the eggs so that they don't scramble. Slowly pour in the rest, whisking until smooth.

Arrange the brioche chunks in the prepared baking dish, sprinkle with half the raspberries, then pour the egg mixture all over. Leave to sit for about 30 minutes so that the custard soaks in.

Arrange the remaining raspberries and the sliced peaches or nectarines on the soaked brioche. Nestle the vanilla pod on top to decorate. Sprinkle the whole dish with the demerara sugar.

Place the dish in a roasting tray and pour enough boiling water around it to come halfway up the sides. Bake for 45–50 minutes, until the custard has just set and the top is golden. Once it's out of the oven, arrange the currants over the top, leaving them on their stems like strings of jewels. Leave for 10 minutes to cool down and set, then bring to the table in the tray and spoon into cups or bowls. Serve with dollops of yoghurt for a cooling contrast.

Sticky figgy breakfast buns

I adore buns. Eating a warm sweetened bun for breakfast was the realisation of a childhood fantasy for me – the essence of deliciousness, tearing it apart with my fingers and inhaling the yeasty smell of that steaming centre (you'll know what I mean if you've ever watched the film adaptation of *A Little Princess*, where the little girl buys a paper bag of buns fresh from the oven). Not much has changed in my 30-something years of eating them, although admittedly the 7-year-old me would turn her nose up at the addition of dried figs.

Start these buns the day before and leave them to prove in the fridge overnight. The next morning you can roll them out and kick-start your weekend with a batch of warm sticky heaven. *Makes 10*

125g plain flour
150g strong white bread
 flour, plus extra to dust
½ tsp fine sea salt
40g caster sugar
1 heaped tsp fast-action
 dried yeast
50ml warm whole milk
4 large eggs, at room
 temperature
185g unsalted butter,
 at room temperature,
 plus extra to grease
120g dried figs
50g light brown sugar
70g roasted hazelnuts,
 roughly chopped

Put both the flours and the salt into the bowl of a stand mixer and whisk together. Make a well in the centre and add the sugar, yeast and milk. Using a dough hook, beat the ingredients for 1 minute.

Add three of the eggs to the mixture and beat again at a medium–high speed until the dough pulls away from the sides of the bowl, about 5 minutes. It should be quite sticky.

Weigh out 85g of the butter and cut it into cubes. Beat it into the dough a cube at a time, until fully combined and the dough is silky but still sticky, about another 5 minutes. Use a spatula to scrape down the sides of the bowl, then form the dough into a ball. Cover the bowl with oiled cling film and leave the dough to rise in a warm place until doubled in volume, about 1–2 hours. Transfer the bowl to the fridge and leave overnight.

The next morning, use a knob of butter to grease a 26cm round cast-iron pan or baking tin.

Put the figs into a small heatproof bowl, cover with boiling water and leave to soften for a few minutes. Meanwhile, in a separate bowl, use a wooden spoon to beat the remaining 100g butter with the brown sugar until very smooth.

Drain the figs, pat dry, discard the tough stalks and chop the fruit into small pieces.

Flour a work surface and use a pastry scraper to scrape the dough out of the bowl and roll it into a 35 × 45cm rectangle. Spread the butter mixture over it, then scatter over the figs and half the hazelnuts. Roll up from the long side, then cut into 10 equal pieces.

Place the buns in the prepared pan or baking tin, spacing them apart. Cover loosely with oiled cling film and leave to prove for about 30–60 minutes. To test if the dough is ready to be baked, lightly poke your finger into the side of it, if it springs back but leaves a slight indentation it is ready.

Preheat the oven to 200°C/Fan 180°C/Gas 6. Beat the remaining egg and brush it over the buns. Bake for 20–25 minutes. Scatter the remaining hazelnuts over the top of the buns before serving straight from the pan or tin.

Taleggio and Cheddar
cheese toastie

On photo shoots involving melting cheese, some stylists will
employ a few little tricks and tools to get that money shot of
runny cheese, from warmed palette knives to heat guns from B&Q.
 The taleggio in my toastie heats to stringy perfection, so
there's no trickery required, just genuine buttery, cheesy joy.
I should add (under my boyfriend's insistence) that smearing
a tablespoon of Marmite right to the edges before adding the
grated cheese adds an extra dimension to the toastie. *Makes 1*

CRISPY CHEESE EDGES I like to allow, in fact I
positively encourage, the cheese to spill out from
the sides to get a golden veil around the outside.
If it detaches itself, be sure to serve it anyway.

STRINGY PERFECTION If you leave the toastie to sit
for 1-2 minutes before tearing through its middle,
you'll end up with a good cheese string. If you do it
too soon the cheese will be molten and ooze out without
threading. (The insides of your mouth will thank you
for your patience.)

2 slices sourdough bread,
 about 2cm thick
About 60g salted butter,
 at room temperature
80g mature Cheddar, grated
2 spring onions, thinly
 sliced
50g taleggio cheese
3-4 fresh thyme sprigs
 or a few sage leaves
Dill pickles, to serve
 (optional)

Spread the bread slices with some of the butter. Add the Cheddar
to one slice, making it heftier around the edges and forming a
small crater in the middle. Scatter over the spring onions, then
place the taleggio in the crater. Cover with the other slice of
bread, butter-side down, then spread the top of the sandwich
with about 1 tablespoon of the remaining butter. Press the thyme
or sage into it.

Heat another tablespoon of the butter in a heavy-based frying pan
over a medium heat. Once foamy, add the sandwich, herb-side
down, and place a heavy frying pan or casserole directly on top.
Cook for about 4 minutes. Remove the weight, then use a palette
knife or fish slice to have a peek at the underside – you want it
golden. If it's ready, spread a final tablespoon of butter over the
unbuttered side of the sandwich and flip it over. Sit the weight
on top again and cook for another 3–4 minutes, until golden.
Transfer the sandwich to a plate or board, herb-side up. Leave
to cool for 1–2 minutes if you can wait, then tear or slice with
a knife and eat, with the dill pickles, if you like.

Potato cakes with smoked fish and dill cucumber

One of my all-time favourite restaurants has to be 40 Maltby Street in London. I ate a potato pancake as part of a dinner there and craved it for breakfast the next day, so had to come up with my own breakfast version to satisfy my longing. I take a Scandi approach to these, pairing them with creamy cucumbers coated in dill and some smoked fish.

Depending on who you are sharing your food with (I think we all have family members that aren't so good at sharing), you might want to serve this on a platter and let people help themselves. Flake the salmon into rough chunks so it keeps some of its shape. You can make the pancakes a day (or even two!) before and reheat them with minimal effort. They also work well as canapés. *Makes 16*

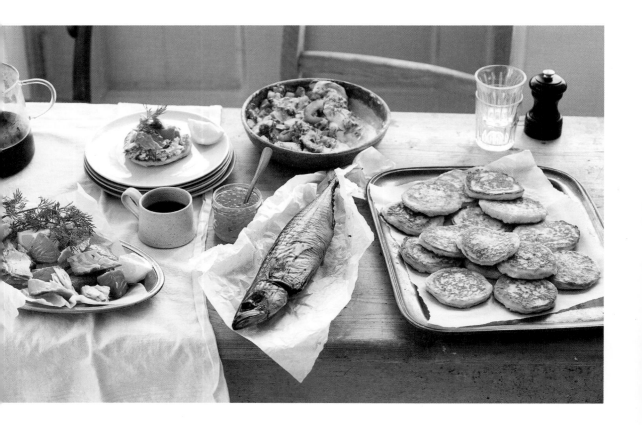

FOR THE POTATO CAKES
350g cold mashed potato
 (equivalent of 2 large
 uncooked potatoes,
 steamed and mashed)
3 eggs
175ml whole milk
½ tsp fine sea salt
1½ tsp caster sugar
150g plain flour
1½ tsp baking powder
Olive oil, for frying

FOR THE DILL CUCUMBER
1 large cucumber
1 tsp fine sea salt
40g dill, very finely
 chopped
100g Greek yoghurt
A good pinch of caster sugar
Zest and juice of 1 lemon
1 tsp white wine vinegar,
 or to taste
Flaky sea salt
Crushed black pepper

TO SERVE
300-400g hot-smoked salmon,
 mackerel or trout fillets,
 flaked
2-3 tbsp salmon roe
 (optional)
Grated horseradish root
 (optional)
Crushed black pepper
Dill fronds, to garnish

First make the dill cucumber. Half-peel the cucumber by removing just a few strips of the skin lengthways. Not only does this look interesting, it allows the salt to penetrate better, while maintaining some of the cucumber's shape. Cut the cucumber in half lengthways and use a teaspoon to scoop out and discard the seeds. Slice the cucumber halves widthways into 5mm slices, on a slight diagonal. Place in a colander and sprinkle with the salt. Leave for 30 minutes, then rinse and pat dry with kitchen paper. Place the cucumber in a bowl and stir in the dill, yoghurt, sugar, lemon juice, half the zest and the vinegar. Taste and adjust the seasoning if necessary.

Next, make the potato cakes. Put the mashed potato into a bowl and whisk in the eggs and milk until smooth. Stir in the salt and sugar. Sift the flour and baking powder over the top and fold to make a smooth batter (don't worry if there are small lumps, you won't notice them).

Place a little oil in a large non-stick frying pan over a medium heat. When hot, add half a ladleful of batter for each potato cake, making it about 8cm in diameter and working in batches. Cook for about 2 minutes, until small bubbles appear on the surface and the underside is golden brown. Flip the potato cakes over and cook until golden on the other side, then transfer to a plate and keep warm in a low oven while you cook the remainder, adding more oil to the pan each time.

Arrange the potato cakes on a large platter with the various serving accompaniments. To eat, pile some cucumber on a pancake and top with flaked fish, a little salmon roe (if using), some of the remaining lemon zest and a sprinkling of fresh horseradish, if you wish. Garnish with dill fronds and finish with black pepper.

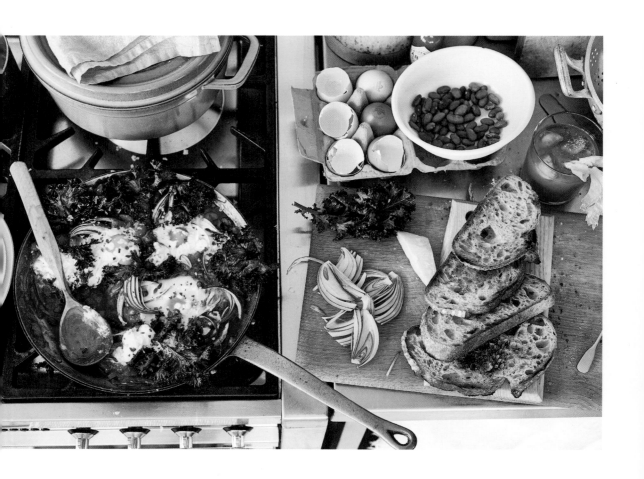

One-pan breakfast beans with crispy kale and goat's curd

I have to admit that this recipe was born out of a hangover. It made use of the odds and ends in the fridge (you could substitute the kale for any other greens that you might have) and offered a wholesome feeling of fullness to counteract the cocktails from the night before. With oozing egg yolk, sweet tomato acidity, creamy cheese and some crispy kale poking out, this is a nourishing sight for sore eyes and sore heads. It's also excellent accompanied by a Bloody Mary. *Serves 2*

DECORATING WITH VEGETABLES I use vegetables both to flavour and decorate the dish. I cut the red onions in vertical slices attached at the stem (see page 34) and pull the prettiest branches of kale to the top. Not only will the kale crisp up nicely when grilled, but this also shows off its lovely purple ribs.

1 tbsp olive oil

2 red onions, peeled and sliced into vertical slices (see page 34)

3 garlic cloves, peeled and finely sliced

1 × 400g tin cherry tomatoes

400ml cold water

1 × 400g tin borlotti beans, drained and rinsed

1 tsp sumac

½ tbsp thick balsamic vinegar (I use the Belazu brand)

A pinch of caster sugar (optional)

100g purple kale, destalked and shredded

4 eggs

4 tbsp goat's curd or feta

20g Parmesan, grated

Flaky sea salt and freshly ground black pepper

Red chilli flakes, to serve

Preheat the grill to high.

Warm the olive oil in a sauté pan over a low heat. Add two thirds of the onion, all the garlic and a pinch of salt. Sweat for about 10 minutes, with the lid on, before adding the tomatoes and cold water. Simmer for 10–15 minutes.

Stir in the beans, sumac and vinegar. Taste and add a pinch of sugar if required, and adjust the seasoning. Spread the kale on top, poking some in and letting some stick out of the pan.

Make four little wells in the beans and crack an egg into each one. Dot the surface with dollops of the goat's curd or feta and sprinkle with the Parmesan. Arrange the remaining slices of red onion on top, fanning them out slightly.

Pop the pan under the grill for 5–7 minutes to crisp up the kale, cook the whites of the eggs through and lightly brown the cheese. Serve with a few sprinkles of red chilli flakes and offer toast on the side for dipping and dunking.

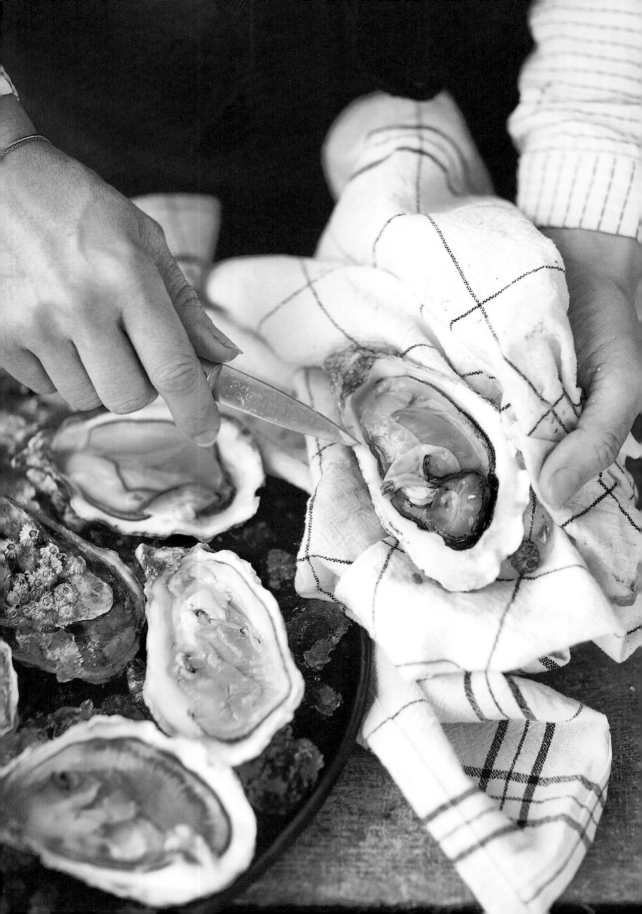

Finger Food
and Snacks

Deep down we all love eating without knives and forks, and this chapter is about things that are easy and delicious and can be held in one hand while the other is wrapped around a glass of wine. There are no fiddly little canapés here – hefty preparation time rarely translates to the best nibbles, so I've devised a few shortcuts to embrace entertaining in a colourful and creative way. The Easy aperitif spread on page 106 is a speedy solution when you're racing against the clock, and so simple that you can put it together even when wearing your best silk shirt, while some of the other dishes, like Sesame tempura vegetables (see page 129), do require a little more time in the kitchen. Eating with your fingers is always going to be a pleasure, whether that's a quick snack for one or treats for a gathering of friends.

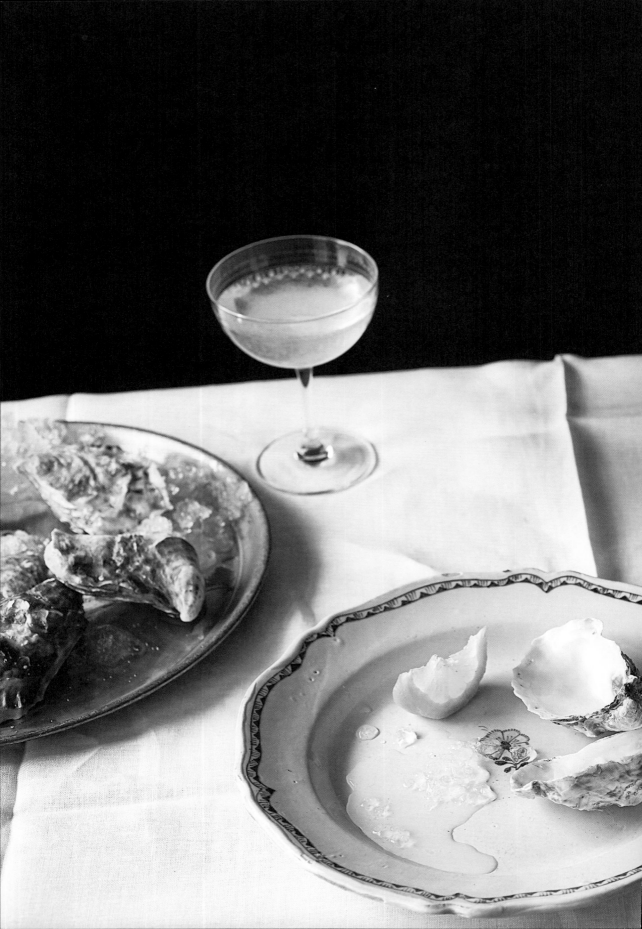

Dips

Dips aren't just for bowls. Serving them on a plate creates extra surface area for scattering over seeds, chopped herbs or dried spices; and you can dress them up further by swirling through some yoghurt or drizzling on oil. The dip recipes overleaf are speedy and easy, but even if you're not making your own, this treatment will instantly jazz them up and is a great cheat for making them *look* homemade.

There's so much more to crudités than cucumber and carrot batons – think about using a range of colours and shapes. Try fennel, cut into wonky wedges with the leafy fronds left on. Red endive adds extra colour, as well as being naturally scoop-shaped. I like to pull out the delicate and less fibrous heart from a head of celery, or buy baby veg, as these are sweeter, faster to prepare and prettier by a long shot – you don't need to peel them, just a little scrub will do the trick.

Leave the leaves on radishes and celery, as well as the tops on carrots. To keep your crudités crunchy and vibrant, plunge them into a bowl of iced water for a few minutes before patting dry and serving.

Alternatively, try the rye crisps on page 301 with your dips, broken into higgledy shards for a rustic look. Shop-bought breadsticks can be brushed with a little extra virgin olive oil and then scattered with za'atar or another spice mix. Homemade flatbreads (see page 122) are delicious, but you can just as easily spruce up some pittas with a brief trip under the grill, followed by a drizzle of sesame oil and a smattering of black sesame seeds, dried herbs, flaky sea salt and coarsely cracked black pepper.

SWIRLING DIPS To create the perfect craters you see in houmous served in Turkish restaurants: dollop the dip in the centre of the plate, then use the back of a spoon to spread it around. Rest the spoon on top of the centre of the plate and twist the plate clockwise to create an even crater in the centre; it acts as the perfect moat for a drizzle of oil.

Miso houmous

Miso and tahini, a surprising marriage between Japanese and Middle Eastern ingredients, is a delicious combination. *Makes about 400g*

1 × 400g tin chickpeas, drained and rinsed
2 tbsp light tahini
2 tbsp white (shiro) miso
1 plump garlic clove, or 2 small ones,
 peeled and crushed
Juice of ½–1 lemon
About 50ml extra virgin olive oil
Flaky sea salt and freshly ground
 black pepper
Picked thyme leaves, to garnish
Toasted sesame oil or extra virgin
 olive oil, to drizzle
Sweet smoked paprika, to finish

Place all but 10 of the chickpeas in a food processor, add the tahini, miso, garlic and lemon juice to taste, and blend. Add the olive oil and blend again until very smooth. If you need to loosen it add a splash more oil or water. I like to make it quite loose to get a good smooth swirl when I shape the crater. Season generously to taste.

Serve the houmous in a shallow bowl or on a plate, swirling it to make a crater as described on page 101. Scatter the reserved chickpeas and some thyme leaves over the top, drizzle with oil and finish with a pinch of paprika. As an alternative topping, use the garlic-roasted chickpeas from page 213.

Carrot, cumin and coriander dip

Lightly spiced and roasted, this punchy carrot dip is a vibrant alternative to your run-of-the-mill houmous. I like to serve it with plenty of toasted pumpkin seeds scattered on top, but the pistachio dukkah on page 207 works brilliantly too. *Makes about 550g*

750g carrots, peeled
4 tbsp olive oil, plus extra to drizzle
2 tsp ground coriander
1 tsp ground cumin
1 tbsp light tahini
1 garlic clove, peeled and crushed
1 tsp sweet smoked paprika
Juice of ½–1 lemon, to taste
½–1 red chilli
100g Greek yoghurt, or more to taste
Flaky sea salt and cracked black pepper

Preheat the oven to 200°C/Fan 180°C/Gas 6.

Cut the carrots in half lengthways and place in a snug baking dish. Drizzle with 2 tablespoons of the olive oil and 2 tablespoons of water, then the coriander, cumin and a good scattering of salt. Roast for 50–60 minutes or until tender. Set aside to cool.

Transfer the cooked carrots to a food processor, add the tahini, garlic, remaining olive oil, paprika, lemon juice and chilli to taste, and blend for as long as it takes to make a smoothish mixture. Add the yoghurt and whizz again to the desired consistency. Season to taste.

Serve in a shallow bowl or on a plate, swirling to make a crater as on page 101. Finish with cracked black pepper and a drizzle of olive oil.

Beetroot and butter bean dip

Earthy, sweet beetroot here gets mellowed by
the gentle butter beans, which also enhance
the dip's creaminess. *Makes about 400g*

½ x 400g tin butter beans, drained, rinsed
250g pre-cooked beetroot, roughly chopped
1 garlic clove, crushed
1 tbsp Greek yoghurt, plus extra to serve
 (optional)
Juice of ½ lemon
Flaky sea salt and freshly ground
 black pepper
Dried oregano or other dried herb, to garnish

Dry the butter beans then add them to a food
processor with the beetroot, garlic, yoghurt and
lemon juice. Blend until smooth, then season.

Serve in a shallow bowl or on a plate, swirling
as on page 101. Finish with a dollop of yoghurt,
if using, and a spinkling of dried oregano.

Roasted garlic aïoli with crunchy veg

Food writers always wax lyrical about the arrival of autumn produce, so it feels almost uncouth to say I'm most content in the kitchen in the hot summer months, surrounded by stone fruits, sun-ripened tomatoes and peppery radishes. This colourful platter of crunchy veg is the type of food I crave on a hot summer's day; glass of rosé in one hand, a carrot to scoop up a velvety aïoli in the other. I've mellowed out the traditional raw-garlic mayonnaise by roasting the bulb until it is sticky and sweet, which is a good trick if you prefer a subtler garlic flavour. Smoked or steamed fish, or a lightly poached chicken breast, make a great addition if you want to stretch it further, but I rather like serving it simply, no cutlery required. *Serves 6 as a snack or starter*

PRESENTING PEAS When it comes to the fresh peas, I like to serve them raw and open a few of the pods to reveal the peas on the inside. To pod them, tear down the fibrous 'seam' and the peas will pop out.

FOR THE AÏOLI
1 large head garlic
200ml good-quality light
 olive oil, plus extra
 to drizzle
2 egg yolks
1 tsp Dijon mustard
2 tbsp lemon juice
Flaky sea salt

FOR THE DIPPERS
1 stem cherry tomatoes,
 on the vine
16 baby new potatoes,
 boiled until tender
10 baby carrots, scrubbed
100g peas in their pods
150g blanched and shocked
 green beans (see page 30)
2 medium-boiled eggs
 (8-minute timing, see
 page 51), peeled and halved
12 caperberries
12 olives

Preheat the oven to 200°C/Fan 180°C/Gas 6.

To make the aïoli, first slice the head of garlic in half through its waist. Place in a small baking dish, drizzle with a little olive oil and sprinkle with salt then bake for 30–40 minutes, or until really soft. Squeeze the flesh out of the cloves into a small bowl. Season again and mash with a fork to a smooth paste.

Put the egg yolks and mustard into a bowl and whisk by hand until combined. Start adding the 200ml of oil bit by bit, whisking vigorously all the time until you have a thick, unctuous mayonnaise. Add the lemon juice and mashed garlic paste. Whisk to bring together, then set aside until needed.

Serve the aïoli in a bowl, alongside a platter containing the vegetables, eggs, caperberries and olives.

Easy aperitif spread for friends

Being an optimist in the kitchen can have its downfalls, as I have experienced on the numerous occasions when I have recklessly allowed a mere couple of hours to prepare a spread of canapés. In my head the prep takes a couple of hours, in reality I find myself piping mayonnaise and deep-frying pork belly bites in my favourite top while getting drunk on Aperol spritz and missing out on the mingling.

But here's the thing; you can actually put on an impressive spread with next to no elbow grease. These quick little ideas are effortless and won't leave you frazzled – each of them can be done in around 5 minutes. *Serves 4–6 as pre-dinner nibbles*

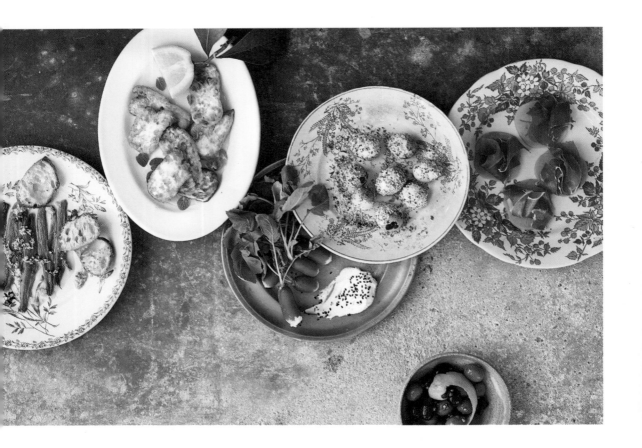

Cheat's marinated olives

Discover the dramatic difference you can make to a jar of olives by simply tossing them in a little extra virgin olive oil to make them really glossy and inviting, then spiking them with a few seeds and a spritz of citrus.

200g black or green olives, drained
1 tbsp extra virgin olive oil
½ tsp coriander seeds, toasted
1 long curled strip of orange or lemon zest
 (see page 38), plus a squeeze of the juice

Toss the olives, oil, seeds and zest together, then decant into a small serving bowl or saucer. Position the curl of zest in a spiral on top of the olives and squeeze over a little citrus juice before serving.

Garlicky anchovies with bread 'crisps'

Gently allowing garlic to caramelise in butter brings out its sweetness, which offers the ideal contrast to the richly salty anchovies here. Be careful when removing the anchovies from their oil to avoid crushing or breaking them; separate them with your fingers to keep the fillets intact. To serve, lay each anchovy flat on the plate and scatter the garlic on top, making sure each fillet gets a good covering. These are best served with something equally punchy, like a dirty martini or a bitter negroni.

¼ baguette, cut into 5mm slices
olive oil, for brushing
1 plump garlic clove, or 2 small ones, peeled
2 tbsp unsalted butter
1 × 50g tin good-quality anchovies
 (I like the ones by Ortiz)
1 tsp fresh thyme leaves

Preheat the oven to 180°C/Fan 160°C/Gas 4. Line a baking tray with baking parchment.

Place the baguette slices on the prepared tray and brush lightly with olive oil. Bake in the oven for about 10 minutes, turning halfway, until crisp and lightly golden,

Finely chop the garlic (you want some texture here, so not too tiny). Melt the butter in a small saucepan over a very low heat. Fry the garlic in the butter for 5 minutes, until only slightly coloured and caramelised. Be vigilant, as you don't want the garlic to burn.

Carefully remove the anchovies from the tin and separate, then arrange them in a line on a small serving plate. Sprinkle with the garlic and the thyme leaves. Serve with the bread 'crisps'.

Radishes with whipped butter

Whipping butter isn't just for fancy restaurants. This simple presentation idea makes the butter light and smooth, and go a little bit further, so that you can dunk crunchy radishes into it. The method below makes more than you're likely to need, but it's tricky to beat less butter in a stand mixer. You can store the whipped butter in the fridge and bring it back to room temperature to use again at a later date, or better still, add some of the flavourings from page 221 and use it for baking scallops.

1 bunch French breakfast radishes
150g unsalted butter, at room temperature
Nigella seeds
Flaky sea salt

Leave the leaves on the radishes if they are fresh and perky. Dunk the radishes (leaves and all) in a bowl of iced water for 5 minutes to crisp them up, then remove and pat dry.

Whisk the butter in a stand mixer at a high speed for 4 minutes, or until very light and fluffy (scrape down the sides of the bowl a few times as you go), or if you are feeling energetic, beat in a bowl by hand until super light. Spoon a dollop of the butter onto a serving plate (or even a clean flat stone, as trendy restaurants do) and use a butter knife or palette knife to make a downward smear on one side. Scatter with nigella seeds and salt in the opposite direction from the smear. Serve the radishes on the side, some with their leaves on, others without.

Halloumi with lemon and honey

This simple combination of salty halloumi and zesty citrus is a big winner, in my book. I generally serve the halloumi in slices so that the largest possible surface area of cheese gets a good soak in the syrup, but you could cut it into 2cm cubes then serve them with a few toothpicks.

1 packet halloumi cheese (about 225g)
1-2 tbsp olive oil
Juice and finely grated zest of 1 lemon
1 tbsp clear honey
1 tbsp fresh oregano leaves
Lemon wedge, with leaves if possible, to serve

Cut the halloumi lengthways into 1cm slices and pat dry with kitchen paper.

Heat the oil in a large frying pan over a medium–high heat. When hot, add the halloumi (in batches if necessary – you don't want to crowd the pan or all the liquid will escape and the halloumi won't crisp up). Fry on each side for about 2 minutes, then drain on kitchen paper.

In the meantime, put the lemon juice into a bowl and add the honey, stirring well to combine. Toss the halloumi slices in the lemon honey, then arrange them, overlapping, on a serving plate. Sprinkle with the zest and oregano leaves and serve with the leafy wedge of lemon on the side.

Rolled quails' eggs

There's something really desirable about little quails' eggs perched on a plate. Sometimes I leave the shells on and make my guests do the peeling work; or peel off the pointed tip to help get them going.

12 quails' eggs
1 tbsp sesame seeds
1 tsp celery salt

Bring a small pan of water to the boil and use a slotted spoon to lower the eggs carefully into it. Simmer gently for 2½ minutes, then transfer to a bowl of iced water to cool.

In the meantime, toast the sesame seeds in a dry frying pan until lightly golden, then transfer to a small bowl. Add the celery salt and mix well.

Peel the eggs (though see my note above) and toss in the sesame mixture. Serve on a little plate, with some of the celery mixture scattered about.

Persimmon and prosciutto

Persimmons are an underrated fruit, I feel. With their glorious creamy texture and beautiful star-shaped centre, it almost seems a shame to conceal them with the salty folds of prosciutto. Almost... Depending on the season, other fruit would work really well here too; try figs quartered and wrapped in the prosciutto, or bite-sized chunks of melon with slices of the ham daintily folded into wavy ribbons over the top.

2-3 persimmons (kaki)
6 slices prosciutto

Discard the leafy tops of the persimmons and use a sharp knife to peel off the skin. Slice into rounds about 4mm thick. Tear each slice of ham in half lengthways, then fold it over itself in a ribbon-like way on top of the persimmon rounds. Arrange on a plate and serve.

Baguette bruschette

As a strong advocate for the low-effort, high-impact approach to sociable eating, this is probably my ultimate party trick: the loaded open sandwich. Not only is this trio of bruschette quick to prepare, with barely a moment needed in the kitchen, but all three are bursting with colour and flavour.

Serve these on a large chopping board with a sharp or serrated knife at the ready for people to cut off chunks of their preferred choice. For three bruschette, you'll need two baguettes, cut in half (leaving you an extra half for tomorrow morning's toast).

The 'pan bagnat' topping is a hybrid of the classic Provençal sandwich that prides itself on being soggy with juices, and the Spanish *pan con tomate*, which calls for rubbing toasted bread with garlic and tomato. The vibrant green broad bean, pea and ricotta topping is fresh and zesty, a classic combination for summer eating; while the peppery blue cheese and juicy peach marriage really showcases the virtues of savoury and sweet partnerships. *Serves 8–10 as a snack*

SKINNING BROAD BEANS To skin broad beans, blanch them in boiling water for 30 seconds before shocking them in ice-cold water. They can then be squeezed to pop them out of their skins. If using frozen broad beans, once defrosted you can pop them out of the skins without blanching them first.

Photographs overleaf

Broad bean, pea and ricotta

½ baguette, sliced from a whole lengthways
 and toasted under a grill for a few minutes
40g peas (fresh or frozen)
150g ricotta
Juice and zest of 1 lemon
100g broad beans, podded and skinned
 (see left)
2 tbsp Herb oil (see page 25),
 or extra virgin olive oil
A few small fresh mint leaves
Flaky sea salt and freshly ground
 black pepper

Blanch the peas in boiling water for 30 seconds if frozen, and 1–2 minutes if fresh. Drain and pat dry. Allow to cool.

Meanwhile, put the ricotta, lemon juice and most of the zest into a bowl and beat well. Season to taste.

Spread the seasoned ricotta over the cut side of the baguette and scatter with the peas and broad beans. Drizzle with the oil, add another twist of black pepper and top with the mint leaves. Finish with the remaining lemon zest.

Pan bagnat

½ baguette, sliced from a whole lengthways
 and toasted under a grill for a few minutes
1 large ripe beef tomato
1 garlic clove, peeled
2 tbsp extra virgin olive oil
8 tinned anchovies
A few pickled red onions in rounds
 (see page 125)
2 medium-boiled eggs (8-minute timing;
 see page 51), peeled and halved
10 black olives, pitted and halved
A few small fresh basil leaves
Fresh chive or borage flowers (optional)
Flaky sea salt

Grate the tomato into a bowl using the coarse side of a box grater. Finely grate in the garlic using a Microplane grater, then add the olive oil and season with salt. Stir well, then spread this mixture over the cut side of the baguette – you want the juices to soak into the bread (*bagnat* means 'bathed' after all).

Arrange the anchovies over the top, along with a few pickled onions, the eggs and the black olives. Finish with a few basil leaves and the flowers (if using).

Peach, Gorgonzola and black pepper

½ baguette, sliced from a whole lengthways
 and toasted under a grill for a few minutes
100g Gorgonzola or dolcelatte,
 at room temperature for the best ooze
 and spreadability
2 ripe peaches (I like white)
Black peppercorns, coarsely chopped
 with a knife
Fresh purple or green basil leaves

Spread the cheese over the cut side of the toasted baguette, all the way to the edges.

Halve the peaches and remove the stones. Lay them cut-side down on your board and slice into 2mm slices. Take three or four of the slices and spread them out like a fan from their pointed tips. Arrange the peach fans over the baguette, overlapping them as you go.

Add plenty of black pepper and a scattering of basil leaves, to finish.

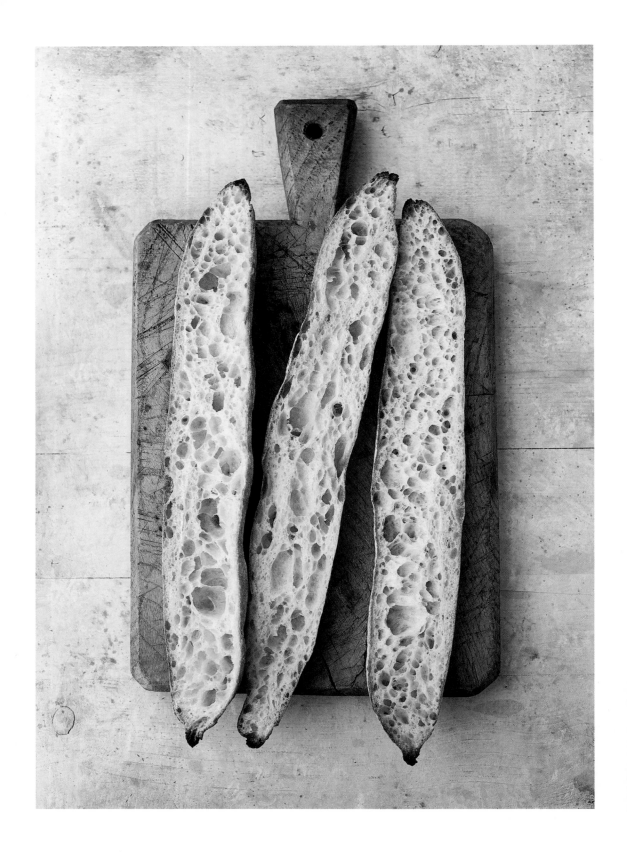

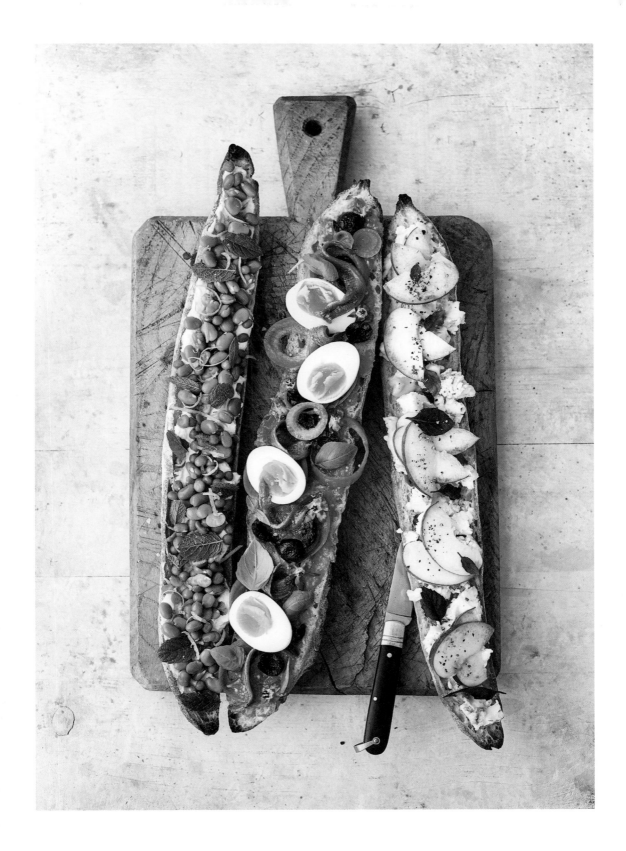

A good charcuterie platter

When you're feeling a bit extravagant, an abundant platter of charcuterie, or even a small carefully curated plate, is a quick and easy option that excites the eyes and tantalises the taste buds; and it is a sure-fire way to please a crowd.

Mix up the flavours, textures and fat content of the charcuterie for a balanced board. Whole-muscle cuts of cured meats are generally leaner than cured sausages, for example. Within the spectrum of cured whole-muscle cuts lies everything from prosciutto di Parma and jamón ibérico Bellota (from the leg) to coppa (neck) and lomo (loin), which vary in fat content by breed and country of origin. Look at the marbling of fat through the meat for a guide to how rich the charcuterie is likely to be.

Cured sausages range from heavily-spiced small chorizo to fatter, fennel-seed-studded finocchiona, plus all the regional varieties of saucisson (look out for one with hazelnuts). Offering a mixture of shapes and thickness is key to a balanced platter.

Allow 50–70g cured meat per person if you are serving it with other food, and opt for 140–150g if serving just with bread. Ask the deli counter for paper-thin slices of the whole-muscle cuts as it not only goes further, but also looks nice.

The cardinal rule with charcuterie is to cut it cold but serve it 'warm'. Cutting from cold will give you a cleaner slice, but you want the fat to come to room temperature for a better flavour, so take it out of the fridge a good 30 minutes before serving.

I always buy small saucisson whole rather than pre-sliced for presentation purposes (and because I'm greedy!). Place it on a board with a sharp knife by the side of it and cut a few initial slices about 3–4mm thick. You can leave your guests to do the rest.

When you're laying out the platter, rather than leaving the slices of cured meat flat as if they came from a packet, fold them over on themselves in loose ribbons, which creates height and a look of abundance.

Fattier cures, such as saucisson or lardo, benefit from some crunchy acidity to cut through their richness, so offer them with gherkins, caperberries or pickled walnuts on the side. These add a good textural contrast too.

The Italians usually serve quite dry biscuits, such as grissini or taralli, with charcuterie, while the French opt for slivers or chunks of baguette. I am no slave to either, but as a creature of habit, if I am serving the board with pre-dinner drinks and dinner to follow, I usually opt for fennel taralli, which won't fill you up too much ahead of the main event.

Keep slices of pâté or anything you don't want touching other components on the platter on wax paper or baking parchment,

and give it a dedicated knife. When I'm styling a platter for a photo shoot I crumple up the paper a little first so that it doesn't look too pristine.

Final touches of colour, flavour and contrasting shapes go a long way. Add some quartered figs, small bunches of grapes (use scissors to snip off the perkiest branches), caperberries, a few walnuts in their shells, some roasted Marcona almonds or a handful of olives to the platter before serving.

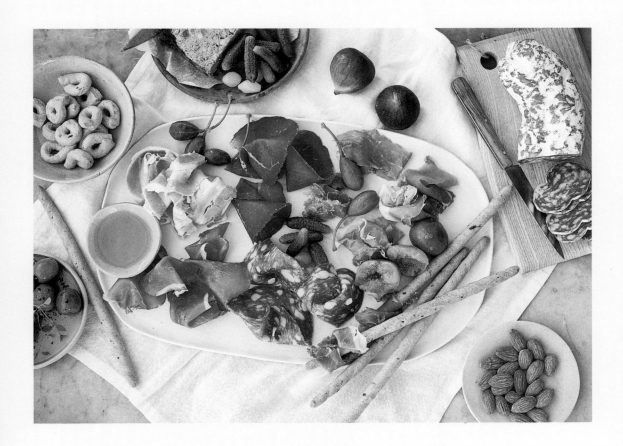

Tartelettes

These savoury snack tarts are like traditional canapés but they bypass the fiddlyness of forming bite-sized pastry squares. I bake them whole in long lengths with a simple crème fraîche spread, bejewelling them with a range of summery toppings along the way. They are simple, satisfying and sit elegantly alongside a spread of colourful finger food. *Makes 4 tartelettes, enough to serve 6–8 as a snack or starter*

PASTRY PRECISION I keep a trusty metal ruler in my kit box, which is especially helpful for neatly and evenly cutting strips of pastry. For this recipe, measure the width of the whole piece of pastry then divide it by four. Make small indents where you are going to cut. Use a pizza cutter or your longest knife to cut out the strips, using the metal ruler as your guide.

FOR THE PASTRY BASES
3 eggs
1 × 320g or 375g sheet
 ready-rolled all-butter
 puff pastry
4 tbsp crème fraîche
Flaky sea salt and freshly
 ground black pepper

FETA AND ONION
1 red onion, peeled and
 thinly sliced
50g feta, crumbled
4 fresh thyme sprigs,
 to garnish

COURGETTE AND RICOTTA
1 small courgette, ideally
 with flowers, peeled into
 very thin ribbons
2 tbsp ricotta
A few mint leaves, to garnish
Olive oil, to drizzle

FIG
2-3 figs, quartered
1 tsp balsamic vinegar
1 tbsp clear honey
Chopped and roasted
 hazelnuts, to garnish

TOMATO AND OLIVE
2 heritage tomatoes or
 5 cherry tomatoes (ideally
 yellow, green and red),
 cut into 2mm slices
10 black olives, pitted and
 sliced
Basil leaves, to garnish
Olive oil, to drizzle

Preheat the oven to 200°C/Fan 180°C/Gas 6. Line a baking tray with baking parchment.

Whisk one of the eggs in a small bowl to make an egg wash.

Place the pastry on the prepared baking tray and use a pizza cutter or sharp knife and a ruler to cut it into four equal strips lengthways. Separate the strips, leaving about 3cm between them. Using a small paring knife, make a shallow incision around each strip, about 1cm from the edge – be careful not to cut all the way through. It will look like a frame. Prick the centre of the pastry with a fork, then brush the frames with some of the egg wash. Bake for 20 minutes.

Meanwhile, whisk the crème fraîche into the remaining egg wash, along with the two other eggs. Season well with salt and pepper.

Prepare the topping ingredients, doubling or trebling the quantity if you want to have more of a certain flavour.

Remove the tray from the oven and press down inside each pastry frame with your fingers or a palette knife, to indent it for the filling. Spoon a quarter of the crème fraîche mixture into each one. Add your chosen toppings, minus the garnishes and drizzles, and bake for a further 15–20 minutes.

Remove from the oven and add the final garnishes and drizzles to the top of each tartelette. Serve them whole on a board or platter with a sharp knife, letting people cut themselves a chunk.

Oysters with sour apple and cucumber granita

If I could afford to eat oysters every day, I honestly would. I even go so far as to plan my holidays according to where the oysters are very fresh and the crisp white wine is abundant. This recipe was inspired by a visit to the Sportsman restaurant just outside Whitstable, where I once went on a birthday oyster binge. What else is an oyster fanatic to do?

Note that you will need to allow 4 hours' freezing time, on top of the 15 minutes' prep. *Makes 12*

SERVING OYSTERS Rock salt works incredibly well here as a means of holding the oysters in situ and for preventing their juices from escaping, but you can pop them on crushed ice, or a mix of both. You could even ask your fishmonger for some seaweed to add to the cushion.

12 oysters
200g rock salt or crushed
 ice, or a mixture

FOR THE SOUR APPLE GRANITA
2 tbsp water
30g caster sugar
½ Granny Smith apple, cored
1 small cucumber,
 roughly chopped
Juice and zest of 2 limes

To make the granita, put the water and sugar into a small pan and bring to a simmer. As soon as the sugar has dissolved, remove from the heat.

Whizz the apple and cucumber in a blender until totally smooth. Add the lime juice and the sugar syrup, whizz to combine, then pour into a plastic container that fits in your freezer. After 4 hours, use a fork to break up the granita so it resembles soft snow, then return to the freezer until needed.

To shuck the oysters, you'll need a tea towel (don't use your favourite one as it will end up a gritty mess). I would advise using a pair of rubber gloves too. Grasp the oyster in the tea towel, with the hinge (the pointed end) facing you and the flatter side facing upwards. Push the tip of your oyster knife through the gap in the hinge at an angle. When you can feel that it's quite deeply embedded, carefully twist until the shells detach from one another. With the shell open, run your knife all the way around the top shell (or lid) to release the oyster, being careful not to mangle it. Open up the shell and brush away any grit with your fingers (if it's really gritty, wash it out very gently). Repeat with the other oysters and discard the lids. If you want to be extra diligent, slide a knife under the oysters to fully release them.

To serve, arrange the salt or ice on a plate with the oysters on top. Add a tablespoon of granita to each one and sprinkle with some of the lime zest.

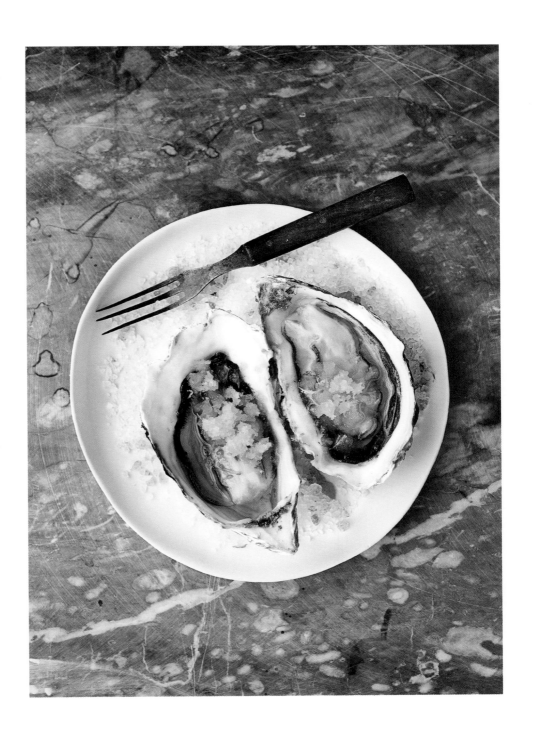

Goat's milk ricotta

For me the most rewarding moments in the kitchen are when there's a touch of culinary alchemy, whether it's the thickening of a custard with egg yolks or, in this case, making your own soft cheese at home from fresh milk. The addition of acid (in this instance lemon juice, but vinegar works too) to warmed milk makes it coagulate so that it separates into curds and whey. I like the tanginess of goat's milk, but you can just as easily substitute this for cow's milk.

I use the ricotta for both sweet and savoury dishes, drizzled with a little honey and scattered with roasted nuts for breakfast, or seasoned with a pinch of flaky sea salt and dolloped on tartelettes or bruschette (see pages 116 and 110). You could also serve it on a cheeseboard or with the flatbreads on page 122, dressed up with flowers, herbs or a scattering of pistachio dukkah (see page 207). *Makes about 250g*

1 litre goat's milk
Juice of 2–3 lemons

Heat the milk gently in a saucepan until it reaches 83°C on a digital thermometer. Remove from the heat and pour in the juice of 2 lemons. Leave for a minute or so to separate. If the milk does not separate, add a little more lemon juice.

Line a colander with muslin or a clean tea towel, letting it hang over the sides. Strain the liquid through it, then bring the corners of the cloth together to make a sack. Tie with string and suspend over a bowl to catch the drips. (I hang it from a hook dangling from a shelf or in the picture opposite it's hanging from a bamboo stick threaded through a chair. The sack could also be hung from a tall tap over the sink.) Leave for 1–2 hours, or longer if you want a drier ricotta (though it must be in the fridge if you choose to leave it for longer than 1–2 hours).

To store the ricotta, transfer it to a plastic container or bowl, cover and chill until required. It will keep for up to 2 days.

Herby spelt and yoghurt flatbreads

Soft and squidgy but well-charred on the base, these herby flatbreads are simple to whip up at a moment's notice. They're an ever-reliable vehicle for scooping up dips, sauces or homemade ricotta; they're also a good accompaniment for the Pomegranate-glazed lamb on page 250.

The haphazard herb topping was the result of a quick excursion into the garden with scissors one evening when I was making these; now I never go without a bouquet of crisped herbs on the top. In the summer, you can cook the flatbreads on the barbecue if you have it cranked up and serve them with skewered lamb, letting the juices soak into the bread. *Makes 2*

250g white spelt flour (or strong white bread flour), plus extra for dusting
1 tsp baking powder
½ tsp fine sea salt
85ml natural yoghurt
85ml warm water
1-2 tbsp extra virgin olive oil
1 large handful mixed herbs (I use a mix of flowering chives, oregano, borage, thyme, sage or rosemary)
Goat's milk ricotta (see page 121), to serve (optional)
Pistachio dukkah (see page 207) or other seeds, such as sesame, nigella or black onion (optional)

Mix together the flour, baking powder and salt in a large bowl. Make a well in the centre and pour in the yoghurt and warm water. Combine to make a slightly sticky mixture. Turn out and knead for a good 5 minutes until you have a smooth ball. Leave to rest for at least 15 minutes in the bowl, covered with cling film or a clean, damp tea towel. (It's even better if rested for a few hours.)

Divide the dough in half. Lightly flour a work surface and roll one half into a circle about 5mm thick. Brush the top with some of the oil and sprinkle with half of the herbs – the more haphazardly the better – leaving some of the sprigs whole. Repeat this step with the remaining piece of dough.

Preheat the grill to high.

Place a large frying pan over a high heat until it is as hot as possible. Add the first flatbread and cook for 2 minutes, or until the base is golden and the edges are puffing up. Place under the grill for a further 1–2 minutes, or until the top is looking golden in patches and the herbs have wilted into the bread. Set aside while you cook the other flatbread.

Serve the flatbreads warm as an accompaniment, snack or starter. I often pair them with my goat's milk ricotta scattered with some pistachio dukkah or seeds.

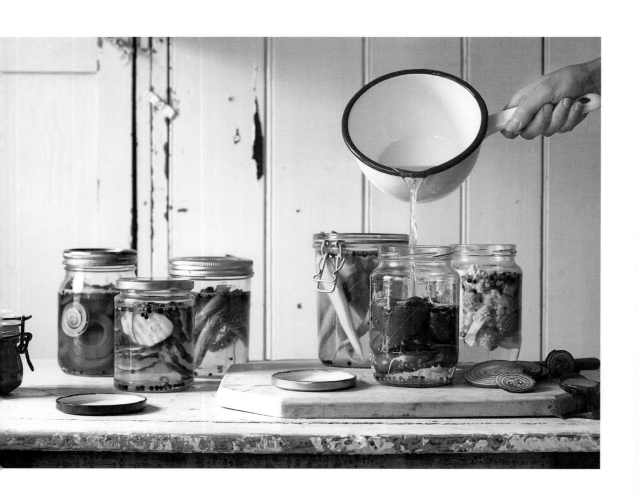

Rainbow fridge pickles

In my opinion there are few dishes that can't be enhanced by the colour and crunchy acidity of lightly pickled vegetables. I always have a batch in my fridge ready for jazzing up everything from bowls of lentils (see page 200) to stews or salads. But aside from adding a refreshing tang to a dish, a pickling session makes use of any surplus veg looking for a new lease of life. These rainbow pickles also make for a good little snack alongside a pre-dinner drink. You can mix and match the vegetables if you like, adjusting the quantities accordingly. *Each vegetable makes enough to fill a 1-litre jar*

FOR THE PICKLING LIQUOR
250ml rice wine vinegar
250ml water
125g caster sugar
2 tbsp fine sea salt
1 tsp peppercorns
2 bay leaves
1 tsp coriander seeds,
 toasted

VEGETABLE OPTIONS
2 red onions, peeled,
 quartered and separated
 into petals, or peeled and
 sliced into 5mm rounds
1 cucumber, sliced into
 rounds about 5mm thick
 (I use a crinkle-cut knife)
2 bunches radishes (I like
 to keep them whole)
400g cauliflower (about ½
 head), cut into bite-sized
 florets
12 whole baby carrots,
 scrubbed and green tops
 trimmed to 1cm
½ red cabbage (about 400g),
 thinly sliced with a
 mandolin

First make the pickling liquor: measure the vinegar, water, sugar and salt into a small saucepan. Add the peppercorns, bay leaves and coriander seeds. Bring to a gentle bubble, then simmer for about 5 minutes to dissolve the sugar. Set aside to cool to room temperature, before placing in the fridge to chill completely.

Once the liquor is cold, pack your chosen vegetable(s) into a 1-litre jar and fill almost to the brim with the liquor. Scrunch up a piece of baking parchment and place it in the top of the jar to keep the vegetables submerged. Leave in the fridge for at least a day.

The pickles will keep for 1–2 weeks in the fridge.

Disco dyed eggs

I have a soft spot for any pub or bar that has the gutsiness to serve a boiled or pickled egg as a bar snack. In fact, having achieved a retro cool status, these bar snacks are making a comeback. My crazy colourful versions – bold pink and rich yellow – are admittedly rather kitsch, but indulge me on this one.

The recipe uses a similar pickling liquor to the Rainbow fridge pickles on page 125 but here it's spiked with a whole beetroot or turmeric, to dye the eggs and make them look seriously punchy. The eggs can be served on a platter for a drinks party but they work equally well in a grain bowl or salad. Make them at least a day ahead for the best colour and flavour; they'll last for up to 5 days in the fridge. *Makes 12*

PEELING EGGS Try to use slightly older eggs for this, as very fresh ones are trickier to peel and you won't get a perfect, smooth finish. If you do have really fresh eggs, go ahead and boil them, then after running them under cold water, roll them on your work surface to crack the shell lightly all over, then submerge in a bowl of iced water for a few minutes before peeling them under water or a running tap.

12 eggs
100g thick crème fraîche
1 tbsp salmon roe (optional)
A few fresh dill fronds
Black pepper, to serve

FOR THE PICKLING LIQUOR
1 tbsp fine sea salt
100g caster sugar
400ml rice wine vinegar
3 bay leaves
8 black peppercorns
400ml water
2 raw beetroot, peeled,
 or 1 tbsp ground turmeric,
 or both

First make the coloured pickling liquor. If making just one colour, place all the ingredients in a medium pan and bring to a simmer. Simmer for 2–3 minutes or until the sugar has fully dissolved, then set aside to cool. When cold, pour into a tall 2-litre jar. If making two colours, divide the pickling liquor in half before adding the beetroot to one half and the turmeric to the other, then heat separately. Pour the coloured liquors into 1-litre jars.

Bring a pan of water to the boil, then carefully lower in the eggs with a slotted spoon (you may need two pans). Cook for 10 minutes at a steady simmer. Drain and hold the pan under running cold water to cool the eggs quickly.

Peel the eggs and add them to the cold pickling liquor. For the pink version, bring the beetroot to the top to keep the eggs submerged. For the yellow version, crumple a piece of baking parchment and place it in the top of the jar instead. Store the pickling eggs in the fridge for at least 24 hours so that the colours and flavour can develop.

When you are ready to serve, remove the eggs from the liquor, cut them in half and transfer to a serving plate, yolk-side up.

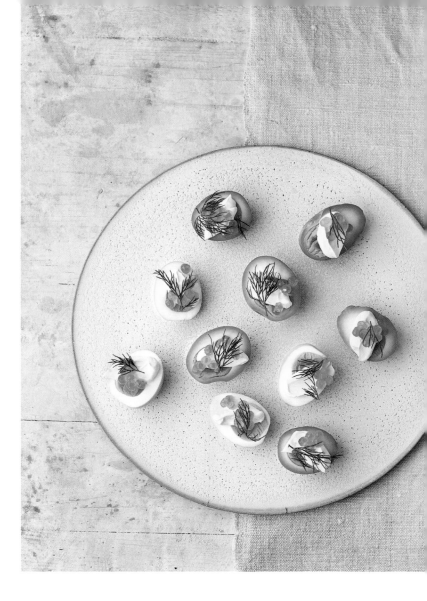

Clean your knife between cutting each egg so you don't leave any traces of yolk in the white, as these bite-sized beauties are all about colour contrast. If you want to keep the eggs in position on the plate, cut a small sliver from the curved underside of each one so that they sit firmly.

Use two small teaspoons to scoop a dollop of thick crème fraîche onto each yolk, then use a clean teaspoon to add some salmon roe (if using). Top each egg with a dill frond and a sprinkling of black pepper.

Sesame tempura vegetables

Deep-frying isn't traditionally the prettiest of cooking methods but the lightness of a Japanese batter is an exception to this rule; it licks the edges of the vegetable without concealing the colour. The art here is to showcase the vegetables in all their glory. *Serves 4*

KEEPING TEMPURA CRISP You need to serve the tempura the moment it has been cooked: if it sits too long it will steam on the inside and you'll lose the crispness of the batter. Make sure you serve it with plenty of space between the veg too - if you pile them, they'll steam.

SHOWING OFF SHAPES I leave the leaves on radishes and the tops on carrots for tempura, and keep spring onions whole to show off their shapes and keep waste to a minimum.

VEGETABLES
8 pieces purple
 sprouting broccoli
8 okra
8 baby carrots, scrubbed
1 small aubergine,
 cut into 2cm batons
8 shiso or giant Thai
 basil leaves
8 spring onions, darkest
 green ends trimmed
8 radishes, with leaves on
1 litre vegetable oil
50g sesame seeds
100g cornflour
100g plain flour
200-225ml ice-cold
 sparkling water

FOR THE DIPPING SAUCE
2 tbsp soy sauce
½ tbsp fish sauce
2 tbsp mirin
1 tbsp finely diced
 spring onion
2 tsp lime juice
2 tbsp rice wine vinegar
1 tsp grated root ginger

Start by making the dipping sauce. Measure all the ingredients into a small bowl, taste and adjust to your preference, then set aside.

Get all your vegetables ready, making sure they are thoroughly dry. Line a large baking tray with kitchen paper or J-cloths. Heat the oil in a wok or a large, heavy-based saucepan over a medium heat. Use a thermometer to check the temperature – you want it to be 170°C.

Put the sesame seeds into a small bowl. Put the cornflour and plain flour into a separate medium bowl and gradually add the sparkling water, whisking it in drop by drop until there are no lumps.

Using one hand, dip the vegetables one at a time into the batter – it's fine if they're only partly coated – then use your clean hand to sprinkle a pinch of sesame seeds over them. Carefully lower 5–6 vegetables into the hot oil using a slotted spoon (frying any more will overcrowd the pan and lower the temperature of the oil). Fry for 3 minutes, or until they are rigid (they won't colour much, that's part of the beauty of tempura). Drain in the lined tray. Repeat until you have used up all the vegetables.

Serve the tempura immediately, with the dipping sauce alongside.

Artichokes with lemon butter

There's a wonderful wine bar in Paris where they operate a help-yourself policy. Vats of cornichons, hunks of bread and massive slabs of butter are lined up on the zinc bar alongside a row of steamed whole artichokes. Once you have finished nibbling your way through the fleshy tips of the leaves, they whip your artichoke away, discard the furry 'choke' and re-dress the heart, giving it a whole new lease of life with a dusting of paprika and a lemony dressing. This is my homage to many a happy day and night spent standing at the bar of Le Comptoir du Relais. *Serves 4 as a starter*

PAIRING WITH WINE Artichokes can throw the flavour of an accompanying wine out of kilter, making it taste artificially sweet, so opt for a bone-dry white or rosé.

3 lemons, 2 cut in half
 widthways, plus the zest
 of the third
4 globe artichokes
1 tsp peppercorns
75g salted butter
½ tsp sweet smoked paprika
Flaky sea salt

Half-fill a large bowl with cold water and squeeze in the juice of one lemon. Keep two more lemon halves at the ready for the next step.

Cut 4cm from the top of the artichokes and trim the stem to about 2cm from the base. It's important to leave the stem intact because it is just as tender as the heart. Start peeling away the outer leaves – usually about one tour of the outside but sometimes two. Rub the base with the lemon halves.

Trim away the uneven green edges from the base in a circular motion and peel the green fibrous outside of the stem, rubbing with lemon as you go. Store in the lemon-water while you trim the rest of your artichokes.

Put 3cm of water into a pan large enough to hold the artichokes in one layer. Add the peppercorns, the lemon zest and some salt and bring to a simmer with the lid on.

Pop the artichokes in the pan, stem-side up, replace the lid and keep at a very low simmer (you are looking to steam them) for 20–30 minutes (the timing will depend on the size of your artichokes so just keep checking them).

When they are ready, a sharp knife should slide into the base easily and the inner leaves can be pulled off with just a little resistance. Drain in a colander and set aside to cool.

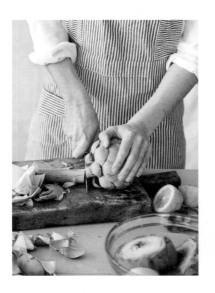

Meanwhile, melt the butter in a saucepan until sizzling but not coloured, remove from the heat and add the juice from the final lemon halves. Transfer to a little serving bowl.

To serve, place the artichokes on a platter with the butter and a pile of sea salt alongside. Invite people to peel off the leaves and dip their fleshy bases in the butter and salt before eating. When you have worked your way through the leaves to the centre of the artichokes, whip them away from the table. Pull out the remaining tiny leaves to reveal the hairy choke, then use a teaspoon to scoop it out and discard it. Slice the hearts of the artichokes, drizzle with any remaining lemon butter and bring them back to the table on a serving plate with a few pinches of paprika.

Photograph overleaf

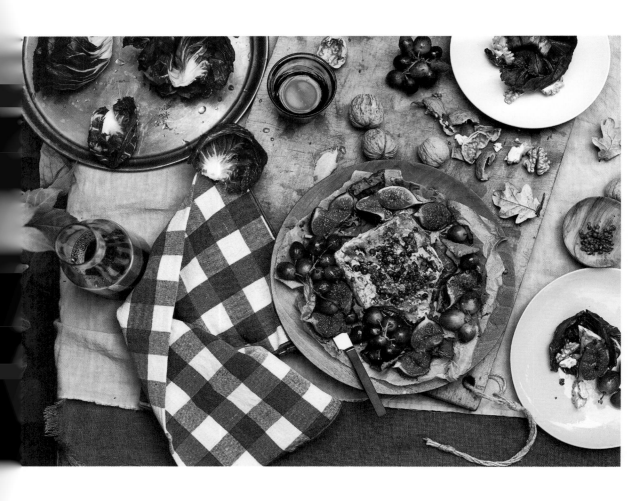

Sticky baked feta with radicchio cups

This little homage to the autumn harvest is a warming starter or snack to dig into on darker nights. Baked whole and nestled in aromatic fig leaves – nature's answer to baking paper – the feta warms to sticky glossy perfection before being studded with some pink peppercorns and scooped into bitter and crunchy radicchio leaves. *Serves 4*

WET WALNUTS Wet walnuts come into season for a fleeting few weeks in the autumn. The wet nuts are the fresh ones, encased in their shells but boasting a delicate milky mildness and creamy texture. They go brilliantly with this dish but if you can't find them, buy the dried ones in their shells.

4 fig leaves or vine leaves
 (optional)
1 × 200g block feta, drained
4 tbsp clear honey
1 tbsp pomegranate molasses
1 tbsp pink peppercorns,
 bashed
250g grapes, on the stalk,
 separated into neat
 clusters
3 fresh figs, quartered
3 tbsp balsamic vinegar

TO SERVE
1 head radicchio
1 handful wet or dried
 walnuts in their shells

Preheat the oven to 200°C/Fan 180°C/Gas 6. Line a small baking dish a little larger than the block of feta with the fig or vine leaves (if you can't get hold of either, use baking paper). Put the feta on top and drizzle over 1 tablespoon of the honey and the pomegranate molasses. Bake for 20–30 minutes or until golden and sticky. Place under a hot grill for a couple of minutes if it isn't sticky enough. Remove from the oven and scatter with the pink peppercorns.

Meanwhile, line a separate baking tray with baking parchment, spread out the grapes and figs on it and drizzle with the remaining honey and the balsamic vinegar. Bake for 20–30 minutes, until the skins crinkle and the colour deepens.

In the meantime, prepare the radicchio cups. Trim the base off the radicchio, then carefully separate the leaves and place them in a bowl of iced water.

Put the baked feta on a board in its wrapping, with the roasted grapes and figs and the walnuts. Dry the radicchio leaves and place them on a small serving plate or in a basket alongside the board, in the same way as you might serve bread. To eat, scoop some of the feta into a radicchio cup and top with a piece of fig, some nuts and a few roasted grapes.

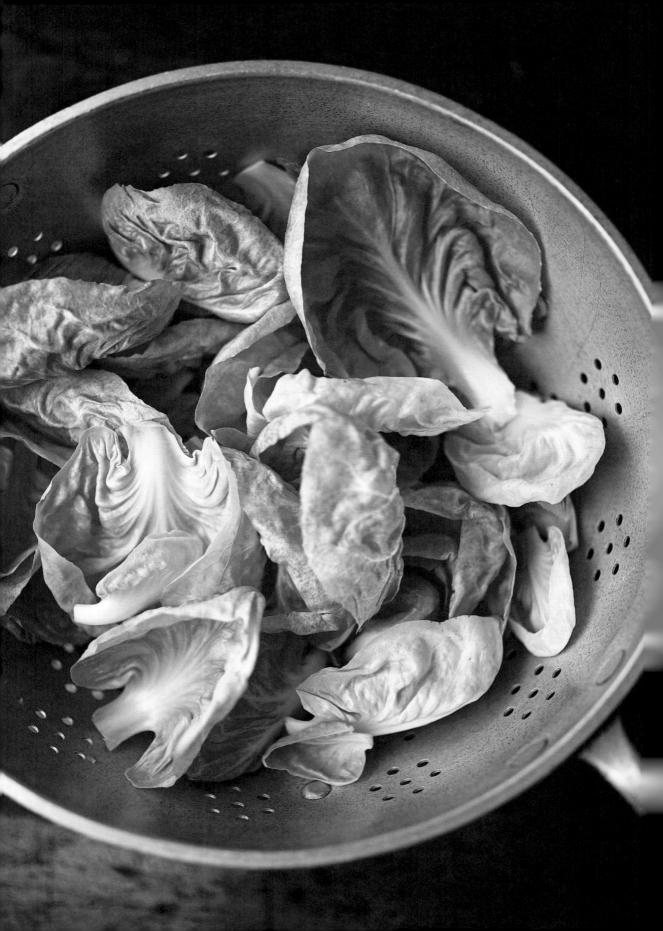

Seasonal Salads

There was a time when I thought salads were the simplest dishes to style, but if you aren't careful a salad can turn from a thing of beauty into a dumping ground for odds and ends. The success of even the humblest of salads hangs on a balance of flavours, textures, seasonings and ways of slicing and dicing, so it's always worth thinking about how the preparation will affect both the look and the flavour. My Melon, cucumber and San Daniele salad (see page 142) is ribboned to let the dressing coat all the strands, while the Bashed beetroot on page 162 is bruised to urge the dressing into its sweet roasted flesh.

The recipes in this chapter celebrate each season's bounty, with simple flavour pairings and delicate dressings to enhance their natural beauty.

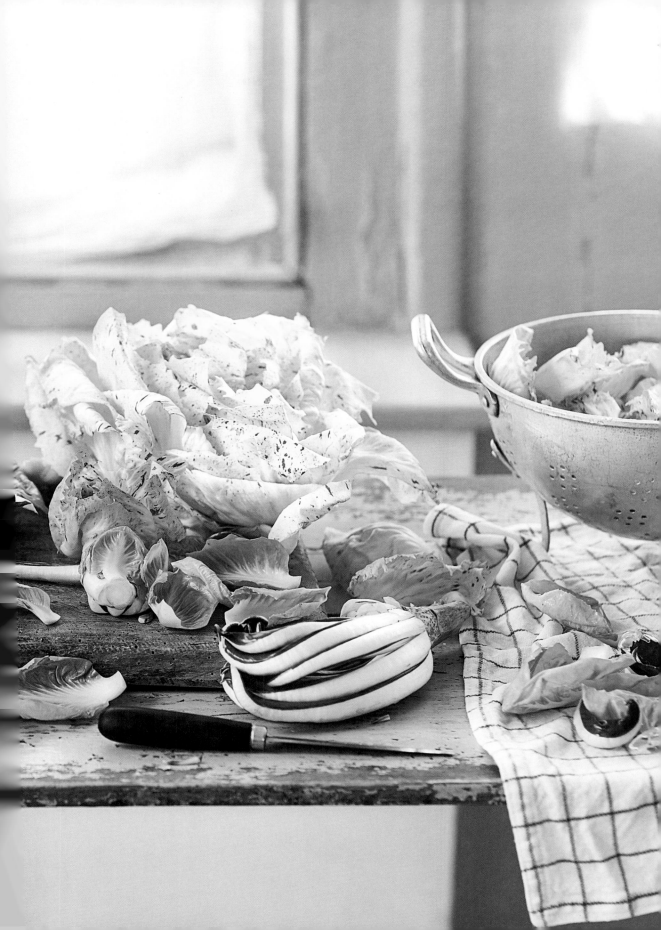

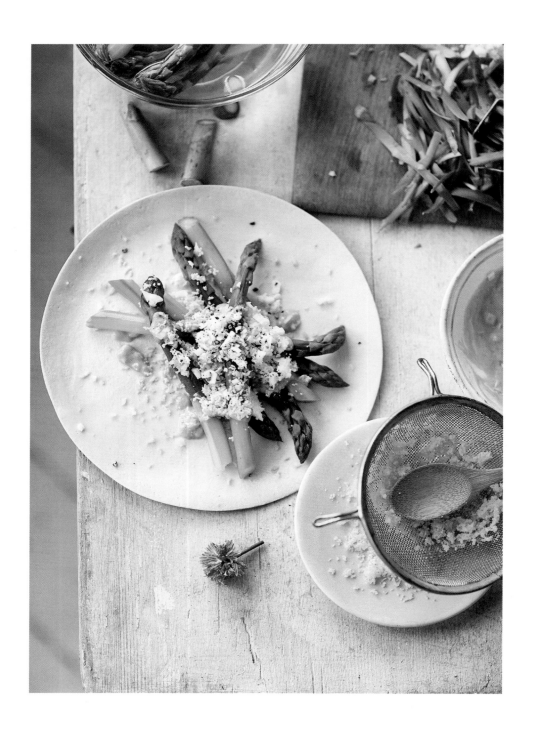

Asparagus mimosa

Asparagus and eggs make the best of food friends in this classic French dish. Sporting the white, yellow and green of a daffodil, it's an ode to the shades of spring – the delicate dusting of yolk is not dissimilar to the eponymous fluffy yellow flowers.

Peeling the base of the asparagus makes the dish an even more vibrant green, but you can omit this step if you like a rustic finish. You can roughly chop the yolk, but passing it through a sieve is what a fastidious French chef would do, and I must admit I like the subtle dusting effect. *Serves 4 as a starter or side*

SERVING UP IN STYLE Play around with the presentation here. Sometimes I overlap the spears, stacking them over one another; other times I lay them flat on a serving platter and scatter the egg white and yolk over in two distinct lines of colour.

500g asparagus
2 hard-boiled eggs
 (10-minute timing;
 see page 51), peeled

FOR THE DRESSING
2 tsp Dijon mustard
1 tbsp red wine vinegar
A pinch of caster sugar
3 tbsp extra virgin
 olive oil
1 shallot, peeled and
 very finely diced
Flaky sea salt and freshly
 ground black pepper

Trim the ends off the asparagus on the diagonal (you can snap them, but I find it neater to use a knife). Use a peeler to take off about 5cm of the skin above the trimmed end.

Bring a medium–small pan of generously salted water to the boil. Insert the asparagus with the tips upright; they cook more quickly than the stems, and the steam from the pan is enough to soften them. Simmer for 3–4 minutes, or until tender but still with a little bite, then immediately plunge the asparagus into a bowl of iced water.

To make the dressing, put the mustard, vinegar and sugar into a bowl and whisk together. Add the oil and half the shallot and whisk again. Taste and adjust the flavour to your taste. Set aside until needed.

Cut the eggs in half and put the yolks to one side. Roughly chop the whites.

Pat the asparagus dry then place in a bowl and toss with the dressing. Arrange on a platter (or individual plates if serving as a starter), overlapping them slightly and keeping the tips visible. Scatter the egg white in a line across the centre of the spears. Scatter with the remaining shallot. Press the yolks through a sieve with the back of a spoon and lightly sprinkle over the plate(s). Season with salt and black pepper to finish.

Melon, cucumber and San Daniele salad

In the height of summer, this melon and cucumber combination is one of the most refreshing medleys you could hope for. Ribboning the two tones of melon and cucumber is not just for presentation: creating the extra surface area lets the orange blossom dressing delicately coat the individual strands. Do wait until just before serving to prepare the salad, so the melon doesn't sit around and get soggy. *Serves 4–6 as a starter or side*

TASTING DRESSING There's no need to season the salad with salt, as the ham contains plenty and will do the job. To test the balance of the dressing, dip a ribbon of the melon into it. If the balance of sweetness and acidity is right, dress away.

CREATING STRUCTURE I like to serve this in a shallow salad bowl or plate to show off the colours and curls. The melon has a tendency to sit flat in the plate though, so I try to encourage height and shape by overlapping and layering the slices with the more robust ribbons of cucumber or ham. Clean hands are the best utensil you could use for this.

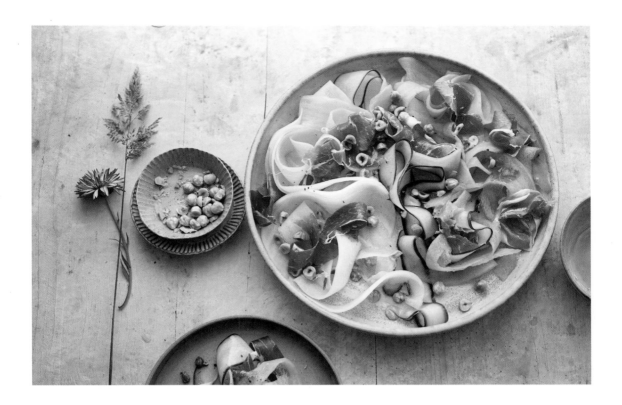

½ honeydew melon

1 small cantaloupe melon

1 large cucumber

100g San Daniele or
 Parma ham, thinly sliced

50g hazelnuts, roasted
 and halved

Cracked black pepper

FOR THE DRESSING

2 tbsp extra virgin olive oil

1 tbsp lemon juice

1 tsp honey

1 tsp orange blossom water

First make the dressing: combine the ingredients in a bowl and whisk together. Set aside until needed.

Scoop out the seeds from the melon. Carefully cut off the skin. Use a mandolin or sharp knife to slice the melon into 2–3mm slices.

Use a peeler to shave the cucumber lengthways into ribbons; I usually discard the very outer ribbons of skin, as they are tough.

Assemble the two colours of melon in a shallow plate or serving bowl, then add the cucumber ribbons.

Spoon the dressing over the melon. Tear the ham slices and ribbon them over the top. Sprinkle with the hazelnuts and some cracked black pepper.

Caprese three ways

The killer 'tricolore' combination of tomato, mozzarella and basil is arguably one of the greatest food collaborations ever conceived. I rarely steer too far from it, but when tomato season is in full swing sometimes a few little deviations can make a colourful change. *Each variation serves 4–6 as a starter or side*

Photographs overleaf

Tomatoes, shallots, mozzarella

I think of this as the 'carpaccio' version of a tomato salad, showing off the interesting shapes and using perfect rings of shallot to quite a graphic effect. I stick to red tomatoes here, and try to get an interesting mix of shapes.

500g tomatoes (datterini and beef varieties
 work well, for interesting shapes)
1 banana shallot, peeled
200g buffalo mozzarella
2 tbsp good-quality extra virgin olive oil
Flaky sea salt and coarsely ground
 black pepper
A few fresh basil leaves, red if available,
 to garnish

Slice the tomatoes widthways into rounds and arrange them on a plate, overlapping but not too perfectly. Slice the shallot widthways into rounds too and add them to the tomatoes. Tear the mozzarella and dot it around. Drizzle over the oil and sprinkle with salt and pepper. Garnish with the basil leaves.

Tomatoes, raspberries, mozzarella, basil

Credit for the ingenious flavour combination of raspberry and tomatoes goes to Harry Cummins, a great chef and friend. These unlikely bedfellows mimic one another in acidity and sweetness in an intriguing way.

The raspberry vinegar is also a good match for bitter leaf salads or for drizzling over pan-roasted duck breast or livers.

```
500g tomatoes (mixed colours, shapes
  and sizes)
200g buffalo mozzarella
75g raspberries
2 tbsp good-quality extra virgin olive oil
Flaky sea salt and freshly ground
  black pepper
A few fresh basil leaves, to garnish

FOR THE RASPBERRY VINEGAR
125g raspberries
About 300ml red wine vinegar
```

First make the vinegar. Place the raspberries in a 400ml jar and pour over enough of the vinegar to submerge them fully. Seal tightly and leave to macerate at room temperature for 1 week. Strain through a fine mesh sieve, discarding the pulp, and the vinegar is ready to use.

Slice the tomatoes widthways into rounds and arrange them on a plate, overlapping but not too perfectly. Tear the mozzarella ball haphazardly and distribute around the plate. Drizzle with a few teaspoons of the vinegar (save the rest for another dressing), then tear the raspberries over the top. Drizzle with the oil and sprinkle liberally with salt and pepper. Garnish with the basil leaves.

Heritage and vine tomatoes, buffalo mozzarella, basil

This way of serving tomatoes was inspired by a burrata salad created by Michel Roux for his *Cheese* cookbook, for which I was the 'prop' stylist. He arranged the tomatoes on the plate, leaving some whole with their stems on, some roughly cut, some halved. I liked his non-prescriptive approach, which really allowed the shape of the tomatoes to shine in an understated and elegant way. This is a great option for a relaxed garden gathering with a smoky barbecue involved.

```
500g tomatoes (mixed colours, shapes
  and sizes)
200g buffalo mozzarella
2 tbsp good-quality extra virgin olive oil
Flaky sea salt and freshly ground
  black pepper
A few fresh basil sprigs, to garnish
```

Arrange the tomatoes on the plate, some cut, others whole; a string on the vine looks pretty too. Add the whole ball of mozzarella, plus salt, pepper and a drizzle of olive oil. Arrange a few basil sprigs or leaves on top.

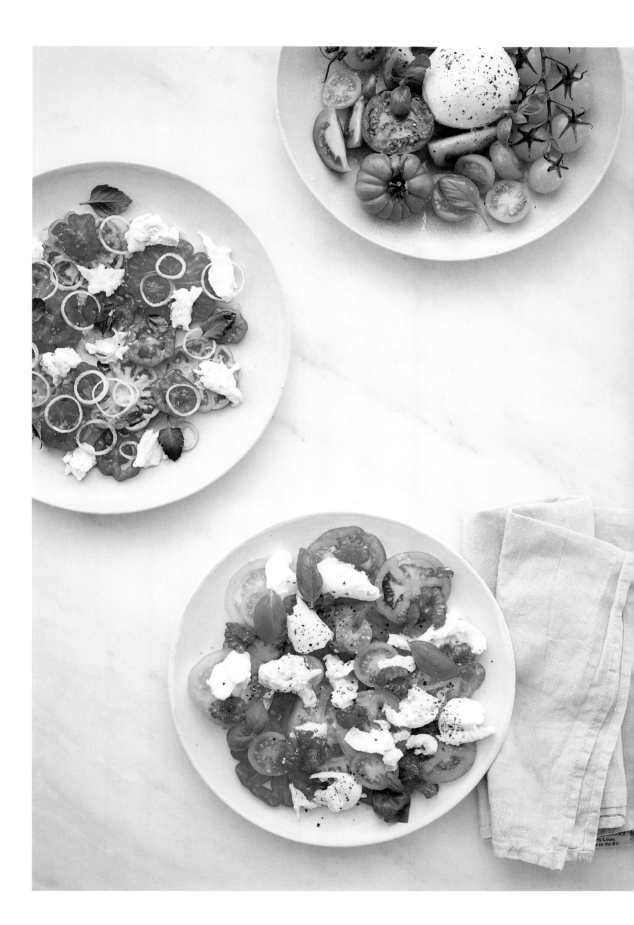

The building blocks
of a good salad

Branch out with your salad leaves, and try to step away from the classic pre-washed ones in a bag. You get much more for your money if you buy heads of lettuce individually, and this will add variety and substance to your salad bowl. Think about buying a mixture of shapes and colours.

Always wash and dry the leaves. A salad spinner is the best tool for drying, but the other option is to tip the washed leaves into a clean tea towel and, using it like a sling, whirl it around. Store the leaves carefully, in freezer bags or the packaging they came in, in a drawer in the fridge (don't get caught out and have them freeze against the back of the fridge!). Delicate baby leaves wilt quickly so I try to buy them fresh on the day of using.

Use two or three main types of leaf per salad if possible, and a range of flavours, weights and shapes. Don't limit yourself to classic salad leaves: consider delicate snippings of herbs and edible flowers too. Mix delicate and frondy bits with chunky, bulky leaves like Little Gem and radicchio. Add the delicate leaves right at the end, otherwise they will quickly wilt in the dressing.

Balance the leaves with the style of dressing: bitter leaves need sweetness and can withstand a heavy dressing; delicate leaves need acidity-led dressings that are light in texture; and tougher leaves benefit from heavier dressings that coat and penetrate the fibres.

Build a salad in the same way as you would dress yourself – think tonally. It's easy to get carried away with colours in salads when you are excited by a stack of amazing produce. Suppress the desire to throw all the bold colours on to one plate; the most impactful salads visually stick to tones. My Bittersweet salad with whipped goat's cheese (see page 154) plays with warm oranges and pinks, and works a treat for bringing some much needed colour to the depths of winter when all of the ingredients in this dish are in season.

Think about the natural shapes of the leaves and do leave large ones whole (round lettuce, endive and lollo rosso, etc.) – the natural shape of the leaves will act as a vessel for other components in the salad. Trim stalks, discard any damaged outer leaves and carefully pull the leaves apart. In the case of Little Gem, just trim the stem and either halve or quarter the whole heads – the little nooks and crannies are great for trapping dressing.

Less is more: try to work with five main components or flavours, not more, as that would simply confuse the taste buds and look messy.

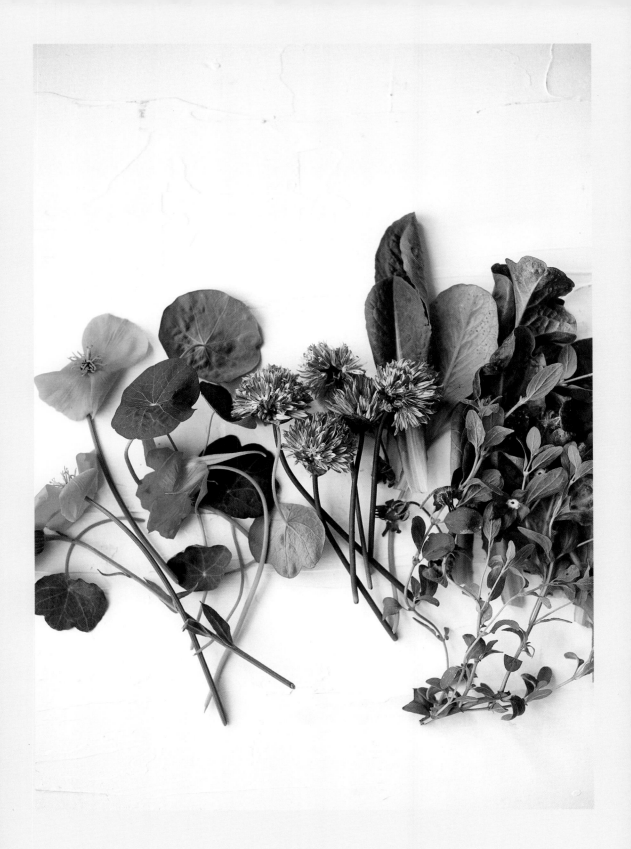

A few tips on assembly

Delicate leafy salads wilt quickly so you have to work fast from washing to serving. On a photo shoot we will often dress a salad very lightly, just enough to give it a glisten for the camera, then serve the sauce or dressing separately on the side.

Make sure the salad leaves are dry before dressing them or the water will dilute the dressing – this seems obvious I know but it is amazing how often this happens.

Always dress salads with your hands in a large mixing bowl, tossing the components from underneath with your fingers loose and open; you will dress more evenly and won't damage the leaves.

When you are using sturdier structured leaves as the base (kale, cabbage, etc.), thick sauces massaged through look inviting and decadent and help break down the structure of these tougher leaves. Make sure you remove all tough stalks first and don't be afraid to massage the leaves firmly – this will really soften them.

Salads don't need to be raw: try grilling or griddling sturdier leaves like romaine and Little Gem for a modern take on a classic Caesar.

Don't forget to season with salt, add it to the dressing at the beginning to allow it to dissolve. I love acidity with salads partly because acidity counteracts bitterness too, so try a spritz of lemon on those bitter winter leaves.

To taste your dressing, dip an ingredient from the salad into it. Using a finger doesn't actually enable you to figure out what it's going to taste like, as the leaves themselves will bring out a different flavour in the dressing. When preparing ahead of time, make your dressing and keep it in a jar in the fridge until ready to serve.

Simplest summer salad

I am a tireless champion of the simple salad. This recipe is an exercise in minimalist discipline, combining only the freshest of leaves and flowering herbs, which in an ideal world have been plucked straight from a window box or garden. The raw ingredients are brought together in a tangle of colour and freshness that only the lightest of dressings could enhance – just a kiss of extra virgin olive oil and lemon juice and it's good to go. With the acidity from the dressing and the aroma from the herbs, this is the perfect post-main-course palate cleanser, as the French and Italians would have it, but it also goes well alongside the Pan-fried fish on page 227. *Serves 6*

HOW TO DRESS LEAVES Contrary to the general rule that acidity keeps fruit and some vegetables from discolouring, when it comes to green leaves, the opposite is the case. Be sure to dress this right at the last moment. Dressing the leaves with your hands is the best way of ensuring a light touch.

ENHANCING WITH HEIGHT If I am plating this salad for individual servings, I use my hands to plate the leaves, building them on top of one another so they stand tall and perky on the plate, not flat and weary.

1 small head lollo rosso
 or butter lettuce
50g baby salad leaves
 (nasturtium leaves,
 beetroot tops, mizuna
 or wild rocket)
50g mixed fresh herbs
 (dill, chervil, parsley,
 mint, basil or chives),
 leaves picked or snipped
30g edible flowers
 (marigold, nasturtiums,
 pansies, borage or chive)

FOR THE DRESSING
5 tbsp good-quality extra
 virgin olive oil
2-3 tbsp lemon juice
Flaky sea salt and freshly
 ground black pepper

Separate the lettuce leaves but keep them whole. Place in a bowl of iced water. Add the baby salad leaves and the herbs. (I don't add the flowers, as this can damage them.)

Just before serving, gently dry the leaves in a salad spinner. Do this as lightly as possible so they keep their shape.

Whisk the dressing ingredients in a large bowl, using 2 tablespoons of lemon juice to start. Dip a few leaves in to test it, add the extra lemon juice if required and season.

Dress the salad at the last minute, very delicately tossing it with your hands, in a large bowl, getting everything nicely coated. Use your hands to scoop the salad into a serving bowl or onto individual plates.

152

Bittersweet salad with whipped goat's cheese

In the depths of winter, crimson red blood oranges and bitter leaves burst onto the scene, bringing all the bright colours and bold flavours I have been craving. This salad brings them together on top of a goat's cheese cream that's stained with juices. *Serves 2 as a main course or 4 as a side*

COLOUR IN WINTER Watermelon radishes prefer cold soil and, while they're not essential for this salad (you can omit them or use regular radishes), I like to add a few matchsticks for an extra pop of colour and crunch.

50g shelled walnuts

1 tbsp clear honey

150g fresh goat's cheese

50ml double or
 whipping cream

2 blood oranges

1 watermelon radish

100g mixed bitter leaves,
 such as radicchio, endive,
 tardivo, Treviso or
 Castelfranco

3 tbsp extra virgin olive
 oil, plus extra to drizzle

1 tbsp red wine vinegar

Flaky sea salt and freshly
 ground black pepper

Preheat the oven to 200°C/Fan 180°C/Gas 6.

Scatter the walnuts on a baking tray and roast in the oven for 10 minutes. Roughly chop, then place in a small bowl and toss with the honey while still warm.

Whisk the goat's cheese in a stand mixer at a high speed for 2 minutes, until smooth. Add the cream and whisk again until light and airy; be careful not to overwhip or it will turn grainy. Season well, add the finely grated zest of the oranges and set aside.

Use a knife to peel away the skin and pith of the oranges (see page 38). Slice into 5mm-thick rounds. Set aside, reserving the juices. Slice the radish into 2mm-thick rounds, then cut the rounds into thin matchsticks. Set aside in a separate bowl.

Trim the base of the lettuce head and separate the leaves, maintaining their shape. Wash and dry the leaves. In a large bowl, mix the olive oil with the vinegar and season. Add the orange slices and their juices. Dip a leaf in the dressing to check the balance of acidity and sweetness and adjust accordingly, then add the leaves to the bowl and mix together with your hands.

Dollop the whipped cheese on your serving plates and use the back of the spoon to sweep it across in a half-moon shape. Put the radicchio and orange slices alongside and overlapping it, allowing the smaller leaves to perch on top, and making sure the curliest leaves are on view. Sprinkle with the radish matchsticks and walnuts. Drizzle with any remaining orange juices from the bowl and let them seep into the cheese, then swirl over a drizzle of olive oil and finish with a grind of black pepper.

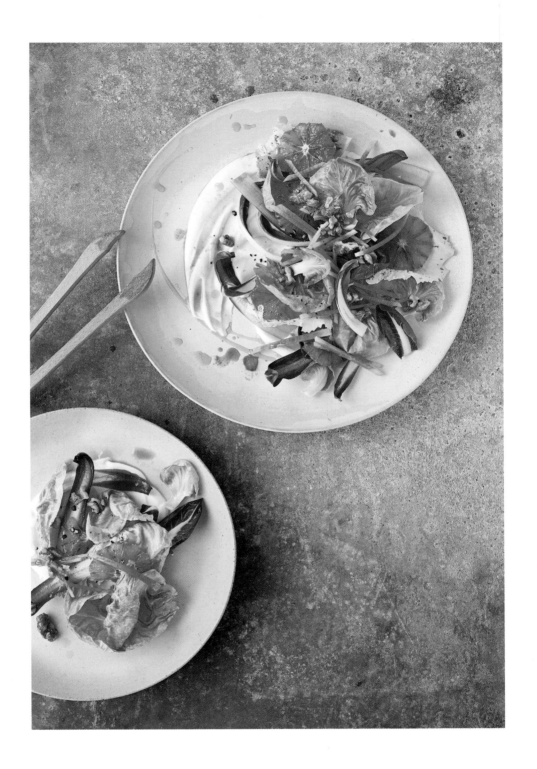

Watermelon and tomato salad with Sichuan salt

A tingling Sichuan seasoning might seem an unlikely match for the sweetness of watermelon, but it adds a prickly sparkle of citrusy saltiness. I rely on good-quality tomatoes for this recipe, the riper the better, as it's all about flaunting flavours. If you can't muster the energy to make the full version of the dish, slice off some watermelon wedges and serve them with a heaped pile of the seasoning to dip into as you go; it's a snack I could turn to all summer long. *Serves 4*

PRESENTING WITH PANACHE I like to serve this salad with the chilled tomato 'broth' in a jug and pour it around the salad; this will keep it cool and adds some extra action to the dining table.

1 medium watermelon
500g ripe tomatoes (I like to use datterini for their shape and sweetness), halved through the waist
3 tbsp extra virgin olive oil, plus extra to drizzle
Sherry vinegar or caster sugar (if required)
100g salted ricotta or feta, finely shaved with a peeler or mandolin
A few green or purple basil leaves
Flaky sea salt

FOR THE SEASONING
1-2 tsp Sichuan pepper
½ tsp flaky sea salt

To prepare the watermelon, take a slice off the top and bottom, so that it stands upright, then cut off the skin with a sharp knife. Square off the block of watermelon to make one large rectangular cube. Reserve the offcuts of watermelon flesh.

Weigh out 300g of the watermelon offcuts and place in a blender. Add 200g of the tomatoes and a generous pinch of salt and whizz until completely smooth. Strain through a fine sieve into a bowl and discard the pulp. Add the oil. Taste and adjust the flavour as required; it might need a touch of sherry vinegar or a pinch of sugar. Transfer to a jug and chill until needed.

Cut the large cube of watermelon into 2cm cubes – you want to end up with about 300g (munch on any left over!). Put the cubes of watermelon and the remaining tomatoes in a bowl and toss together.

Toast the Sichuan pepper for the seasoning in a dry frying pan for 4–5 minutes, until fragrant, then use a pestle and mortar to crush it with the sea salt flakes.

Stack the watermelon and tomatoes on top of one another in four shallow bowls. Add the cheese shavings. Sprinkle generously with the seasoning, then add the basil and an extra drizzle of olive oil. Pour the chilled broth around the salad to serve.

Rainbow shaved salad with a Vietnamese dressing

A mandolin is one of the most trusted tools in the kit box I carry around like a priceless handbag from one photo shoot to the next. It shaves the thinnest and most precise slices which only a professional chef's knife skills could otherwise achieve. Here, delicate wisps of raw vegetable are lightly tossed in a Vietnamese-style dressing which adds a zippy tang without concealing the vibrant colours.

If you want to make this more substantial for a main course, serve it on top of cold vermicelli noodles and double the quantity of the dressing so that all the strands are well coated. *Serves 4 as a starter or side*

KEEPING THE COLOUR I prepare all the vegetables in different bowls before tossing this salad, to retain the individual colours.

CRISPING RADISHES Ahead of using radishes raw, place the whole radishes in a plastic container or bowl of iced water. This gets them super crunchy and firm so that they can be sliced into perfect rounds and will curl up like flower petals. You can do the same to refresh limper beetroot and carrots.

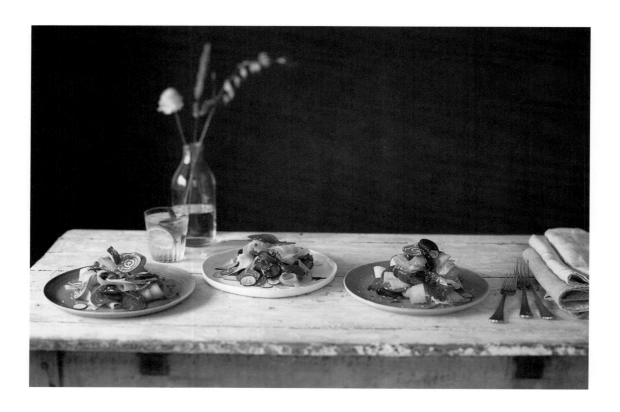

3 small beetroot, candy
 variety if available,
 trimmed and peeled
1 lemon, halved
1 fennel bulb, trimmed
2 carrots (ideally 1 red
 and 1 purple), peeled
10 radishes, a mix of
 colours if available
1 tbsp white or black sesame
 seeds, to serve
1 small handful Asian herbs,
 such as Thai basil or
 Vietnamese mint if
 available, otherwise use
 normal mint and basil,
 leaves picked

FOR THE DRESSING
1 tbsp caster sugar
1 tbsp Asian fish sauce
 (nam pla)
1 red chilli, finely chopped
Juice of 2-3 limes
½ tsp grated fresh
 root ginger

Whisk the ingredients for the dressing together in a large bowl. Taste and adjust to your preferred acidity, heat level and sweetness.

Using a mandolin set to about 1–2mm (with the guard on or wearing protective gloves so you don't cut off your fingers), slice the beetroot widthways. Place in a small bowl.

Squeeze the juice of half the lemon into a bowl with a cupful of water. Cut the fennel into quarters then set the mandolin to 0.5mm and slice the quarters into ribbons. Place in the lemon water (this stops the fennel discolouring).

Shave the carrots into ribbons using a Y-shaped peeler or the mandolin.

Slice the radishes widthways with the mandolin and place in a bowl of iced water to curl up (if you haven't already had them in iced water as per the tip opposite).

When you are ready to serve, pat the vegetables dry if they have been in water, then add them to the bowl with the dressing. Use your hands to toss all the ingredients together: you want everything to be well coated in the dressing. Pile the ingredients onto a serving platter or divide between four individual bowls or plates. To give the salad height (which shows off the ribbons), I use my hands to tease the ingredients into a tall tangle. Scatter over the sesame seeds, then arrange the herb leaves on top or serve them alongside for people to help themselves.

Smashed potato gribiche salad

My ideal potato salad is a mixture of crunchy and soft, with a spiky sauce to penetrate it. While I do usually sneak boiled eggs into most dishes, I held back from making a traditional gribiche sauce here (which would include shredded boiled eggs) to let the crispy potatoes be the star of the show.

Take the time to chop all the ingredients for the dressing as finely as possible, harmonising all the flavours before whisking them into a thick emulsified sauce. I like this salad served a little warm, which allows the dressing to permeate those bursting potato seams, but it will also taste great cold (it will be pleasantly soggy this way, if that's your thing). If you want to keep the potatoes extra crispy, mix them with the dressing just before serving. *Serves 4–6*

1.5kg baby new potatoes
2-4 tbsp olive oil
Flaky sea salt and freshly
 ground black pepper

FOR THE GRIBICHE SAUCE
3 tbsp finely chopped
 gherkins
2 tbsp capers, finely chopped
2 shallots, peeled and
 finely chopped
2 tbsp red wine vinegar
1 tsp Dijon mustard
125ml extra virgin olive oil
1 handful mixed frondy herbs
 (such as chervil and dill),
 small leaves picked, larger
 ones finely chopped

Preheat the oven to 240°C/Fan 220°C/Gas 9.

Bring the potatoes to the boil in a large pan of salted water. Cook until tender, about 8–10 minutes. Drain and let cool slightly.

Drizzle two large baking trays with 1–2 tablespoons oil each. Place in the oven to get hot for about 5 minutes. Meanwhile, put the boiled potatoes on a board and press with a fork or the palm of your hand so that they burst a little from their skins. Not only does this help the potatoes get extra crispy, it will also allow the dressing to be absorbed better.

Spread the potatoes out (this helps them crisp up) on the hot trays and season. Roast for 35–40 minutes, turning halfway through, until golden and crisp.

While the potatoes are in the oven, make the gribiche sauce. Put the gherkins, capers and shallots in a bowl and whisk with the vinegar, mustard and oil. Add the chopped herbs (keeping the picked leaves back for later).

Transfer the cooked potatoes to a bowl. Either serve them tossed with the dressing or with the dressing on the side, and the picked herbs scattered on top just before serving.

Bashed beetroot with warm herb vinaigrette and Puy lentils

Roasting beetroot in little parchment parcels locks in their natural sweetness and urges the skins to shed, unveiling the glistening flesh beneath. These stainy skins will smudge everything in sight, especially fingers, so have your Marigolds at the ready for the peeling part.

Once peeled, and after a gentle bash to burst their flesh (I sometimes then brown them in a hot pan too), the beetroot are tossed in a herby dressing and served on a bed of glossy lentils. *Serves 4 as a starter or side*

INJECTING FLAVOUR Bashing your beetroot not only adds rustic appeal, but also allows the seasonings and dressings to penetrate the flesh better. I do the same for the potato salad on page 160.

MAKING COLOURS POP I like serving these bright beetroot on white or pale plates, to emphasise their colour and allow the juices to show up.

800g bunched baby beetroot (a mix of colours), leaves trimmed
1-2 tbsp olive oil
150g dried Puy lentils, rinsed in cold water

FOR THE HERB VINAIGRETTE
30g dill, finely chopped
7 tbsp extra virgin olive oil
Juice and zest of 2 lemons
A generous pinch of caster sugar
Flaky sea salt

Preheat the oven to 220°C/Fan 200°C/Gas 7.

If your beetroot are different sizes, arrange the smaller ones, the medium ones and the larger ones on three separate sheets of foil as they will take different times to cook. If they are much the same size, place them all on a single large sheet. Drizzle with the oil and use your hands to ensure the beetroot are well coated. Wrap the foil over them, then place in a baking tray (remembering which size is which) and bake for about 30 minutes if small and up to 1 hour if large.

In the meantime, bring a pan of salted water to the boil, add the lentils and cook for 15–20 minutes, or until tender but still holding their shape. Taste them a couple of times towards the end to ensure they don't overcook. Give them a rinse after cooking if they look a little murky. Drain and set aside.

Once the beetroot are out of the oven and cool enough to handle, pop on some rubber gloves and peel off the skin by rubbing them; it should slip off. Place them on a chopping board and press them with the base of a saucepan until they split a bit.

To make the vinaigrette, place three quarters of the dill in a bowl, add the remaining ingredients and whisk together. Drizzle a little of the vinaigrette on the lentils to give them a glossy finish. Place the lentils on a platter or individual serving plates.

Toss the beetroot with half the remaining vinaigrette, then arrange on the plate(s). Sprinkle with the remaining dill and drizzle on the remaining vinaigrette.

Red cabbage wedges with anchovy and pangrattato

The tightly packed ribs of a red cabbage wedge have an almost architectural appeal. Like the rest of the brassica family, red cabbage responds well to a good charring on a griddle pan (or barbecue if the weather permits) and my anchovy sauce is a vibrant and punchy addition. *Pangrattato*, often referred to as 'poor man's Parmesan', is a favourite in my household, where stale sourdough breadcrumbs often get transformed into a crunchy garnish spiked with lemon and parsley.

Try serving this salad on the side of a seared bavette or flat-iron steak – it needs to be paired with something strong enough to stand up to the sauce. *Serves 4–6*

1 red cabbage
About 2 tbsp olive oil,
 for tossing
8 anchovy fillets, to serve
Flaky sea salt

FOR THE ANCHOVY SAUCE
2 small garlic cloves,
 peeled and grated
6 anchovy fillets, chopped
1 tsp Dijon mustard
1 tbsp red wine vinegar
1-2 tbsp lemon juice
5 tbsp extra virgin olive oil
Freshly ground black pepper

FOR THE PANGRATTATO
2 tbsp extra virgin olive oil
80g coarse dried breadcrumbs
Grated zest of 1 lemon
10g flat-leaf parsley
 leaves, finely chopped

Preheat the oven to 220°C/Fan 200°C/Gas 7. Line a baking tray with baking parchment.

To cut the red cabbage into wedges, trim about 1cm off the base and peel off about two rounds of the external leaves (you could use them for the pickles on page 125). The core is going to be crucial for keeping the wedges in place, so cut the cabbage into eight equal pieces, maintaining some of the core in each wedge. Toss with the oil and season with sea salt.

Heat a griddle or heavy-based frying pan until very hot. Sear the cabbage wedges for about 4 minutes on each side, then transfer them to a baking tray, spread them out and place in the oven for 30–40 minutes, or until soft and tender.

In the meantime, make the dressing: combine the garlic, anchovies, mustard, vinegar and 1 tablespoon of lemon juice in a blender. Add the olive oil and whizz again until completely smooth, which can take up to 5 minutes in a good blender. Taste and adjust the seasoning. Add a couple of twists of pepper and a little extra lemon juice if required.

To make the pangrattato, heat the oil in a frying pan. Once hot, add the breadcrumbs, season with salt and pepper, then cook over a medium heat, stirring until golden. Toss through the lemon zest and parsley.

Serve the red cabbage wedges drizzled with the dressing and scattered with the pangrattato, then drape an extra anchovy fillet over the top of each wedge.

Roasted buttermilk chicken and grape salad

Roasting grapes to tender-soft stickiness not only transforms their flavour but also deepens their colour. I don't generally use chicken breast in cooking, usually opting for fuller-flavoured thigh meat, but marinating in buttermilk is a magical way of tenderising the breast and locking in all the juices to keep it succulent. Not one to waste the skin, I crisp it up and add it at the end as a crunchy crouton.

Blistering the Little Gem on the griddle might look a bit cheffy but it's an easy way to tease out an extra dimension from this fairly ubiquitous lettuce, and with its closely packed leaves, it traps heavy dressings better than any of its contemporaries.
Serves 2

HOW TO GRIDDLE The key to successful griddling is to heat your griddle for 5 minutes before adding the lettuce and avoid moving it until you are sure you have a good sear. I press it firmly down with my fingers (taking care not to get burnt) or a fish slice.

1 chicken supreme
 (about 380g) or 2 smaller
 breasts, skin on
150ml buttermilk
1 tbsp olive oil,
 plus extra for crisping
 the chicken skin
120g seedless black
 or red grapes
1½ tbsp balsamic vinegar
½ tbsp honey
3 heads Little Gem lettuce
2 celery sticks, with leaves
Flaky sea salt and freshly
 ground black pepper

FOR THE DRESSING
75ml buttermilk
1 tbsp wholegrain mustard
50g crumbly blue cheese,
 such as Stilton, plus a
 little extra to serve

Separate the skin from the chicken. Place the chicken in a bowl, cover with the buttermilk and chill for a couple of hours (or overnight if you have time). This will tenderise the meat.

Preheat the oven to 200°C/Fan 180°C/Gas 6.

Wipe the excess buttermilk off the chicken and place it in a small baking tray. Drizzle with the olive oil and season well. Bake for 40–50 minutes (less if using the breasts).

In the meantime, separate the grapes into clusters, keeping them on their stems. Combine the vinegar and honey in a bowl, add the grapes and toss carefully to coat. Transfer to another small baking tray and place in the oven for 20–30 minutes. The exact time will depend on the size and type of grapes you are using, so keep a close eye on them – you want them nicely caramelised and soft but still holding their shape.

Lay the chicken skin flat in another small tray, rub with a little olive oil and scatter with sea salt. Roast for about the same time as the grapes, until bubbly and crisp. (I cook everything on different trays, as the juices will leak and for presentation purposes it's best to keep them separate.)

Place a griddle pan over a high heat to get very hot. Meanwhile, trim the base of the lettuces and cut in half lengthways through the core. Wash and pat dry, then place flat-side down on the griddle until they start to smoke and there are charred lines across the underside. Season and place in a large serving bowl.

To make the dressing, stir the buttermilk, mustard and crumbled cheese together in a bowl. Season.

Slice the celery in 1cm-thick diagonal pieces, reserving the leaves for garnishing. Add the celery to the bowl of lettuce.

When the chicken is ready, cut it into 1cm-thick slices and add it to the serving bowl. Sprinkle with the celery leaves, then top with the roasted grapes and drizzle them with the balsamic juices from the roasting tray. Cut the chicken skin in half and add it to the bowl along with a scattering of crumbled blue cheese. Serve the dressing alongside.

Soup and
Bowl Food

Of all the vessels out there to be treasured, bowls are without a doubt the ones I am most drawn to. The rich, chilled Confit garlic ajo blanco on page 174 is best eaten in a shallow dish, creating a large surface area for scattering the frozen grapes on top so each mouthful of soup gets a little lift, while I love to eat the Beetroot soup on page 178 from a deep bowl, ideally while curled up on the sofa.

Bowl food, for me, represents complete comfort: nourishing, sustaining and designed to be eaten with just a spoon, fork or chopsticks.

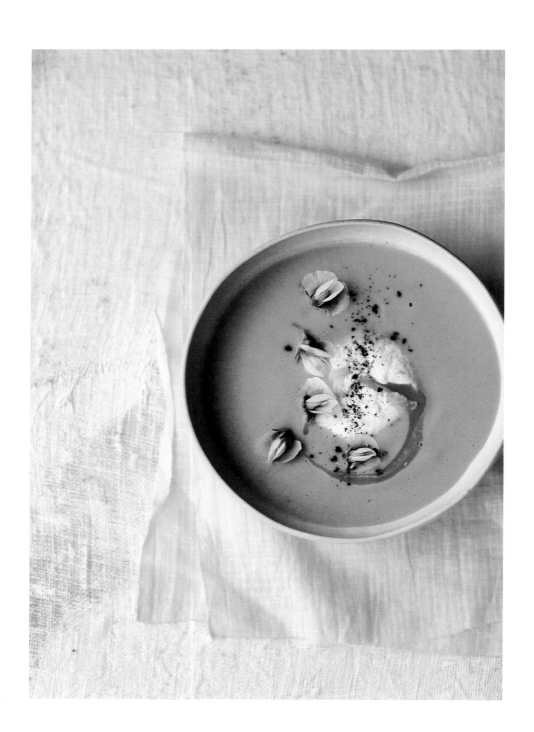

Spring pea and broad bean soup

The trick with fresh vegetable-based soups is to work quickly, because unlike a meat-based broth, the longer you cook it the duller the flavour will be, and the more muted the colour. Allowing them to just thaw in the stock is sufficient for the beans and peas that are blitzed into this velvety green soup.

I like to sneak a soft poached egg into the soup too, and let the yolk ooze through as I eat it. You can make the eggs ahead of time and store them in iced water for up to a day. The hot soup will bring the eggs back to room temperature when you serve them.

If you can't find pea flowers for the garnish, perch other edible flowers or a tangle of pea shoots on top of the egg. *Serves 4*

1 tbsp olive oil
1 onion, peeled and
 finely chopped
2 leeks, roughly sliced
 into rounds
1 litre vegetable stock
200g fresh or frozen peas
200g fresh or frozen broad
 beans, skinned (see page 110)
1 handful fresh mint leaves
4 poached eggs (see page 53)
1 small handful pea flowers
Flaky sea salt and freshly
 ground black pepper

Pour the olive oil into a frying pan, add the onion, leek and a pinch of salt and fry gently for 10 minutes. Add the stock and simmer for 5–10 minutes. Season with salt and pepper. Add the peas, broad beans and mint leaves and stir through, then remove from the heat. If using fresh peas and broad beans, cook them for 1–2 minutes before adding the mint. Blend thoroughly until super-smooth.

Use a slotted spoon to place a poached egg in the bottom of each serving bowl. Cover with the soup, then top with the pea flowers and a generous scattering of pepper.

Confit garlic ajo blanco with frozen grapes

Blanched almonds whizz up to pure white velvet perfection in this take on a classic Spanish *ajo blanco* (literally meaning 'white garlic'). Adjust the garlic to your taste, or take a leaf from the Spanish book and go for it with reckless abandon. My method of slowly cooking the garlic in oil mellows out some of the harshness of raw garlic, leaving a sweet and softer taste.

White grapes are often blended into a traditional chilled ajo blanco, but I like to serve this with frost-kissed red grapes, either on the side to nibble on between mouthfuls of soup, or popped into the bowls. *Serves 6–8 as a starter*

PEELING GARLIC QUICKLY A quick method for peeling a whole bulb of garlic is to grab two metal bowls of the same size, then separate the cloves and place them in one of the bowls. Put the second bowl on top (creating a sphere) and start shaking as vigorously as you can, for about 20 seconds. The skin should slip off.

CHOOSING AND USING PEPPER For white soups like this one, you might prefer to season with white pepper to keep its colour pure. Alternatively, go bold with the black pepper, pounding it in a pestle and mortar, or cut whole peppercorns with a knife to keep them extra coarse.

4-6 small bunches
 seedless grapes
200g blanched almonds
400-500ml cold water
1 large head garlic, cloves
 separated and peeled
About 200ml olive oil
1 slice stale white bread,
 crusts removed (about 50g)
1 tbsp sherry vinegar
Flaky sea salt

TO SERVE
Zest of 1 lemon
3 tbsp flaked almonds,
 toasted
Extra virgin olive oil

Place the bunches of grapes in a lidded plastic container lined with baking parchment in the freezer for 2 hours.

Preheat the oven to 200°C/Fan 180°C/Gas 6.

Meanwhile, leave the almonds to soak in 400ml water. I do this in the blender jug to save on washing up.

While the almonds are soaking, put the garlic cloves into a small ovenproof dish and add as much olive oil as required to submerge them. Cover with foil and place in the oven for 40 minutes. You want them tender to the point of a knife, but not too coloured.

Once the confit garlic is ready, add it to the almonds and liquid in the blender, along with the bread, vinegar and 2 tablespoons of the garlic oil and blitz until completely smooth. I always blend for a good 5 minutes to get the creamiest texture. Season well with salt. Add a bit of water to achieve your desired consistency.

Cover with cling film (or keep it in the jug of your blender with a lid on) and chill for 1–2 hours (the longer you leave it, the better the flavour). The soup will thicken further as it rests, so you might need to thin it again slightly with ice-cold water and whizz it in the blender once more before serving.

To serve, divide the soup between small cups or shallow bowls – it's very rich, so keep the servings small. Scatter with plenty of lemon zest, the flaked almonds, a swirl of oil and a few frozen grapes cut in half – or serve the frozen bunches on the side for people to help themselves.

Red pepper gazpacho with mussel scoopers

In summer months, nothing beats a chilled soup to kick off a meal. Charring the red peppers for this gazpacho adds a rewarding smoky note, texture and smooth vibrant colour that couldn't be achieved with tomatoes alone.

Mussels are the sea's answer to spoons, giving you a bite of mussel with every mouthful of soup – it's an outstanding combination. Do adjust the seasonings to your own taste as the sweetness and acidity of tomatoes will vary greatly.
Serves 4 as a starter or 2 as a main course

PREPPING MUSSELS To scrub and debeard your mussels, start by discarding any with cracked shells or any that are open and don't close when you tap them. Fill your sink with cold water and rinse the mussels. Sort through them, pulling the beard (the bristly bit between the two shells) out with your fingers and discarding it. Use a vegetable brush or clean scourer to scrub the outside of the shells.

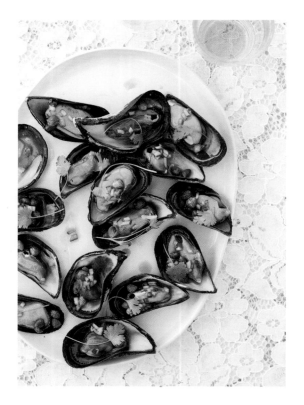
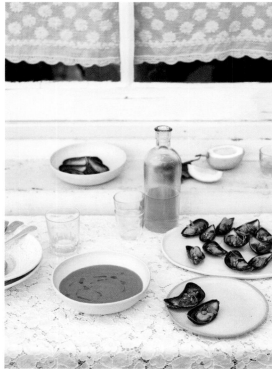

FOR THE GAZPACHO
4 red peppers
300g really ripe,
 best-quality tomatoes
½ tbsp sherry vinegar,
 or to taste
2 tbsp extra virgin olive oil,
 plus extra for swirling
1 garlic clove, peeled
150ml water (or more for
 the desired consistency)
Flaky sea salt and freshly
 ground black pepper

FOR THE MUSSELS
About 150ml white wine
 or water
650g mussels, debearded
 and scrubbed
1 tbsp red wine vinegar
¼ tsp caster sugar
¼ red onion, peeled and
 very finely chopped
2 tbsp capers, drained,
 and rinsed if salted
A few small coriander leaves
A squeeze of lemon juice

Preheat the grill to medium–hot. Grill the red peppers on a baking tray, turning them with tongs, until the skin blackens all over. This will take 15–20 minutes in total.

Transfer the peppers to a plastic bag and tie it shut. Leave for 15 minutes. Once cool enough to handle, remove the peppers, peel off the skin and discard the seeds too. Place the flesh in a blender with all the other gazpacho ingredients, and blend for 5 minutes, or until extremely smooth. Season to taste then transfer to a covered container and chill for at least 1 hour.

Next cook the mussels. Pour a 1cm depth of water or white wine into a large saucepan and bring to a simmer over a very high heat. Add the mussels, pop the lid on and give the pan a really good shake. Leave on the heat for 3 minutes, then give the mussels a stir. If they aren't quite open, pop the lid back on and give them another minute. Drain through a colander. When cool enough to handle, scoop all the mussels out from their shells and place in a bowl. Discard any that haven't opened. Save half the shells and rinse them clean.

Arrange the mussel shells on a platter or individual plates and put the mussels back into them. You can serve them on a bed of coarse salt to make them stand up if they are wobbling around.

Put the red wine vinegar, sugar and a pinch of salt into a small cup or glass and stir to dissolve, then mix in the red onion. Drizzle over the mussels, then dot them with the capers and coriander leaves, and add a good squeeze of lemon juice. Ladle the chilled soup into bowls and add a swirl of olive oil. Spoon up the soup with the mussel scoopers, getting a mouthful of everything all at once.

Beetroot soup with cream clouds

My recipe repertoire of bright pink food is startlingly extensive, and none is more vibrant than this beetroot soup. In summer I serve it chilled, with grated boiled eggs and dill, and in winter it gets dished up piping hot, adorned with a voluptuous snowy cloud of horseradish-spiked cream and a scattering of multi-coloured beet crisps. *Serves 4*

ADJUSTING CONSISTENCY On photo shoots, stylists often err on the thicker side with soups, so as to perch things on top without them sinking. I have done the same in this recipe; you can always add more water or stock when you come to blending if this doesn't suit you. It's always safer to go thicker and adjust after.

2 tbsp olive oil
2 celery sticks,
 finely diced
2 carrots, peeled and
 finely diced
1 large red onion, peeled
 and finely diced
2 bay leaves
4 beetroot
1 litre vegetable stock
1 eating apple, cored
 and cut into chunks
1 tbsp sherry vinegar
Flaky sea salt

FOR THE CRISPS
4 baby beetroot, mixed
 colours if you wish
½ tbsp olive oil

TO SERVE
150ml whipping cream
1 tsp freshly grated
 horseradish root, plus
 a little extra to serve,
 or 2 tsp horseradish
 cream (optional)

Heat the olive oil in a heavy-based pan or casserole dish. Add the celery, carrots, onion, bay leaves and a pinch of salt and sweat over a low heat for 10 minutes.

Peel the beetroot (use a pair of rubber gloves to save your hands from pink stains) and cube into rough chunks. Add to the vegetables and cook for a further 5 minutes. Add the stock and the apple, bring to a simmer, then cover and cook for 30–40 minutes, until the beetroot is very tender. Fish out the bay leaves.

In the meantime, preheat the oven to 180°C/Fan 160°C/Gas 4. Line a baking tray with baking parchment.

To make the crisps, slice the baby beetroot as thinly as you can (about 1mm) on a mandolin with the protective guard on or wearing protective gloves. Place in a bowl, add the olive oil and a pinch of salt and toss to coat evenly. Spread out on the prepared tray so that none of the slices overlap, and roast for 10 minutes. Turn them over and cook for a further 5 minutes, or until crisp. Watch carefully, as they can catch quite quickly. Transfer to a wire rack to cool.

Meanwhile, blitz the cooked vegetables until very smooth with a stick blender. Add the sherry vinegar to taste. Whizz the soup for even longer than you think it needs, as smoother is always better for this. Keep it warm in the pan.

Whip the cream until soft peaks form. I tend to do this by hand, as it can very quickly overwhip if you are too zealous with the stand mixer. The airiness will allow the cream to sit on the surface of the soup without sinking. With a light hand, stir the horseradish, if using, through the cream. If you prefer a less puffy pillow of cream, you can whip just a small amount of air into the cream, then drizzle it over the soup with a teaspoon to create little swirls on the surface.

Pour the soup into four bowls, smoothing the top with the back of the ladle for a perfect finish. Put a large spoonful of cream on top, using a second spoon to push the dollop off. Scatter some of the beetroot crisps over the top of the cream. Finish with a little more grated horseradish, if using.

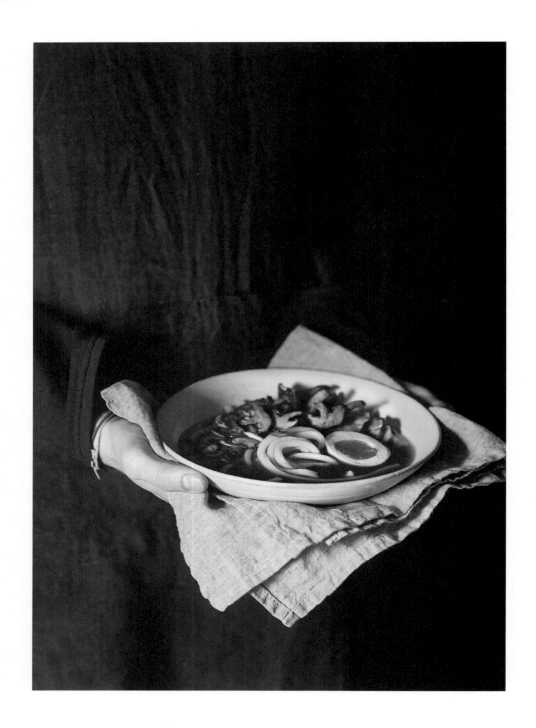

Shiitake miso udon broth

Brown on brown might not sound like a winning formula for beautiful food, but the depth of flavour from this mushroom stock and miso combination is seductive enough to make it work.

This is very much a midweek favourite in my household – store-cupboard-based and intensely satisfying. I buy frozen udon noodles, which are pleasingly chewy, and I always have a good-quality miso paste to hand. I tend to go for red miso as it undergoes a longer fermentation process than shiro (white) miso, which will only have been fermented for 6 months, and it adds that umami depth of flavour that has me smacking my lips. Don't panic if you can't source kombu (a type of dried seaweed); the miso and shiitake pack plenty of punch on their own, but it adds an extra depth of flavour if you can find it. *Serves 2*

MAKING NOODLE NESTS To serve noodles as a stylist would, gather a portion's worth of cooked noodles in your fingers, coil them around the back of your fingers and loop them back through. Place them in the bowl in a nest before pouring over the broth.

50g dried shiitake
 mushrooms
800ml water
2cm piece fresh root ginger,
 sliced into slivers
1 × 15cm piece of kombu
 (optional)
2 heaped tbsp red miso paste
150g fresh shiitake
 mushrooms
2 tbsp vegetable oil
 or olive oil
1 tbsp soy sauce
260g frozen udon noodles
1 medium-boiled egg
 (6-minute timing;
 see page 51), peeled
 and halved
4 spring onions, sliced
 at an angle (or cut into
 curls, as on page 184)

Place the dried shiitake in a medium pan and cover with the water. Bring to the boil, add the ginger and kombu (if using), and simmer for 10–15 minutes. Remove from the heat and stir in the miso.

Halve the larger fresh shiitake through their stems, leaving the smaller ones whole. Put the oil into a large non-stick frying pan over a high heat. Once it is hot, add the mushrooms and cook for 2–3 minutes on each side, or until really golden. At that point, stir in the soy sauce and remove from the heat.

Blanch the noodles in boiling water to defrost, then drain well.

Strain the miso broth through a sieve, discarding the bits. Arrange the noodles in two bowls, in elegant nests (follow the method above), and ladle the broth over them. Finish with the mushrooms, egg and spring onions and serve immediately.

Ceviche in a green broth

I love the sour flavours in a Peruvian ceviche so much that I'll actually lick the plate clean if no one is watching. The addition of a chilled green broth to this citrus-marinated sea bream allows you to do this more gracefully, with the use of a spoon. The nutty toasted quinoa topping adds a moreish crunchy element to the dish, and any left over will be delicious for breakfast with toasted nuts, fruit and yoghurt. *Serves 4*

BALANCING SOURNESS The seasoning of this soup is somewhat subjective. I am notorious for loving a sharp and citrusy zing, so taste the broth regularly and remember that sourness or sharpness can be easily counteracted by an addition of salt or a little hit of sugar.

Juice of 2 limes
1 green chilli, very
 thinly sliced
½ red onion, peeled
 and sliced into fine
 half moons
½ tsp caster sugar
300g sea bream fillet or
 other very fresh delicate
 white fish, skinned
2 green tomatoes
Red amaranth (optional)
1 tbsp black or red quinoa,
 dry-toasted for 3 minutes
 or until it pops
Herb oil (see page 25;
 I use parsley)
Flaky sea salt

FOR THE BROTH
40g baby spinach
1 large cucumber
20g fresh coriander
1 whole green chilli
Juice of 1-1½ limes, to taste
1-1½ tsp caster sugar,
 to taste

Place the lime juice in a glass or other non-reactive bowl. Add the chilli, onion, sugar and a pinch of salt. Stir to combine.

Cut the fish into 1.5cm cubes and add them to the bowl. Toss well, then cover with cling film and chill for 30–60 minutes.

In the meantime, prepare the broth. In a blender, whizz the spinach, cucumber, coriander and chilli. Add the juice of one lime and blend until smooth. Strain the liquid through a sieve lined with a J-cloth or muslin into a jug. Season with lime juice, sugar and salt until you are happy with the flavour. Chill.

When the fish is ready, strain its marinade into the broth and stir to combine. Taste again and adjust the seasoning.

To serve, divide the broth between four shallow bowls (I find white ones work best for really making the colours 'pop'). Slice the tomatoes widthways into 5mm rounds and arrange in the bowls. Add the marinated fish and onion, using your fingers if you want to be neat about it. I like to build things up from the centre of the bowl. Top with some red amaranth (if using) and sprinkle with the quinoa. Just before serving, put the herb oil in a squeezy bottle (or use a small spoon) and add small droplets to each bowl – these look beautiful floating around the top of the broth.

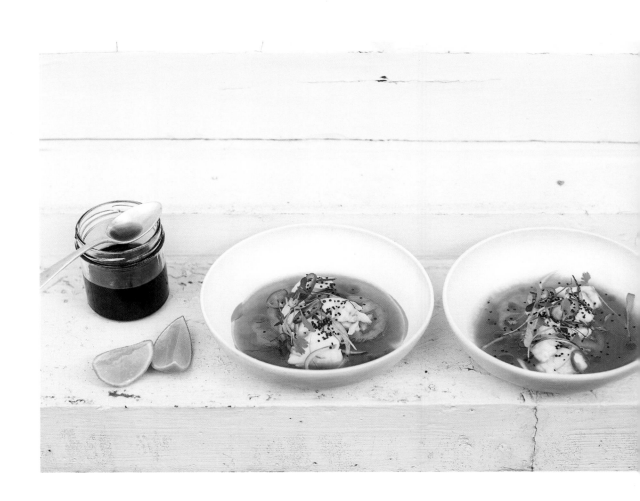

Monkfish tail and bok choy laksa

A proper Malaysian-style laksa – coconut-based broth enriched
with galangal, turmeric and lemongrass – has to be up there
as one of my favourite dishes of all time. While I'm the first to
admit this is very much a shortcut version (purists look away
now, as I have omitted a few of the harder-to-source ingredients),
the flavour is punchy and the colours are as vibrant as in a
more elaborate version. Traditionally you would assemble all
the ingredients in the bowl, then pour the broth over the top.
Here you add the broth to the bowl first, using the smallest
ladle you have, so you don't splash it everywhere. This means
you can accessorise the top without the garnish being buried
by a downpour of liquid. *Serves 4*

MAKING SPRING ONION CURLS Many home cooks discard
the green part of a spring onion, but I like to use the
whole thing for colour and freshness as part of a final
elegant curly garnish. Trim off the spring onion's
tough ends and root and cut it in half lengthways. Slice
as finely as you possibly can down the length to get
strands. Dunk the strands in iced water and you'll see
them curl into a pretty tangle after a few minutes.

FISH ON THE BONE Poached white fish has a tendency to
fall apart, making it tricky to plate it elegantly, but
cooking on the bone not only adds extra flavour to the
broth, it enables you to keep a pristine portion of fish
intact. If you buy a whole monkfish tail, which will
weigh about 600-800g, that's around the perfect quantity
for four people. Cut into four cross-section portions
straight through the bone, using a really sharp knife.

2 eggs

2 baby bok choy heads,
 halved lengthways

100g rice vermicelli
 noodles

1 × 600-800g monkfish tail,
 cut widthways into 4
 equal pieces

4 large raw, unpeeled prawns

2 tbsp tamarind paste,
 or to taste

1-2 tsp Asian fish sauce,
 or to taste

FOR THE PASTE

4 sticks lemongrass,
 bashed with the back
 of a heavy knife

4cm piece fresh root ginger
 or galangal, peeled

4cm piece fresh turmeric,
 peeled, or 1 tbsp ground
 turmeric

3 red chillies

2 banana shallots, peeled

4 garlic cloves, peeled

3 tbsp vegetable oil

2 × 400ml tins coconut milk

TO SERVE

4 curled spring onions
 (see opposite page),
 to garnish

2 limes, cut lengthways
 into 'cheeks' (see page 39)

A few fresh coriander leaves

A few fresh Thai basil leaves

1 watermelon radish or
 regular radish, finely
 sliced into matchsticks

Roughly chop the paste ingredients minus the oil and coconut milk, pop in a food processor and whizz to a paste (you might need some of the oil to assist in loosening this). Alternatively, chop everything finely by hand. I include the chilli seeds, but taste a tiny bit of yours first to check how hot they are and add accordingly.

Heat the oil in a saucepan over a medium heat and add the paste (or finely chopped ingredients). Lower the heat and fry for 10 minutes to release all the different aromas. Don't be tempted to use your favourite wooden spoon to push it around the pan, as the turmeric will stain it. Add the coconut milk, then refill the tins with water and add this to the pan too. If you have good chicken or fish stock, you could add that instead for extra depth. Simmer for 20 minutes, then strain the liquid through a sieve and discard the solids. Return the liquid to the pan and place on the hob to simmer.

Lower the eggs into a pan of boiling water and boil for 6 minutes. Add the bok choy for the last minute, then drain and place in a bowl of iced water to stop everything cooking. Peel the eggs in the cold water and set aside, discarding the shells.

Cook the noodles according to the packet instructions.

In the meantime, place the monkfish pieces and prawns in the laksa broth. Simmer with the lid on for 6 minutes. The fish is ready when the tip of a knife makes it just slightly come away from the bone. Add the tamarind paste and fish sauce to taste.

Ladle the broth into four wide, pasta-style bowls. Drape the bok choy around the sides. Use your fingers to gather the noodles into nests (see page 181 for more guidance). Using tongs, add a piece of the fish and place a prawn to the side, perching it on the bok choy so that the tail is visible. Halve the eggs and add one half to each bowl. Garnish with the spring onion curls, and serve the limes, herbs and radishes on the side for people to dress the bowl with themselves.

Photograph overleaf

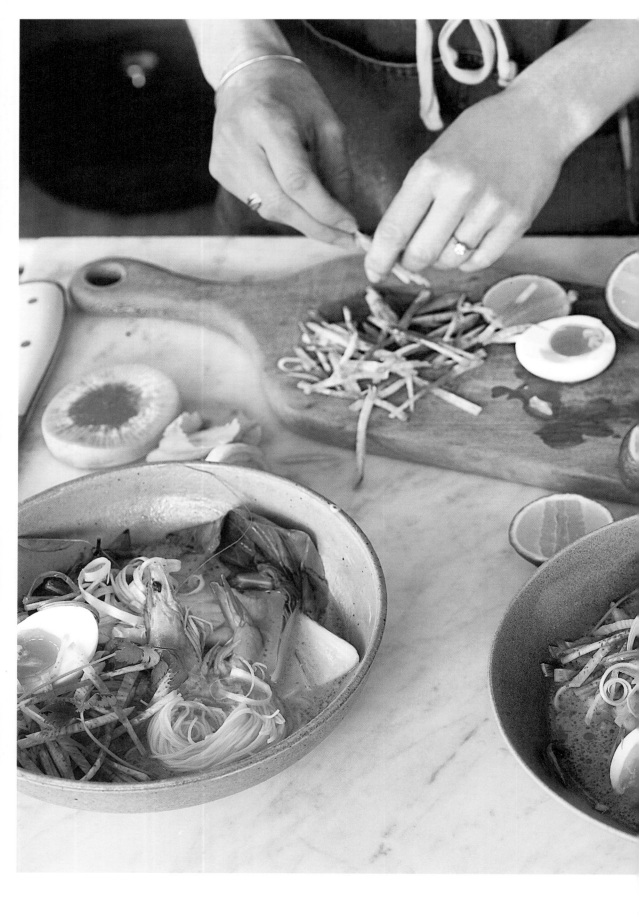

Chicken, chard and barley broth

Working in an industry in which we are constantly seeking ways to make food jump off the page, it's easy to forget about the unsung heroes at the base of a great dish, and a well-made broth is one such demure beauty. Using a whole chicken for this recipe might seem extravagant, but it makes for the most light and delicious broth, and once you shred the chicken off the carcass you can use it not only in the soup but for all manner of midweek meals, from mustard-slathered chicken sandwiches to chunky Caesar salad. *Serves 6*

1 chicken, about 1.4kg
2 carrots
1 onion, peeled and halved
2 celery sticks
1 tsp black peppercorns
2 bay leaves
200g pearl barley, rinsed
1 bunch rainbow chard,
 kale, cavolo nero
 or spinach
1 small leek, trimmed and
 sliced into 1cm rounds
Flaky sea salt and freshly
 ground black pepper

FOR THE BASIL GREMOLATA
1 small bunch basil
1 plump garlic clove, peeled
 and finely chopped
Zest of 1 lemon
4-5 tbsp extra virgin
 olive oil, plus extra
 to drizzle

First pick the leaves from the basil for the gremolata and put them under a damp piece of kitchen paper. Set aside the stalks.

Put the chicken into a large saucepan or casserole just big enough to fit it snugly, and pour in enough cold water to cover it by 4cm. Add the carrots, onion, celery, peppercorns, bay leaves, reserved basil stalks and a pinch of salt. Bring the liquid to the boil, then partially cover with a lid and simmer for 1–1½ hours, until the chicken is tender and can be easily shredded from the carcass.

Remove the pan from the heat and strain the stock through a colander into a large bowl; discard the cooked veg. Set the chicken aside to cool, then pour the strained liquid back into the pan and continue to simmer over a medium heat for a further 30–45 minutes, or until you are happy with the depth of flavour, remembering that as you reduce it, the stock will intensify.

While the stock is simmering, put the barley into a small pan and cover it with about 5cm of the hot stock. Season with salt. Cook for 25–30 minutes (check the packet) or until al dente, topping up with more stock if it dries out.

Once the chicken is cool enough to handle, shred the meat off the bones. Reserve about 300g for the soup and save the rest in an airtight plastic container for another recipe.

Set aside four (or more) of the prettiest and smallest chard leaves. Separate the the remaining chard leaves from their stalks, then chop the stalks into 2cm pieces and chiffonade the leaves (see page 21) to make 3cm-wide ribbons.

Now make the gremolata. Bash the basil leaves with a pestle and mortar, along with a pinch of salt. Add the garlic, lemon zest and olive oil and bash to a rough paste. Adust the seasoning to taste.

Taste and season the stock at this point, and don't be shy with the salt. Strain again for extra clarity, discarding any unwanted bits. Add the chard stalks and leek to the stock and simmer for 3 minutes. Add the chard ribbons and whole leaves, and simmer for 1 minute more. Fish the whole leaves out with some tongs and set aside.

To serve, place some shredded chicken in six soup bowls. Pile a generous spoonful of the cooked barley on top. Ladle in the broth, then use the tongs to share out the leek and chard ribbons. Finish each bowl with one of the whole chard leaves draped around the edge, a twist of black pepper, a generous dollop of the gremolata and a drizzle of oil.

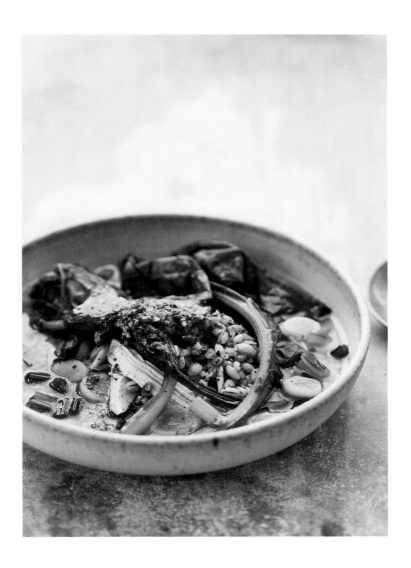

Tuna and crispy kale rice bowls

The Hawaiian-inspired 'poké bowl' – a colourful bowl of rice and vegetables topped with marinated fish – hit the global food scene relatively recently. As a long-time supporter of the Japanese chirashi (in which seasoned sushi rice gets topped with slices of sashimi), poké bowls are bang up my street. My version is a hybrid of the two, perfect as a one-bowl light lunch with friends. *Serves 2 as a main course*

PICKLED GINGER 'ROSES' To make a quick ginger rose, simply gather a few slices of pickled ginger on top of one another in your fingers and twist them into a circle, before tucking them into the bowl.

190g sushi rice
200g kale, a mixture
 of purple and green
2½ tbsp sesame oil
1 tbsp sesame seeds,
 plus extra to serve
8 radishes, trimmed
200g good-quality raw tuna
2 tsp soy sauce
1 tsp rice wine vinegar
4 spring onions,
 trimmed and cut into
 3mm diagonal slices
Flaky sea salt

FOR THE RICE SEASONING
2½ tbsp rice wine vinegar
1 tbsp mirin
1 tbsp sugar

TO SERVE
1 ripe avocado, halved
2 tbsp pickled ginger
Wasabi (optional)

Wash the sushi rice thoroughly in cold water to remove the excess starch. When the water runs clear, drain well. Transfer to a small saucepan, add 300ml water and leave to soak for 30 minutes. Bring to the boil, cover with a lid and simmer on a very low heat for 10–12 minutes. Once the rice is cooked, remove from the heat, place a clean tea towel under the lid and set aside for 10 minutes.

Preheat the oven to 120°C/Fan 100°C/Gas ½.

Meanwhile, combine the rice seasoning ingredients in a bowl, stirring to dissolve the sugar.

Use a wooden spoon to spread the rice out in a medium non-metallic dish to allow it to cool, but don't scrape up any rice that's stuck to the bottom of the pan. Stir the seasoning through the rice, separating the grains as you go.

Tear the kale from its thicker stalks and spread it out on a baking tray. Toss with 1 tablespoon of sesame oil, the sesame seeds and a pinch of salt. Place in the oven for 30 minutes, or until crisp and partly golden.

Heat a small sauté pan, add 1 tablespoon of oil and, when it's hot, add the radishes. Cook for 6–8 minutes, tossing every so often, or until slightly coloured and wrinkled.

Before serving, cut the tuna into 1.5cm cubes and place in a bowl. Add the soy sauce, vinegar and ½ tablespoon of oil and toss with half the spring onions. Adjust the seasoning to taste.

Divide the rice between two bowls and add the roasted kale (I like to show off its pretty ribs by perching some of the best bits on the edge of each bowl). Add the radishes and place the tuna somewhere in the middle. Thinly slice the avocado widthways in its skin and then carefully scoop out with a spoon and put in the bowl, keeping the slices together (see page 29 for more guidance). Scatter some extra sesame seeds and the remaining spring onions over the top and add a pickled ginger rose (see opposite page). Serve with wasabi, if you like.

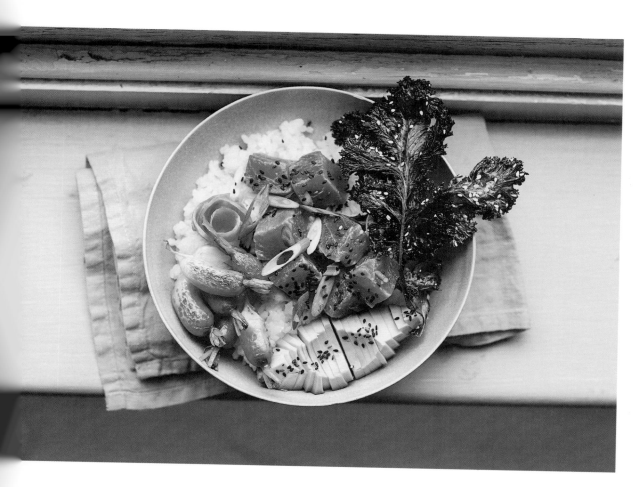

Spring orzo stew with chunky almond pesto

This celebration of springtime greens is the sort of speedy supper that is wonderful when the evenings get longer and the promise of summer is in sight. Orzo is a brilliant pasta to have in your store cupboard as it cooks quickly in a soup, absorbing all the flavours from the broth.

Make sure you use a good-quality stock and avoid overcooking the vegetables; you want them to remain vibrant and green. The pesto isn't strictly essential, but it adds a crunchy texture. *Serves 4*

MAKING ASPARAGUS RIBBONS You can use a Y-shaped peeler to create fine ribbons from asparagus. Lay each spear flat on a board and run your peeler along it lengthways to make ribbons. This is not only a lovely means of presenting asparagus, but a delicate way to eat it raw.

WARMING UP SERVING BOWLS To warm your bowls speedily before serving, boil the kettle and fill them with water. Leave for 2-3 minutes, then empty and dry the bowls before ladling in the stew.

50g butter

2 small leeks, trimmed and
sliced into 2cm rounds

1 bunch spring onions,
trimmed and chopped

1 litre good-quality
vegetable or chicken stock

120g orzo pasta

2 baby gem lettuce, halved
lengthways

100g fresh or frozen peas

100g broad beans, podded
and skinned (see page 110)

4 asparagus spears, shaved
lengthways into ribbons
(see opposite page)

20g pea shoots

Flaky sea salt and freshly
ground black pepper

FOR THE CHUNKY ALMOND PESTO

1 handful basil leaves

1 garlic clove, peeled
and roughly chopped

3 tbsp extra virgin olive oil

15g Parmesan, finely grated

25g blanched almonds,
lightly toasted and
roughly chopped

Melt the butter in a medium saucepan over a medium–low heat. Add the leeks, spring onions and a pinch of salt, and sweat for 5 minutes, stirring regularly. Pour in the stock, bring to a simmer, then tip in the pasta. Cook for 6 minutes, then add the lettuce and peas. Cook for a further 1–2 minutes, until everything is tender and the orzo is al dente. Season with salt and pepper, then stir in the broad beans.

In the meantime, make the pesto by roughly pounding the basil with the garlic and a pinch of salt in a pestle and mortar, leaving some of the leaves barely bashed. Add the olive oil and the Parmesan then stir through the almonds.

Ladle the stew into four bowls. Add a dollop of the pesto and top with the asparagus ribbons and pea shoots; I use my fingers to tease them into an overlapping bundle on top of the bowls.

Courgette, pancetta and lemon spaghetti

One of the things I wholeheartedly admire about Italian cooking is the absolute disdain for messing with the classics, so I do feel a little guilty for sneaking fine threads of courgette into this spaghetti dish. There are a few rules I strictly abide by when cooking pasta, however. Heavily salting the pan of water is essential for properly seasoned pasta – it should be as salty as the sea. Starch is your friend: it will emulsify the sauce, so you don't want to rinse the pasta after cooking. For the same reason, you should always scoop a mugful of water from your pan of cooking water before draining so that it can be added later. Once you've drained the pasta, return it to the pan with extra fat (butter, olive oil or bone marrow) and as much reserved pasta water as is required to loosen it, then toss it in the sauce. *Serves 4*

CHOOSING PANCETTA I like to buy a chunk of pancetta and cut it myself to get the cubes exactly the size I want; it also means you can source higher-quality meat.

TAMING SPAGHETTI When we style spaghetti at a photo shoot, we often arrange it into nests to make a neater portion. I've given instructions for doing this in the method below, but feel free to use tongs to just pile it into your pasta bowls.

300g spaghetti
2 courgettes, trimmed
1 tbsp olive oil
250g pancetta, cut into
 1cm cubes
2 plump garlic cloves,
 peeled and finely chopped
Finely grated zest of
 1 lemon plus the juice
 from ½
1 knob butter
100g Parmesan, grated
About 1 tsp coarsely
 cracked black pepper
10g fresh marjoram or
 oregano leaves

Bring a large pan of salted water to the boil. Add the pasta and cook according to the packet instructions, setting a timer for 1 minute less than the cooking time.

In the meantime, use a julienne peeler or a spiraliser to make thin strips or spirals from the courgettes. Alternatively, use a mandolin or vegetable peeler to make long ribbons, then slice them into 2mm strips. Set aside.

Place the olive oil in a sauté pan over a medium heat. When hot, add the pancetta and fry for 3 minutes, or until golden. Add the garlic and cook for a further 1–2 minutes (just enough to soften but not brown). Stir in half the lemon zest and set aside.

When the pasta is almost done (fish out a strand and check if it's al dente), scoop out about half a mugful of the pasta water and set it to one side. Drain the pasta in a colander.

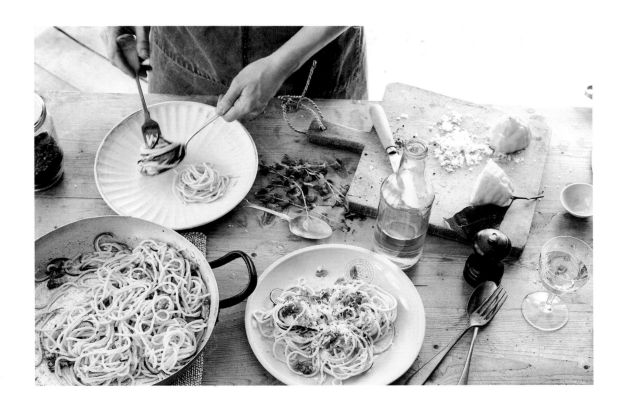

Add the butter to the pancetta mixture and return the pan to the heat. Pour in most of the pasta water and the lemon juice, then add the pasta and courgettes. Use tongs to stir everything around and coat well. Add more of the pasta water if it needs more moisture. Finally, stir in half the Parmesan, a pinch of the black pepper and a few of the herb leaves.

I like to serve pasta in wide, shallow bowls so the 'nest' arrangement can be seen to best effect. To achieve this, use tongs or a fork and spoon to twirl it in the same way as you would a mouthful of pasta before eating it. Pour some of the liquid from the pan over the top, add a little extra Parmesan, then the rest of the lemon zest, herbs and black pepper.

Squash with Parmesan custard

This warming autumn dish pairs squash with a couple of its perfect partners – sage and a rich Parmesan sauce. I usually look for interesting varieties of squash, like 'delicata' with its tender skin and sweet flesh, but butternut is readily available and works just as well. Where possible I avoid the fussy process of peeling squash – often the skin adds its own beauty to the finished plate.

In early autumn, when squash is in season, the last tomatoes will be available and add sweet, acidic grace thanks to the slow roasting, which coaxes out all their flavour. *Serves 4*

PARMESAN SHAVINGS You can shave Parmesan in various different ways. With the recipe below, thin shavings from a Y-shaped peeler make a strong visual impact, without melting straight away.

8 baby plum tomatoes,
 halved lengthways
2 tbsp olive oil, plus
 extra to drizzle
750g squash (delicata,
 acorn, onion, butternut or
 any other type you fancy)
15 sage leaves
250ml single cream
2 egg yolks
100g finely grated Parmesan,
 plus 30g shaved
Flaky sea salt and freshly
 ground black pepper

Preheat the oven to 200°C/Fan 180°C/Gas 6.

Place the tomatoes in a large baking tray. Drizzle with 1 tablespoon oil, toss to coat and sprinkle with salt and pepper.

Slice the squash in half lengthways, scoop out the seeds, then slice the flesh into half-moon shapes about 7mm thick. Add to the tray with the tomatoes. Don't worry if the slices overlap slightly; you want some parts to caramelise on the bottom of the tray and the rest to stay soft, for a mixture of textures. Drizzle with another tablespoon of oil and season well. Pop into the oven for about 20 minutes, then turn the squash over. Add the sage and return to the oven for a further 20 minutes. The squash should be tender and lightly golden and the tomatoes should have wrinkled and gone a deeper shade of red. Set aside.

While the squash and tomatoes are cooking, heat the cream until just below boiling point in a small saucepan. Place the egg yolks in a bowl, pour a small amount of the hot cream over them and whisk vigorously. Add the remaining cream, then stir through the grated Parmesan. Return the mixture to a low heat and whisk constantly until thickened, about 5 minutes.

I like to serve this in shallow bowls, pouring the custard in first, then alternating squash slices with tomatoes. Finish with a few sage leaves and a final tomato on top, then add an extra drizzle of olive oil, some black pepper and a few shavings of Parmesan. A bit of crusty bread on the side is good too.

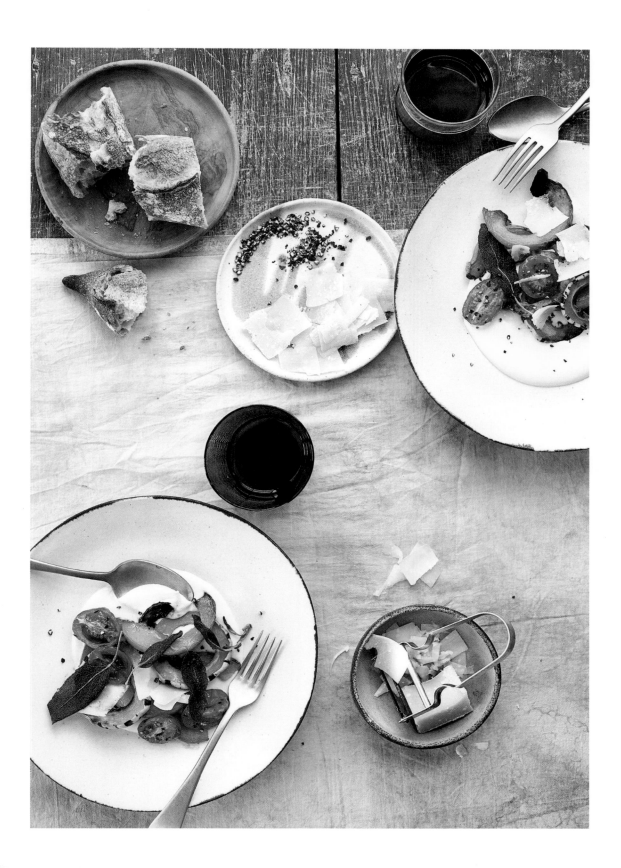

Parmesan polenta with wild mushrooms

The term 'hug in a bowl' is a bit of a cliché, but forgive me if I can't find a better description for this comforting autumnal dish. Polenta requires bold flavours to pique its interest. Plenty of Parmesan and a good stock are often enough but these slow-cooked sticky shallots and earthy wild mushrooms really up the intensity. *Serves 2 as a main, 4 as a light lunch*

SEASONING A STOCK Don't season your stock before reducing it - the saltiness will be concentrated as the liquid boils away.

SKINNING SHALLOTS A quick trick for skinning shallots when you are doing a big batch like this is to place them in a heatproof bowl and pour in enough boiling water to submerge them. Leave them for 2-3 minutes, then plunge them into cold water and use a paring knife to peel the skins away with ease.

3 tbsp olive oil
1 tbsp butter
8 shallots, peeled and
 halved lengthways to
 keep the base together
450-600ml vegetable
 or chicken stock
100g fine polenta
60g Parmesan, finely grated
1 small bunch flat-leaf
 parsley, finely chopped,
 plus extra for sprinkling
220g mixed wild mushrooms,
 brushed clean, larger
 ones halved lengthways
 through the stem
1 plump garlic clove, peeled
 and finely chopped
Zest and juice 1 lemon
Flaky sea salt and freshly
 ground black pepper

Place 1 tablespoon of olive oil plus the butter in a non-stick sauté pan – one that is just large enough to fit the shallots in a single layer – over a medium–low heat. When the butter is foaming, add the shallots cut-side down and leave to cook without moving them for 15–20 minutes, until golden brown.

Add 50–75ml of the stock (enough to give a 1cm depth of liquid) and pop a lid on the pan (or improvise with a plate if necessary). Cook for a further 15 minutes, or until the shallots are very soft. Remove the lid and simmer to reduce the stock until the shallots are golden and sticky.

Meanwhile, put 400ml stock in a medium saucepan and bring to a simmer. Pour in the polenta in a stream. Remove from the heat and whisk vigorously to avoid lumps developing. Return to a low heat and let bubble for 5–6 minutes, adding an extra 100ml stock if it gets too dry. At the end of the cooking time, stir in half of the grated cheese and some of the parsley.

Put 2 tablespoons of olive oil into a large frying pan over a medium–high heat. Once hot, add the mushrooms. You might have to cook them in batches: you don't want to crowd the pan when you are cooking or the water will seep out and you won't get a golden brown finish, which is what we are going for here.

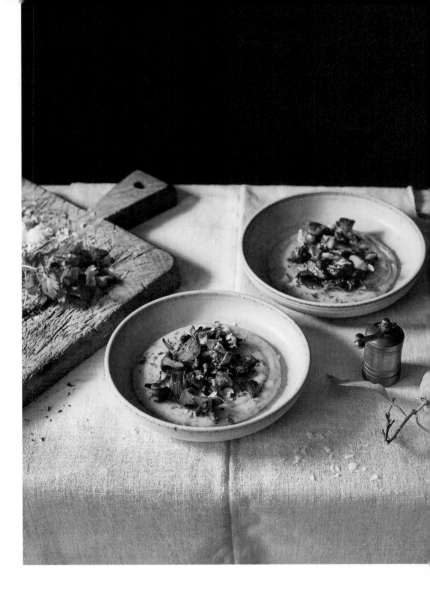

Cook the mushrooms for 2–3 minutes, tossing from time to time. Add more oil if they look like they are drying out. Season (never salt mushrooms too early, as this will encourage the water to escape), add the garlic and fry for a further 2 minutes, until the mushrooms are golden brown. When they are ready, stir in the remaining parsley and the lemon juice.

Use a ladle to divide the polenta between shallow bowls or plates. If you're going for plates, use the back of the ladle to smooth the polenta into perfect circles; it should be just thick enough to allow this. Add the mushrooms, shallots, a few sprinkles of parsley, some black pepper, the lemon zest and the remaining cheese. Serve immediately.

Spiced coconut lentils with spring onion and cumin pancakes

This recipe combines two staples from different eras of my
cooking life. The coconutty lentils are a brilliant weeknight
dinner after a busy working day; wholesome and filling, using
ingredients foraged from the cupboard. The pancakes, on the
other hand, hark back to my student days, when I couldn't
live without carbs and these were just about the cheapest way
of getting them! They work a treat for scooping up the lentils.
I sometimes swirl the batter around the pan to make them
into really thin and crispy crêpes (use an extra 150ml water
if you want to try this). *Serves 6*

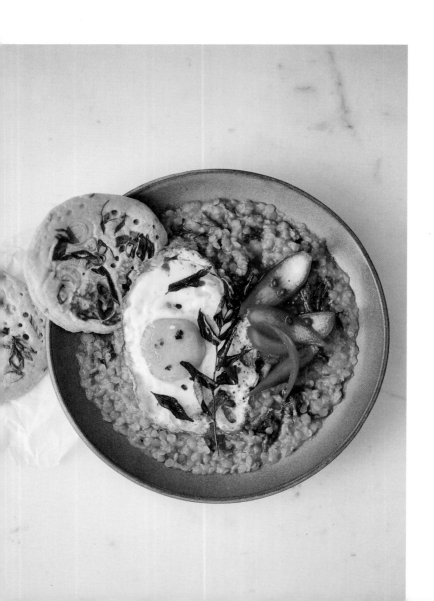

3 tsp coriander seeds

3 tsp cumin seeds

Olive oil, for frying

2 onions, peeled and
 finely chopped

3 garlic cloves, peeled
 and crushed

1 tsp ground turmeric

1 tsp red chilli flakes

1 × 400ml tin coconut milk

750ml vegetable stock

300g red split lentils

100g spinach

Flaky sea salt and freshly
 ground black pepper

Pickled red onion or
 cabbage (see page 125),
 to serve

FOR THE PANCAKES

225g gram (chickpea) flour

1 tsp fine sea salt

1 tsp baking powder

2 tsp cumin seeds, toasted

300ml sparkling water

2 spring onions, trimmed
 and sliced

FOR THE EGGS

10 curry leaves

6 eggs

Toast the coriander and cumin seeds in a dry frying pan over a low heat for 1–2 minutes, then grind until fine using a spice grinder or pestle and mortar.

Heat 2 tablespoons of olive oil in a large pan, add the onions and garlic and sweat, with the lid on, over a low heat for 7 minutes. Add the ground seeds, along with the turmeric and red chilli flakes and cook for a further 2–3 minutes. Pour in the coconut milk and stock, bring to a simmer for 10 minutes, then add the lentils. Simmer for a further 15 minutes while you make the pancakes.

To make the pancakes, put the flour, salt, baking powder and cumin seeds in a bowl and whisk together. Add the sparkling water and whisk to combine. You want a thick batter, like the one used to make American-style pancakes. Stir in the spring onions.

Heat 1 teaspoon of olive oil in a large, non-stick frying pan. Once hot, add a small ladleful of the batter, and another if you have the space. Cook for 2–3 minutes, or until the top has set, then flip over. Cook for another 1–2 minutes, then set aside on a warmed plate with baking parchment between each pancake. Repeat this step, adding a little more oil if necessary, until you have 6–8 pancakes and all the batter has been used up. Keep the frying pan handy.

Now make the eggs. Heat 1 tablespoon of olive oil in the frying pan for about 1 minute. Add half the curry leaves, which will quickly crisp up and flavour the oil. Crack in three of the eggs (take care, as the oil might spit), and cook for about 2 minutes, or until set to your liking. The edges should be crisp. Season with salt and pepper then set aside on a baking tray while you cook the second batch of eggs and curry leaves in the same way.

Stir the spinach through the lentils until just wilted.

To serve, ladle the lentils into six bowls, add a fried egg to each one and put some of the crispy curry leaves on top. Place 2–3 tablespoons of the pickled onion or cabbage on one side. Serve the plate of pancakes alongside.

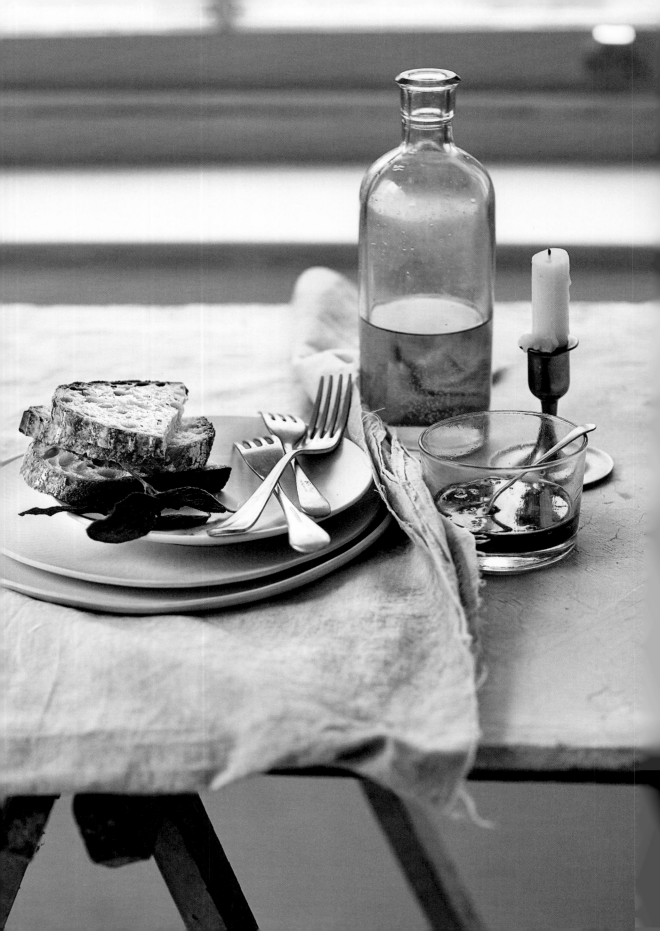

Small Plates

The notion of 'small plates' is a relatively new one
– it's about beautiful presentation that shows off a
special ingredient or technique. Small plates represent
a great opportunity to experiment with your cooking,
using wickedly rich or extravagant ingredients to create
a tiny masterpiece of flavour and style.

There are no strict rules, but the ideal is to focus
on two, or even three, components that perfectly
complement each other. These might be a snow-white
ball of burrata with lightly macerated cherries and
a dusting of pistachio dukkah (see page 207), or steak
tartare, made from the best sirloin fillet, topped with
flakes of aged Parmesan and a crispy-herb vinaigrette
(see page 228). I serve these dishes as light lunches or
simple starters, or if I am feeling more ambitious, I
make a selection as 'tapas' so everyone can try a few
mouthfuls of each.

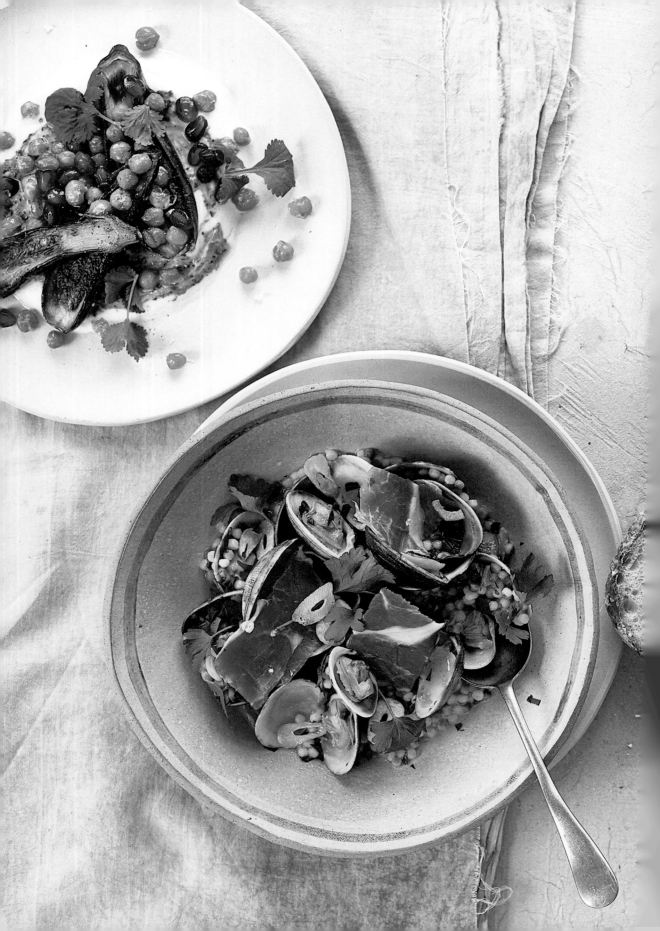

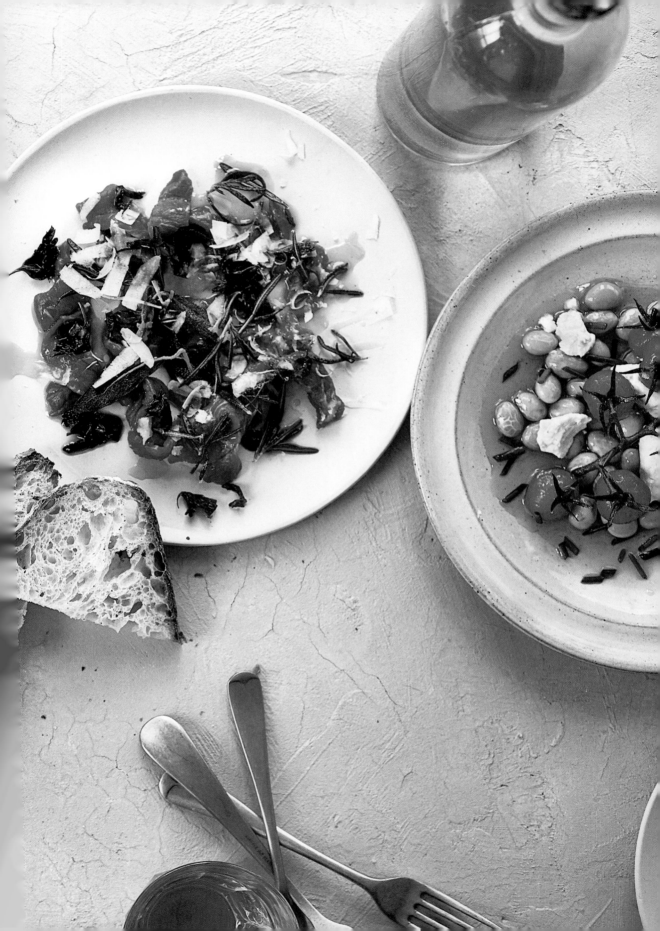

Burrata with pistachio dukkah and cherries

Since burrata left the confines of Italy's 'heel' region of Puglia, there's been no stopping this oozy, creamy alternative to mozzarella. Burrata is extremely versatile, working well in both savoury and sweet contexts or, as in the case of these lightly macerated cherries, a bit of sour-sweetness.

This elegantly understated summer starter gets garnished with a generous dusting of homemade dukkah, a traditional Egyptian spice and hazelnut blend. I make mine with pistachios and black sesame seeds, leaving it textured and chunky; there's always a batch on the go in my kitchen for sprinkling over soups, flatbreads, dips and salads. The quantities given make more dukkah than is required for this recipe, but once you taste it, you'll be sprinkling it on everything. You can store it in a jar for a month or so – the flavour will dull with time, but you can refresh it by lightly toasting it in a dry pan. *Serves 4*

200g burrata
A few fresh basil leaves
Extra virgin olive oil,
 to drizzle

FOR THE CHERRIES
200g cherries, halved
 and stoned
2 tbsp apple cider vinegar
1 tsp caster sugar
A pinch of flaky sea salt

FOR THE DUKKAH
80g shelled pistachios,
 toasted
2 tsp cumin seeds, toasted
2 tsp coriander seeds,
 toasted
40g mixed white and black
 sesame seeds
1 tsp flaky sea salt

Start by macerating the cherries. Toss them in a bowl with the vinegar, sugar and sea salt. Chill for at least 30 minutes.

To make the dukkah, coarsely chop the toasted pistachios, then pulse them in a food processor until roughly and unevenly chopped. Decant into a bowl. Put the cumin and coriander seeds into a spice grinder, add half the sesame seeds and grind to a powder. Add to the pistachios. Stir in the remaining whole sesame seeds and the salt and mix well. Place in a jar until needed.

Divide the burrata between four serving plates. I like to tear it open at the top so that some of the oozy centre is on show. Add the macerated cherries and sprinkle with the dukkah and basil leaves. Drizzle with a swirl of olive oil and serve immediately.

Skinned tomatoes with borlotti and goat's curd

I love the simplicity of this dish, which is mostly about how to transform your average cherry tomato into a more delicate mouthful of flavour. I'll admit that skinning the tomatoes is a little fiddly, but the effort translates into silky-sweet spheres without any of that tough skin standing in the way.

For the best results start making this the day before so that the tomatoes can marinate properly overnight. If you want to make this even fancier you could scatter it with white crab meat. *Serves 4*

SKINNING TOMATOES Don't use overly ripe tomatoes as you want them to retain their shape after they're plunged into boiling water. I try to keep some of the tomatoes on the vine for presentation, but don't fret if they fall off during the skinning process.

300g cherry tomatoes on
 the vine
5 tbsp extra virgin olive oil
300g borlotti beans, podded
75g goat's curd
Flaky sea salt and freshly
 ground black pepper
A few snippings of chives,
 to garnish

Take some of the tomatoes off the vine but try to keep their green 'hats' on. Leave the rest grouped on the vine for presentation purposes. Using a sharp knife, make a 5mm cross in the base of each tomato. Place in a heatproof bowl. Fill another bowl with water and ice. Pour boiling water over the tomatoes and leave for 45 seconds. Using a slotted spoon, transfer them to the iced water. Peel off the skins, trying to keep some of the little 'hats' and groups intact. Transfer to a dry bowl, season generously with salt and gently mix with 3 tablespoons of olive oil. Cover with cling film and chill overnight.

The next day, bring a pan of salted water to the boil and simmer the borlotti beans for 30–40 minutes or until tender (this can vary depending on how fresh the beans are). Drain, decant into a bowl, season well and toss with 2 tablespoons of oil.

While the borlotti are cooking, remove the tomatoes from their juices, transfer them to a separate container and place them back in the fridge. Let the juices come to room temperature (the oil will have hardened), then when you're ready to serve, gently toss the cold tomatoes in the juices, stir through the borlotti and divide between four plates. Dot a few dollops of goat's curd around the plate and scatter with black pepper. Snip the chives over the top.

A note on small plates

Plating up efficiently requires a good mise en place so do 'cook clean' and make sure your surface is clear when it's time to serve. Check that you have all the different elements at the ready (including garnishes and seasoning) and keep some kitchen paper handy too, to clean up any drips or spillages.

Try not to overcrowd your small plates, as a bit of negative space is an excellent way of showing off the form of the food itself. High-end restaurants play on this idea, often serving tiny morsels of food on vast plates. I would suggest steering clear from this at home, to avoid the risk of looking incredibly pretentious – and the unnecessary washing up. Do take a look at the compositional advice on page 63, however, and remember the 'rule of three'.

I find unpatterned and block-coloured plates work best for serving this style of dish, where there's already a lot going on visually. Contrasting the colours of the food with the plate can also help to highlight some of the hero elements in the dish. For the photograph of the beef tartare on page 229, for example, I opted for a black matte plate to bring out its colours. For the wild garlic pasta on page 214, on the other hand, I opted for a paler plate to emphasise its daintiness.

A dish always has a 'best side' visually (like some of us humans!), usually the angle from which it was plated, and ideally each plate should be facing the right way when it's placed on the table. Maybe this seems like excessive attention to detail, but it is very much the kind of thing that a chef will consider in order to create the perfect tableau for their creation.

Seasonality and quality are at the heart of the small plates that feature in this chapter, so buy the best you can afford, and purchase your produce at the height of its season – the flavour will be far superior and the colours more vibrant.

211

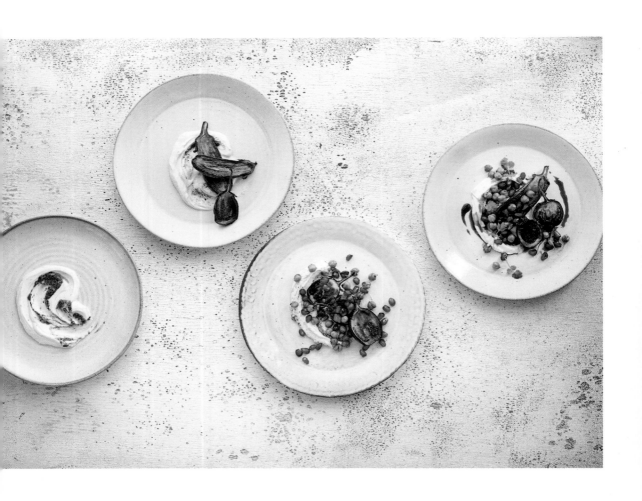

Blackened aubergines with zhoug and garlic-roasted chickpeas

Zhoug is an endlessly versatile condiment. A Middle Eastern herb and chilli paste, it adds a grassy kick of heat to grilled meats or, in the case of this starter, gives some thick yoghurt a spiky lift. Using baby aubergines instead of standard ones speeds up the cooking process, enabling you to char them quickly in a pan until the inside is soft and the outside crisp and dark.

Garlic-roasted chickpeas add crunch to the plate and can also be scattered over soups, salads or dips, or you could just munch them as a snack straight from the tray, as I inevitably do.

I usually serve this on individual plates, but it also works well on a big serving platter, the aubergines topped with dollops of the yoghurt and the pomegranate seeds and chickpeas scattered over the top. *Serves 4*

4-6 baby aubergines
 (about 275g)
Flaky sea salt

FOR THE CHICKPEAS
1 × 400g tin chickpeas,
 drained
4 garlic cloves, crushed
4 tbsp olive oil

FOR THE ZHOUG
30g coriander leaves,
 reserving a few to garnish
20g flat-leaf parsley leaves
1-2 green chillies, deseeded
A generous pinch of
 ground cumin
A pinch of caster sugar
2 garlic cloves, crushed
4 tbsp olive oil
2 tbsp water
Juice of 1 lemon

TO SERVE
200g Greek yoghurt
Seeds from ½ pomegranate
1-2 tbsp pomegranate
 molasses, to drizzle

Preheat the oven to 220°C/Fan 200°C/Gas 7.

Pat the chickpeas dry with kitchen paper. Place in a baking tray, add the garlic and 2 tablespoons of the oil, then toss. Sprinkle with salt and roast for 30 minutes, turning from time to time, until golden.

Meanwhile, place all the zhoug ingredients in a food processor with a generous pinch of salt and whizz to a fine paste. It makes more than you need for this recipe but you can store it in ice-cube trays in the freezer, or in a jar in the fridge with a layer of olive oil poured on top for 3–4 days.

Halve the aubergines, place in a bowl and toss with the remaining 2 tablespoons of oil and a generous seasoning of salt. Heat a large, heavy-based frying pan, add the aubergines flesh-side down and fry for 3–4 minutes on each side, or until dark and golden.

To serve, dollop a quarter of the yoghurt on each plate and stir ½ tablespoon of the zhoug through it. Place two or three aubergine halves on top, overlapping them, then scatter with some pomegranate seeds. Drizzle over the pomegranate molasses and garnish with the remaining coriander sprigs and the garlic chickpeas.

Windowpane pasta with wild garlic pesto

Making fresh pasta is surely the cheapest form of therapy. From the kneading of the dough to the slow and steady feeding of the sheets through the machine, it takes a little time and patience but it always brings a sense of calm to the kitchen. I like to keep the sheets wide and I don't neaten the edges, as a reminder that they're handmade. Adding fresh herbs to the dough to mimic pressed flowers isn't strictly necessary, but it makes the pasta extra ethereal.

When wild garlic season is in full swing, I love to serve the pasta generously coated in a wild garlic pesto, but feel free to switch this up for pesto made from basil and a couple of garlic cloves the rest of the year. *Serves 6*

400g '00' pasta flour,
 plus extra for dusting
4 eggs
1 tbsp olive oil
1 small bunch flat-leaf
 parsley, leaves picked

FOR THE WILD GARLIC PESTO
100g wild garlic (if it
 has flowers reserve
 these for garnishing)
75g Parmesan, grated
50g hazelnuts or pine
 nuts, toasted
100ml extra virgin olive oil

Put the flour on a board or a meticulously clean work surface. Make a well in the centre, crack in the eggs and add the oil and whisk the two of them together with a fork until smooth. Then, using the tips of your fingers or the fork, gradually work the flour around the well into the eggs, until the mixture comes together and forms a smooth dough. Alternatively, place the ingredients in a food processor and pulse until it forms coarse breadcrumbs. Use your hands to bring the crumbs together to form a dough, then decant onto your surface, and start kneading.

Kneading pasta dough does require a bit of work but don't skip it, as your goal is to develop the gluten, which will result in a beautiful springy dough. Press the dough down, push it away and keep it moving as much as you can for at least 5 minutes or until it becomes springier. Wrap it in cling film and rest in the fridge for at least 30 minutes.

You will need a pasta machine to make the pasta sheets, no matter how many chefs and food writers say that a rolling pin will do. Once the dough has rested, remove from the fridge and divide into six equal parts, then cover with a damp tea towel. Dust your work surface with more flour and use a rolling pin to roll out the first part of dough to about 1cm thick. Set your pasta machine to its widest setting and thread the dough through. Fold it up on itself and feed it through twice more. Lower the setting to a narrower one, then feed the dough through the machine again. Repeat this process through all the notches on the pasta machine, except the last (which is usually a bit too fine). Lay your length of pasta out and dab it with a small amount of water.

Place the herbs over the centre up to about halfway along. Now fold the pasta over the parsley then go up two notches and start feeding the pasta through again, stopping at the second-to-last notch. Hang the pasta sheet off the back of a chair or on a coat hanger while you make the rest (*see photograph overleaf*).

To make the wild garlic pesto, place all the ingredients in a food processor and whizz until quite smooth, but maintaining some variation in texture. Set aside.

Bring a very large pan of heavily salted water to the boil (if you don't have a pan that's big enough, do this in two batches). Cut the pasta sheets in half widthways and simmer for 4–5 minutes, or until al dente. Reserve a mugful of pasta water, then drain through a colander. Return the cooked pasta to the pan with the pesto and a few splashes of the cooking water. Toss gently.

Place two strips of pasta on each plate, folding them over themselves, not too neatly. The oil from the pesto will separate a little, leaving behind a lovely green oil. Spoon some of this up and drizzle it around. Garnish with the wild garlic flowers (if using) and serve.

Sweet potato gnudi

Gnudi are a pillow-like, ricotta-based relative of gnocchi. In this recipe, the sweetness from the potato is offset by the savoury depth of the mushrooms, while crunchy fried sage and rosemary add aromatic texture.

Make the gnudi the day before, allowing them to develop a crust on the outside which will ensure they hold together as they cook. A kilo may sound like an excessive amount of semolina needed for dusting, but you really want to put the gnudi to bed well snuggled in for the best results. *Serves 4–6*

500g ricotta

2 medium sweet potatoes
(about 380g cooked flesh)

1kg fine semolina

100g Parmesan, finely grated,
plus extra to serve

4 tbsp butter

4 tbsp olive oil

5 fresh rosemary sprigs

12 sage leaves

200g fresh wild mushrooms
(I use chanterelles),
brushed clean

Flaky sea salt and freshly
ground black pepper

Drain the ricotta through a sieve lined with muslin or a clean J-cloth set over a bowl, to get rid of any excess liquid. Preheat the oven to 200°C/Fan 180°C/Gas 6. Line a roasting tray with parchment.

Prick the sweet potatoes a few times with a fork and put onto the prepared tray. Roast in the oven for about 1 hour, or until a knife slides in easily. Cut a slit along the centre to let the steam out and set aside to cool right down.

Scoop the cooled flesh of the sweet potatoes into a large bowl. Mash until completely smooth, or transfer to a blender and whizz to a smooth fibreless purée. Add the ricotta, 75g of the semolina, the Parmesan, ½ teaspoon salt and a few twists of black pepper. Mix together, then taste and season further if required.

Grab a large tray (or two smaller ones) that will fit inside your fridge and scatter the remaining semolina inside. Fill a small bowl with water. Dip your fingers in the water (this will keep them less sticky) then using a tablespoon, scoop a walnut-sized amount of mixture into your hands and roll it into a sphere, making it as neat as you can. Roll this in the semolina until well coated, reshaping it if necessary with your fingers (it will be easier now that it is dusted). Repeat with the remaining mixture – you should end up with about 40 gnudi. Make sure they are all well nestled in the semolina then chill, uncovered, for 24 hours. This creates a skin that helps them hold their shape when cooking.

When your gnudi are ready, bring a large pan of salted water to the boil. Lower the heat and gently add a batch of gnudi using a slotted spoon. Cook for 4–5 minutes, or until they float to the surface. While they are cooking, clean the tray they were stored in and line it with a J-cloth (you could keep the semolina to make gnudi another day). Use the slotted spoon to fish out the cooked gnudi and transfer them to the tray. Cook the remainder in the same way.

While the gnudi are cooking, heat the butter and olive oil in a large non-stick sauté pan over a medium heat. Add the rosemary and sage and fry for 30–60 seconds, or until really crisp but not dark. Drain on kitchen paper and season. Fry the mushrooms in the pan until golden, season then use the slotted spoon to scoop them out and drain on kitchen paper, leaving behind the oil and butter. Your oil and butter will now be herb- and mushroom-infused.

Add the gnudi to the sauté pan very carefully (do this in batches) and toss gently in the butter (add more if necessary). Cook over a medium heat for 2–3 minutes, or until just golden.

Divide the gnudi between shallow bowls or plates, then drizzle the buttery pan juices over them. Top with the mushrooms and a grating of Parmesan, then with the crisp rosemary and sage.

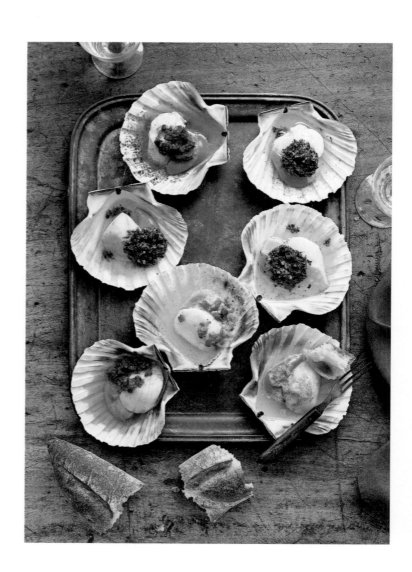

Shell-baked scallops with flavoured butters

Customising your own butter is a quick way of adding a bit of a flair to baked scallops cooked in their own juices infused with a sliver of flavoured butter. During the summer months I like to cook them in the ashy embers of a barbecue; I lay the butters out and cook the scallops to order. Don't forget to serve these with plenty of bread to soak up all the juices. The recipe below makes more flavoured butter than you need, but you can store it in the fridge and slather it on grilled fish or smooth over toast. *Serves 4 as a starter*

500g salted butter,
 at room temperature
12 plump scallops with
 coral (ask your fishmonger
 for their shells)
Flaky sea salt
1 baguette, to serve

FLAVOURINGS
3 tbsp dried seaweed
 salad (try The Cornish
 Seaweed Company)
2 rashers smoked streaky
 bacon, finely diced
 and fried until crisp
2 tbsp very finely chopped
 flat-leaf parsley leaves
2-3cm fresh turmeric root,
 grated, plus freshly
 ground black pepper
75g cooking chorizo,
 finely diced, plus 2 tsp
 olive oil and ½ tsp sweet
 smoked paprika

First make the flavoured butters. Beat the softened butter and divide it equally between five bowls. Beat a flavouring into four of the bowls, except the chorizo – leave this butter bowl plain and follow the directions below. Transfer each butter to a piece of cling film or baking parchment and roll into a log shape about 4cm in diameter, twisting the ends like a sweet wrapper to seal. Chill for at least 30 minutes.

To make the chorizo butter, heat the olive oil in a small frying pan and cook the chorizo until it releases its oil and begins to crisp. Drain the oil into a bowl and chill. Chop the chorizo into small cubes. When the oil is cold, add it to the remaining bowl of butter, along with the chorizo and paprika, mixing lightly with a wooden spoon. Roll it in cling film or baking parchment, as described above, and chill for 30 minutes.

When you're ready to eat, preheat the oven to its highest temperature. Gently clean the scallops under running water, then pat dry and return them to their shells.

Cut the chilled butters into 7mm slices and distribute among the shells. Place the shells in a roasting tray in the oven for about 6 minutes (they might need 8 if on the larger side), or until just cooked and opaque. Don't overcook them or they will become rubbery. Sprinkle with salt and serve with bread to mop up the buttery juices.

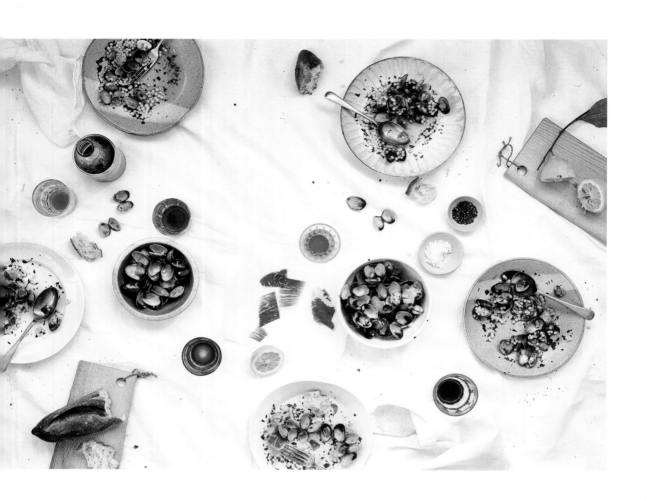

Clams with fregola and jamón

A take on surf and turf, this recipe combines jamón Ibérico and clams. A little jamón goes a very long way and rather than stirring it through the clams while cooking, I like to show it off and drape it over them at the end, adding a deliciously sweet and salty element.

Fregola, a type of small Sardinian pasta, is perfect for this recipe because its chewy texture absorbs the clam juices. Garlic chips make an excellent garnish and are a handy trick to have up your sleeve; they look rather restauranty, but they are actually super-easy to make. *Serves 4–6 as a starter*

PURGING CLAMS Most clams are purged of grit when you buy them but double-check this with your fishmonger. To purge them at home, submerge the clams in cold salted water (sea water, ideally), and leave for 30 minutes. Bivalves like clams are filter feeders, so they will expel any grit from their shells into the water. Change the water and repeat the process until there is no grit left in the bowl.

3 tbsp olive oil

2 plump garlic cloves, peeled and thinly sliced (try to ensure the slices are all the same thickness so they cook evenly)

150g fregola

1kg clams, purged and scrubbed

100ml dry white wine

20g flat-leaf parsley leaves, finely chopped, plus a few extra leaves to garnish

8 slices Ibérico ham

Lemon wedges, to serve

Put 2 tablespoons of olive oil into a small, heavy-based pan over a medium heat. Add the garlic slices and fry to a pale golden colour; this should take 30–60 seconds. Lift them out with a slotted spoon and drain on kitchen paper. Pour the oil into a small heatproof bowl and set aside.

Wipe the pan clean, fill with salted water and bring to the boil over a medium heat. Add the fregola and cook according to the packet instructions. Drain in a colander.

Put the garlic oil into a lidded pan large enough to fit all the clams and place over a medium–high heat. When smoking hot, add the clams and give them a good shake. Pour in the wine and pop the lid on. Steam the clams for about 4–5 minutes, shaking the pan from time to time, until they all open up. Use a slotted spoon to transfer them to a large bowl. Strain the pan liquid over them through a fine sieve (this will remove any lingering grit) and discard any clams that haven't opened during the cooking.

Add the cooked fregola and the parsley to the bowl and toss well. Divide between shallow bowls and drape the jamón over the top. Sprinkle with the garlic chips and a few parsley leaves. Serve with the lemon wedges and pop an extra bowl on the table for discarding the shells as you eat.

Confit salmon with citrus and fennel salad

With its sunset tones, this salmon dish makes for a bright starter or light lunch, making the most of blood oranges when they burst onto the scene in late winter. If you can't get hold of blood oranges, normal ones will work a treat too, but the colour and slight tartness of the blood variety mean they're worth tracking down. This method of cooking salmon is ideal for those who aren't so fond of its heavy and sometimes greasy aspect. Curing the fish seasons it perfectly before it goes for a gentle bathe in warm olive oil. Poaching it this way – confiting it – keeps the flesh firm and it will remain beautifully bright. Ask your fishmonger for a thick cut from the middle rather than the tail end of the salmon (in a good supermarket you'll usually find both options). *Serves 4*

USING FENNEL FRONDS It always surprises me how often people discard fennel fronds. Always hang onto them for a tufty green garnish at the end.

4 tbsp fine sea salt

2 tbsp caster sugar

2 thickly cut pieces of salmon (about 200g each), skin removed

About 400ml extra virgin olive oil, plus extra to drizzle

1 tsp pink peppercorns, lightly crushed

FOR THE SALAD

1 fennel bulb, with leafy fronds

2 lemons

1 blood orange or normal orange

2 tbsp extra virgin olive oil

Flaky sea salt

First make the curing mixture by combining the salt and sugar in a non-reactive dish. Pat the fish dry with kitchen paper, then coat thoroughly in the cure. Place the pieces side by side in the dish, uncovered, and chill for 1–2 hours.

Prepare the salad just before you are ready to cook your fish. Cut the leafy fronds off the fennel, reserving them for the garnish. Halve the fennel lengthways and remove the tough outer leaves and stalks (save them for a stock or risotto). Use a mandolin (with the guard on or wearing protective gloves) to finely slice the fennel lengthways into wafer-thin ribbons less than 1mm thick; this will ensure they curl daintily. Place them in a large bowl with the juice of one of the lemons.

Use a small sharp knife to trim the base and top of the blood orange, then slice off the skin from top to bottom, removing all the pith. Cut out the segments (see page 38 for more on this). Do the same with the lemon, but cut the flesh into 1cm pieces. Add the fruit to the fennel and toss together. Season well with salt and toss with the olive oil.

Rinse the fish in cold water and pat dry. Cut the pieces in half widthways to make four portions and set aside for 15 minutes.

Pour the oil into a saucepan that fits the salmon snugly and heat gently to 55°C – this should only take a couple of minutes. Lower the salmon into the oil and remove the pan from the heat. Leave to poach for around 10 minutes (this can take less or more time depending on how you maintain the oil temperature), returning it briefly to the heat if the temperature drops below 45°C (check the temperature regularly with a thermometer). Keep an eye on the fish to ensure that the colour isn't changing at all and it isn't turning opaque. The texture will alter to a melting butteriness, but the colour and shape should be maintained.

Drain the salmon on kitchen paper, then place the portions in the centre of four plates. Take handfuls of the salad and let them fall gently alongside the fish. You don't want it flat on the plate, so tease out some of the prettiest fennel curls and orange segments. Sprinkle with the fennel fronds and peppercorns and drizzle some oil round the edge.

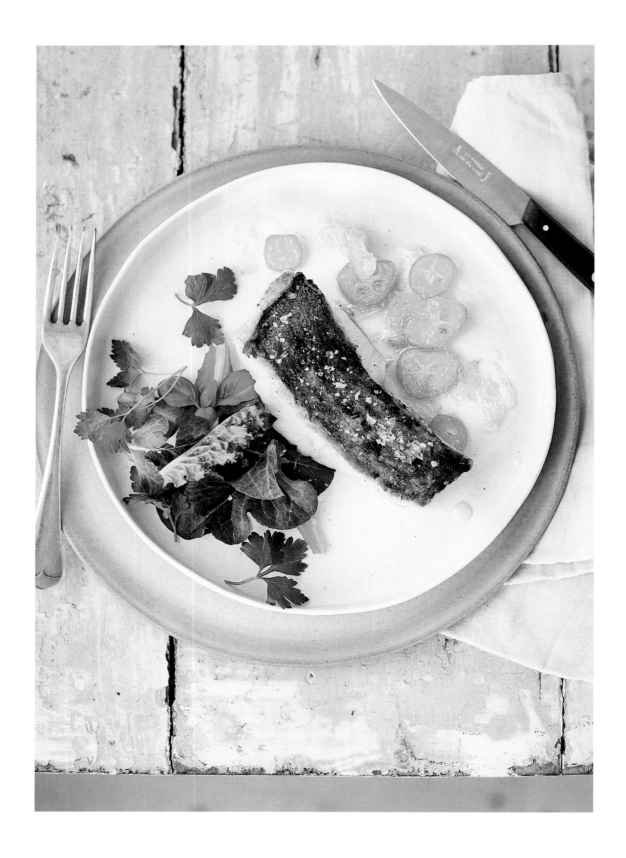

Pan-fried fish with bitter relish

When a piece of perfectly pan-fried, crispy-skinned fish lands on my plate, I know I am about to enjoy one of life's simple pleasures. Serving it this way proudly shows off the golden crust that you have masterfully accomplished and keeps it crisp rather than steaming away under its own flesh. While a squeeze of lemon would suffice, this relish gives a bittersweet lift.
Serves 4 as a starter or main course

CRISPING FISH SKIN This method for crisping up fish skin can be used for all fillets, from sea bream and bass to mackerel, mullet and hake. Just adjust the cooking time according to the thickness of the fillet. Score the skin on longer, thinner fillets as this helps prevent them curling.

4 pollock, hake, red mullet or sea bream fillets (about 125g each as a starter, or 160g each as a main)
4 tbsp vegetable oil
Flaky sea salt and freshly ground black pepper
Lightly dressed salad leaves, to serve (see page 152)

FOR THE BITTER RELISH
1 pink grapefruit, sliced into 5mm rounds then into 1cm pieces
100g kumquats, sliced into 5mm rounds
1 lemon, sliced into 5mm rounds then into 1cm pieces
150g caster sugar
100ml water
2 star anise
2 tbsp rice wine vinegar

Pat the fish dry and place skin-side up on kitchen paper on a plate and chill, uncovered, for around 1 hour. This will dry out the skin, which is essential for it to crisp.

Meanwhile, make the relish – this can be done up to a week ahead. Put the fruit into a pan of cold water and bring to the boil. Drain, repeat the process, then drain again (this removes some of the bitterness). Put the fruits, sugar, water and star anise in a pan and bring to a simmer. Cook over a low heat for 45–60 minutes, or until the fruit is tender and the liquid is sticky and syrupy. Add more water if it gets too thick. Leave to cool and stir in the vinegar. Taste and adjust to your liking.

When you're ready to cook the fish, generously sprinkle both sides of the fillets with salt. Put a heavy-based non-stick frying pan (I use a well-seasoned cast-iron pan for this) on a very high heat. Once it's very hot, add 2 tablespoons of oil. Lower two of the fillets into the pan (away from you in case the oil splashes), skin-side down, pressing them with a fish slice to make sure they get maximum contact with the pan and don't curl up. The cooking time will vary: 2–3 minutes if the fillets are thin; 6–7 minutes if they are thick. When the skin is golden, turn off the heat and flip the fish over, letting the flesh side cook in the residual heat for a few minutes (thicker fillets might need to remain on the heat for an extra 1–2 minutes). Repeat with the other fillets.

Spoon some of the relish onto four plates and place a fish fillet to the side, skin-side up. Add salad leaves and some black pepper.

Beef tartare with crispy-herb vinaigrette

Beef tartare is one of my all-time favourite dishes, but I tend to steer away from the classic French condiments, remaining true to the principle but giving it a modern upheaval. The traditional shallots and gherkins have been replaced by a crispy-herb vinaigrette and salty shavings of Parmesan. Keeping everything cold is important with tartare, so remember to chill your plates ahead. *Serves 4 as a starter*

SLICING BEEF I like to cut the beef for a homemade tartare into really thin slivers, but there's nothing wrong with cubing it. Both methods are below.

250g good-quality beef
 sirloin, thick fat trimmed
50g Parmesan shavings,
 to serve

FOR THE CRISPY-HERB
VINAIGRETTE
5 fresh rosemary sprigs
15 sage leaves,
 preferably small
1 small handful flat-leaf
 parsley, leaves picked
4 tbsp extra virgin olive oil
½ tbsp red wine vinegar
A pinch of caster sugar
Flaky sea salt and freshly
 ground black pepper

Place the beef in the freezer for 20 minutes before starting and your serving plates in the fridge.

Decide whether you want to serve the beef in thin strips or cubes. To cut thin strips, place the meat on a chopping board and slice against the grain as thinly as possible – I use a flexible fish knife for this (the grain is the direction in which the muscle fibres are aligned). Don't worry if the strips are not perfect. To cut cubes, slice the meat against the grain about 1cm thick, then cut the slices into thin strips, then into 1cm cubes. Arrange on a serving platter or four individual plates. I prefer to scatter the meat around the plate, rather than following the traditional French way of building it into a ring.

Now prepare the herbs for the vinaigrette, making sure they are bone dry or they will spit at you when they hit the hot oil. Keep the tiny leaves whole, but roughly chop the others. You want a mix of sizes. Heat 3 tablespoons of olive oil in a small, heavy-based frying pan, then fry the rosemary and sage leaves until crisp, about 30–60 seconds. Drain on kitchen paper, then fry the parsley for about 30 seconds. Drain this too.

Combine the remaining tablespoon of oil with the vinegar, sugar and a pinch of salt in a small bowl. Add most of the fried herbs, reserving a few of the best-looking leaves for garnishing.

Drizzle the vinaigrette over the beef and sprinkle on the Parmesan, a twist of pepper and a little salt. Garnish with the reserved leaves, letting some of them fall to the edge of the plate.

Big Dishes

Throwing a big meal together for a crowd can be an intimidating experience for even the most seasoned professional. On food styling shoots we are often just preparing one perfect plate of food for the camera, not attempting to produce eight of them all at the same time for a crowd of hungry mouths. The dishes that fall under this chapter heading are what I turn to when I want a plentiful spread with little fiddling and fuss; dishes packed with flavour and designed to be presented at the table to a chorus of contented 'oooohs' and 'ahhhhs'.

The Winter Mont d'Or feast (see page 235) is my go-to extravagance for colder days, usually making an appearance after Christmas when I want to keep cooking time to a minimum while still prolonging the festivities with friends. Summer months call for a quick side of salmon rubbed in a sweet and salty cure and flaked into tacos (see page 239), to be assembled at the table with a pitcher of Frozen hibiscus margarita (see page 329).

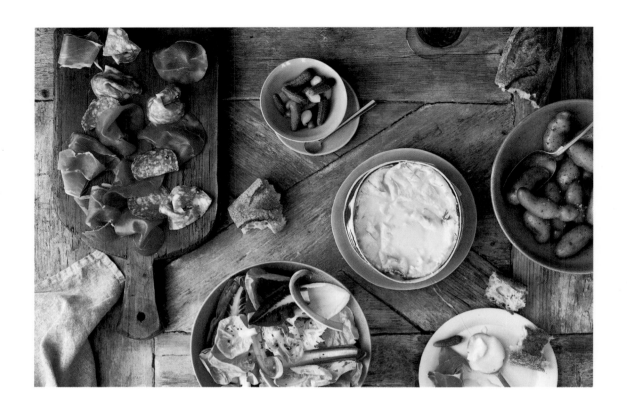

Winter Mont d'Or feast

Mont d'Or is a soft, gooey cheese from the Jura mountains that is only in season from October to March – which is just as well, as I'm not sure many of us could stomach its richness in the heat of summer. While the ripe cheese is gooey enough to scoop straight out of its box, a quick bake in the oven turns it to even more velvety glistening bliss, like a fuss-free fondue. I hesitate to call this a 'recipe', as the premise is so simple that it's practically a shopping list, but it's my go-to meal when I have limited time to prepare something and want to put on a sociable and hearty spread for friends on a cold night. This recipe serves four, but you can double or triple the quantities if feeding a crowd. *Serves 4*

PRESENTING CHARCUTERIE For everything you need to know about buying, slicing and serving charcuterie, turn to page 114.

400g new potatoes (ideally ratte or pink fir apple)
1 knob butter
1 Vacherin Mont d'Or cheese
1 garlic clove, peeled and thinly sliced
A splash of dry white wine
100g Serrano ham, finely sliced
100g cecina or bresaola, finely sliced
100g finocchiona, salami or saucisson, finely sliced
Flaky sea salt and freshly ground black pepper
1 small jar gherkins and pickled onions, to serve
1 baguette, to serve

FOR THE SALAD
½ head radicchio
1 head endive
1 head baby gem lettuce
4 tbsp extra virgin olive oil
2 tbsp lemon juice
1 tbsp Dijon mustard, or to taste

Preheat the oven to 200°C/Fan 180°C/Gas 6.

Bring the potatoes to the boil in a big covered pan of salted cold water. Boil for 10–15 minutes, or until tender. Drain in a colander, let some of the steam evaporate, then transfer to a serving bowl. Toss with the butter and some salt.

Prepare the salad leaves: trim the base of each head, separate the leaves and soak them in iced water.

Open the cheese, leaving it in the lower half of its box, and place on a baking tray. Make diagonal slits in the cheese to create a diamond pattern on the surface. Poke the garlic slices into the slits. Season with pepper, pour over the wine and bake in the oven for 10–15 minutes, until oozingly soft.

While the cheese is baking, drain and dry the salad leaves, leaving them whole to scoop up the melting cheese. Place the olive oil, lemon juice, a pinch of salt and the mustard in a small bowl and whisk together. Season with black pepper and whisk again. Toss the leaves in the dressing just before serving.

Arrange the charcuterie on a wooden board in overlapping ribbons and curls (see page 114). Decant the gherkins and onions into a small bowl. Place the cheese in the centre of the table with a spoon for scooping and all its accompaniments.

Ratatouille galette

A free-form galette is a bit of a blessing because its beauty lies in its humble imperfection. For pastry novices, it is also an excellent starting point for working with really crumbly pastry; there's none of that fiddly business of lining tart bases, you simply tuck up the sides and are good to go. Here, its rustic shape is a good contrast to the geometric precision of the vegetable filling. If your pastry gets difficult to work with at any point, just put it back in the fridge to chill. I like to serve this with wild garlic pesto (see page 214) and a simple salad. *Serves 6*

CHOOSING VEGETABLES It helps to try and find vegetables that are of a similar width, as the uniformity will ensure the tart is extra pretty.

40g unsalted butter

3 red onions, peeled, halved and thinly sliced lengthways

1 tbsp balsamic vinegar

1 courgette

1 slender aubergine

5 plum tomatoes

Extra virgin olive oil, to brush

5 fresh thyme sprigs

1 egg, beaten

Flaky sea salt and freshly ground black pepper

FOR THE PASTRY

350g plain flour, plus extra for dusting

200g cold unsalted butter, cubed

A good pinch of fine sea salt

1 tsp caster sugar

2 egg yolks

2 tbsp cold water

TO SERVE

Thyme or basil leaves

Wild garlic pesto (see page 214)

Start by making the pastry. Put the flour into a large bowl, add the butter and work it into the flour by rubbing it between your fingertips until it resembles fine breadcrumbs. Add the salt and sugar, followed by the egg yolks and water and mix together with your fingertips. Dust your work surface with flour and tip the mixture onto it. Gently bring it together with the palms of your hands until a dough forms. Have ready two large sheets of baking paper. Dust the bottom sheet with flour, then place the pastry on top. Dust the top of the pastry then cover it with the second sheet of baking paper. Roll out into a circle about 5mm thick. Chill the pastry flat while you make the filling.

Heat the butter in a medium frying pan over a low heat. Once the butter is foaming, add the onions and a pinch of salt. Cover with a lid and sweat over a low heat for 15 minutes, until the onions are really soft and sticky. Stir in the vinegar, then transfer to a bowl and leave to cool while you prepare the other vegetables.

Using a mandolin (with the guard on or wearing protective gloves), slice the courgette and aubergine into even slices about 3mm thick. Set aside in separate piles. Use a knife to slice the tomatoes 4mm thick.

Preheat the oven to 200°C/Fan 180°C/Gas 6.

Transfer the pastry to a cold baking tray and peel off the top layer of paper. Spread the cold onions over the pastry, leaving a 3cm border around the edge. Now arrange the vegetables in concentric circles on the onion, starting with the aubergine slices around the edge, overlapping them like toppled dominoes.

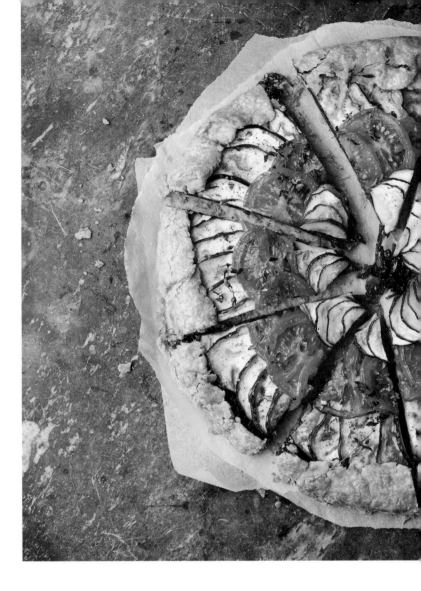

Place the tomato slices beside them, slightly overlapping the aubergine. Repeat with the courgette slices. Brush the top of the vegetables with olive oil, then dot with the thyme sprigs. Fold in the edge of the pastry to encase the vegetables. If it cracks, just press together again. Brush the edges with the beaten egg and bake for 45–55 minutes, or until golden brown with a crispy base. Dot with the fresh thyme or basil leaves and serve with the pesto alongside.

Big Dishes

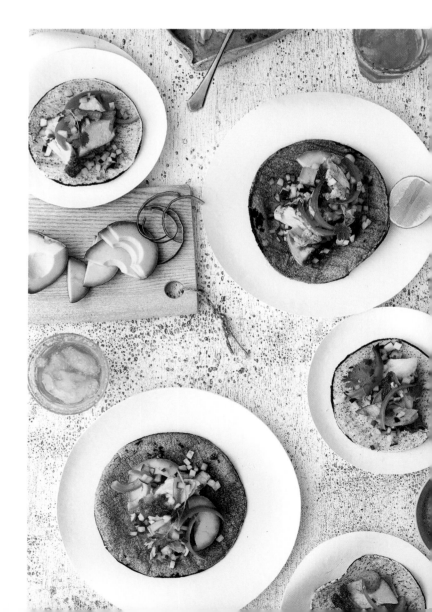

Pulled salmon tacos with coriander soured cream

With their rainbow accompaniments and piquant coriander sour cream, these tacos have 'crowd-pleaser' written all over them, and they're really speedy too. Salmon is one of the few fish that can really stand up to strong flavours and this salty-sweet rub delivers a serious punch. Serve with Frozen hibiscus margaritas (see page 329). *Serves 6*

1 side of salmon (800g-1kg),
 skin on

FOR THE RUB
3 tbsp sweet smoked paprika
2 tbsp light brown sugar
1 tbsp garlic powder
1 tbsp English
 mustard powder
2 tbsp flaky sea salt

FOR THE CORIANDER
SOURED CREAM
200g soured cream
2 fresh green chillies
1 large bunch coriander
1 pickled green chilli, or
 to taste (add ¼ at a time)
1 tbsp lime juice

FOR THE RADISH AND
CUCUMBER SALAD
½ cucumber
1 bunch radishes
1 tbsp lime juice

TO SERVE
18 small soft tacos
 (Cool Chile brand is good)
1 avocado, stoned and sliced
Pickled red onions
 (see page 125)
3 limes, halved lengthways
Pickled green chillies
Coriander sprigs

If you have time, marinate the salmon side in the dry rub 4 hours in advance. Place the salmon skin-side down in a baking tray that will fit in the fridge. Combine the rub ingredients in a bowl, then sprinkle the mixture all over the salmon flesh, covering it completely. Place in the fridge for 4 hours if possible, but 20–30 minutes will suffice.

When you're ready to cook the salmon, preheat the oven to 200°C/Fan 180°C/Gas 6. Cook the fish for 20–25 minutes.

Meanwhile, place 3 tablespoons of the soured cream in a blender with the fresh chillies, three quarters of the coriander, the pickled chilli and some salt. Whizz until smooth. Decant into a bowl, then stir in the lime juice and the remaining soured cream to taste. Add extra salt if required.

Cut the cucumber in half lengthways and use a teaspoon to scrape out the seeds. Cut the flesh into 5mm cubes and do the same with the radishes. Add both to a bowl and toss with some salt and the lime juice.

Using long tongs, toast the tacos directly over a gas hob to char them. If you don't have a gas hob, pop them in a hot griddle pan. Place the tacos in a napkin-lined basket, or tuck into a clean tea towel, to keep them warm.

To serve, place the salmon in the centre of the table and use two forks to shred it off in chunks. Offer the tacos and bowls containing the other accompaniments alongside. Garnish with the coriander.

Fancy fish pie

This fish pie is the perfect project for a cold winter Sunday, with its homemade pastry and fancy fish-scale pattern. If you aren't in the mood for creating a bespoke topping like this one, use a cookie cutter to make any shape you like on the top. Use a 24cm pie dish that's about 3cm deep to bake the pie, which gives a good ratio of pastry to pie filling and plenty of canvas area for your design. Serve it piping hot with mushy peas or a side salad. *Serves 4*

CHILLING PASTRY Keeping your pastry well chilled is essential for making the design. If my kitchen is particularly warm, I roll out the pastry then slide it onto a chopping board and into the freezer.

3 tbsp olive oil

½ fennel bulb, roughly
 chopped into small cubes
 and fronds reserved

1 large leek, trimmed and
 sliced into thin rounds

20g butter

30g plain flour

400ml whole milk

1 tsp English mustard powder

Zest of 1 lemon

100g frozen peas

125g undyed smoked haddock,
 cut into 4cm chunks

200g salmon fillet,
 cut into 4cm chunks

1 × 150g bag frozen shelled
 mussels, defrosted
 according to the packet
 instructions, or at least
 500g live mussels, steamed
 open and shelled (see
 page 177)

1 egg, beaten

Flaky sea salt and freshly
 ground black pepper

FOR THE PASTRY

300g plain flour,
 plus extra for dusting

¾ tsp baking powder

¾ tsp fine sea salt

150g cold unsalted
 butter, cubed

1 egg yolk

100ml water

First make the pastry. Place the flour in a bowl with the baking powder and salt. Add the butter and rub into the flour with your hands (or use a food processor) until you have a breadcrumb texture. Beat the egg yolk and water together, then add to the flour mixture bit by bit until a dough forms. Flatten with your hands and wrap in cling film. Chill for 30 minutes.

Meanwhile, heat the olive oil in a large frying pan. Add the fennel and leek, along with a pinch of salt, and sweat for 10 minutes over a medium–low heat. Use a slotted spoon to transfer the vegetables to a 24cm pie dish.

Melt the butter with the fat remaining in the pan, then stir in the flour and cook for a minute or so. Gradually whisk in the milk, mustard powder and lemon zest. Heat until thick and silky, whisking vigorously as it heats. When it just begins to bubble remove from the heat and season to taste.

Add the reserved fennel fronds, the peas, haddock, salmon and mussels to the pie dish and mix. Cover with the sauce and leave to cool fully (or your pastry will melt when it touches it).

Preheat the oven to 200°C/Fan 180°C/Gas 6.

Cut the chilled pastry in half. Place one piece on a floured work surface and roll into a circle about 3mm thick and large enough to overhang the pie dish by 2cm. Brush the edge of the pie dish with the beaten egg and place the pastry over the now cool pie mixture. Use the prongs of a fork to press the pastry onto the edge of the dish. Trim off the excess, then brush the top liberally with the egg.

Roll out the remaining pastry to a thickness of about 2mm. Using a small sharp knife, cut out a large fish shape. Place it on the pastry lid, then brush with beaten egg.

If you want to go all out, use the tip of a paring knife to cut out the letters for 'PIE'. You'll need your pastry really cold to cut accurately, so pop it on a tray and place in the freezer if it has become too warm to handle. Using a 2cm cookie cutter (or the wide end of a piping nozzle or the sharp end of an apple corer), cut out about 35 circles and overlap them like rows of scales on the pastry fish, brushing each one with beaten egg as you go.

Bake the pie for 30 minutes, until golden brown.

Octopus with chorizo and butter beans

Home cooks often shy away from cooking this elegant ocean enigma, such is its reputation for turning rubbery when not properly prepared. The secret is a slow simmer to tenderise it, then a blast of heat to crisp it up at the end, showcasing those curly tentacles in all their glory. Spice them up with some chorizo and its fiery oil in a classic pairing, adding a smoky, paprika-y depth to the dish, which is grounded by the butter beans tossed in plenty of parsley. *Serves 4*

CURLY TENTACLES To make the tentacles extra curly and keep them tender, dip the octopus three times in the poaching liquor before it is fully submerged and left to cook. It might seem like an old wives' tale, but it works!

1 large bunch flat-leaf parsley, leaves and stalks separated
1 onion, peeled and halved
1 whole octopus (about 1.6kg), get your fishmonger to clean it for you
1 tbsp olive oil
4 chorizo cooking sausages, sliced into 1cm rounds
2 × 400g tins butter beans, drained and rinsed
2 tbsp sherry vinegar
2 tsp sweet smoked paprika, plus extra for sprinkling
100g Pickled cauliflower (see page 125, optional but works a dream)
Flaky sea salt and freshly ground black pepper

Put the parsley stalks and onion into a large pan of water and bring to the boil. Add the octopus (dipping it as per the method above), making sure it is submerged, and turn the heat down to a gentle simmer for 30–45 minutes, or until a sharp knife slips in easily. Transfer the octopus to a plate and leave to cool. Set aside a cupful of its cooking liquid, discarding the rest.

Place the octopus on a chopping board and cut off the tentacles, leaving them whole. Chop the body into 3cm chunks.

Heat the olive oil in a large frying pan. When hot, add the chorizo and fry on both sides until golden. Remove with a slotted spoon and set aside.

Pat the octopus tentacles and chunks dry and add to the hot oil in the pan. Fry on all side for 4–5 minutes, until golden and the thinner parts are crisp. Set aside.

Place the butter beans in a bowl, add the vinegar, paprika, and cooked chorizo and octopus chunks. Season well. Chop half the parsley leaves and add to the beans, along with the pickled cauliflower (if using).

Arrange the bean salad on a serving platter and put the octopus tentacles on top. Drizzle over the red oil left in the frying pan. Scatter the remaining parsley leaves around the platter and sprinkle with a dusting of paprika.

A note on roasts

Designing a successful dinner for a crowd relies on a considered combination of make-ahead items and just a few last-minute elements to bring the meal together, and the humble roast is no exception to this rule. A roast is probably one of the meals most cooks are used to pulling off, but it's always a challenge to get the timings spot on. And with just one small oven, as I have at home, cooking roast potatoes, Yorkshire puddings and a joint of meat in the oven at the same time simply isn't an option. So I try to keep my roasts simple.

Focus on perfectly cooking the meat (using a digital probe thermometer) and share the oven between the joint and only one other item (e.g. roast potatoes or cauliflower cheese), then steam, blanch or sauté the rest. You don't want to be opening and closing your oven door all the time, and lowering the temperature inside.

Caramelise your sprouts in a sauté pan on the hob and steam your carrots; the contrast of cooking methods is not only easier to juggle in a small kitchen, but makes for a more interesting variety of flavours and textures on the plate.

Invest in a carving knife, or at least make sure you have one suitably sharp knife for carving a joint, as this is the only way to achieve a good clean cut. Chopping boards can be a nice serving option, allowing you to carve directly at the table – but do watch out for those juices or choose a board with a drip tray. When removing the meat from where it has been resting before carving, dab the bottom of the joint with kitchen paper to remove some of the excess liquid which will otherwise seep onto the serving board. Make your gravy and be sure to add the resting juices to it.

Have a jug for gravy at the ready. Boil the kettle and fill the jug with hot water to heat it up. Then tip away the water, dry it and pour in the gravy. If you have room, pre-warming plates and serving plates in a low oven is a good way to ensure you don't fret too much about the food going cold on the table when there are lots of dishes to be passed around.

When it comes to condiments, I am no slave to strict or traditional pairings. Apple sauce and pork do make excellent bedfellows, but in my mind mustard goes with everything. When it comes to presentation, I'm a stickler for decanting condiments and sauces into pots and saucers, each with an accompanying spoon.

Pork belly roast with shaken rhubarb

I can't resist the allure of beautifully crackled skin on pork belly. Start cooking this the day before, ready for Sunday lunch; leaving the skin to dry out in the fridge overnight helps to ensure good crackling.

The bright pink rhubarb accompaniment is a take on Scandinavian *rysteribs* – redcurrants shaken with sugar – which is often paired with meat. For my version, rhubarb gets shaken with sugar and left to steep in the juices, adding a vibrant pop of colour and contrasting sourness to the rich and hearty roast. I like to eat this with garlicky wilted greens, and the Crispiest baked potatoes on page 255 go down a storm too. *Serves 4–6*

ROLLING UP PORK BELLY Rolling the belly up with butcher's twine not only looks super-professional, but also makes for easy and neat portioning at the table. Keeping your kitchen string on its roll, slide a length of it under the joint widthways at the end that's furthest from you. Tie the first knot, leaving a long end. Make a large loop around your hand with the other end of the string (this stops it getting tangled and helps you guide it easily) and slide it around the joint again, about 3cm below the first loop. Pull down on the string to tighten it. Continue making loops at 3cm intervals until the entire loin is tied. Wrap the string under the joint once, making a lengthways loop. Tie the string to the long end you left at the beginning, then cut the string. If you find this too complicated, you can just tie individual lengths of string widthways at 3cm intervals.

4 tbsp fennel seeds

4 tbsp flaky sea salt

1.5 kg pork belly, boned
 and skin scored

2 tbsp butter,
 at room temperature

1 small bunch sage,
 leaves picked

FOR THE SHAKEN RHUBARB

6 forced rhubarb sticks

2 oranges, unpeeled

1 tbsp cider vinegar

4 tbsp caster sugar

First prepare the rhubarb. Trim the ends and leaves off the sticks, then cut into 1–2cm pieces. Place in a 1-litre clip-top jar. Cut the oranges into chunks, squeeze a little of their juice into the jar, then add the chunks, followed by the vinegar and sugar. Seal the jar and shake vigorously. Place in the fridge to steep overnight.

Toast the fennel seeds in a dry frying pan over a medium heat for 2–3 minutes, or until aromatic. Grind coarsely, using a pestle and mortar or a spice grinder. Mix with 3 tablespoons of the salt, then store in a jar until needed.

Lay the pork belly on a board, skin-side down. Pat dry with kitchen paper, then rub the flesh all over with the butter. Sprinkle with two thirds of the fennel salt. Chiffonade the sage (see page 21) and sprinkle it over the buttered meat. Roll up the pork, skin on the outside, and tie with string (see method opposite).

Sprinkle the remaining tablespoon of salt over the skin and place in a roasting tray. Leave uncovered in the fridge overnight.

The following day, preheat the oven to 220°C/Fan 200°C/Gas 7.

While the oven is heating, remove the pork belly from the fridge and pat dry if there is any moisture on the skin. Place the joint on a wire rack set in a roasting tray, sprinkle the remaining fennel salt over the top and leave the joint to sit for 30 minutes. Then place in the hot oven for 30 minutes to get the crackling going. After that, turn the oven down to 180°C/Fan 160°C/Gas 4 and cook for around 40 minutes to 1 hour – the thickness will vary between joints. Use a thermometer to check the meat is at least 67–8°C in the middle and underneath (the optimal temperature is 71°C, but it will continue to go up a little while the meat rests), or check that the juices run clear when the meat is poked with a knife through its thickest part.

Heat the grill and place the joint under it to crisp the crackling further, turning it every couple of minutes. Keep a watchful eye, as it can catch quickly (I stand at the oven door). This should take about 10 minutes. Set aside to rest, loosely covered with foil, for 15 minutes, then serve on a wooden board, with a few slices already carved and the shaken rhubarb on the side.

Photograph overleaf

Pomegranate-glazed lamb with rainbow pickle salad

Slow-cooked, cheaper cuts of meat are one of the tastiest and most affordable ways to feed a crowd, but they can be challenging to style. This glazed lamb shoulder gets a colourful lift with its scattering of pomegranate, however. As I usually have a batch of pickles in the fridge, I make good use of them in a rainbow salad, but if you don't have them kicking about, lightly pickle some from scratch while the lamb cooks low and slow. *Serves 6–8*

SERVING SLOW-COOKED LAMB I like to serve this really casually on a board or platter, with a few forks stabbed into it for shredding with.

3 tbsp vegetable oil

1 × 2kg lamb shoulder on
the bone, removed from
the fridge 45 minutes
before cooking

6 red onions, peeled
and quartered

2 tbsp cumin seeds

2 tbsp coriander seeds

2 tbsp flaky sea salt

2 tbsp ground turmeric

120ml hot chicken stock

120ml pomegranate molasses,
plus an extra 3 tbsp to
drizzle

3 tbsp dark brown soft sugar

Flaky sea salt and freshly
ground black pepper

FOR THE RAINBOW SALAD

200g home-made pickles or
vegetables and ingredients
for pickling (see page 125)

1 bunch radishes,
leaves on, washed

10 pickled green chillies

100g mixed black and
green olives, pitted

2 heads baby gem lettuce,
quartered

TO SERVE

Seeds from 1 pomegranate

Herby spelt and yoghurt
flatbreads (see page 122)

Miso houmous (see page 102)
or Greek yoghurt

Preheat the oven to 160°C/Fan 140°C/Gas 3.

If you haven't got any pickles on the go, start by preparing those, using the recipe on page 125 – try the cauliflower or the red onion. You can place the veg in the pickling liquor while it is still lukewarm and leave to pickle while you cook the lamb.

Heat the vegetable oil in a large, heavy-based pan over a medium heat. Meanwhile, season the lamb with some salt. Once the oil is hot, add the lamb and brown it all over.

Arrange the onions in a deep roasting tray or a large, cast-iron casserole. Nestle the lamb on top and use a sharp pointed knife to poke little cross incisions all over the meat.

Toast the cumin and coriander seeds in a hot, dry pan for 1–2 minutes, then grind to a rough powder using a pestle and mortar or spice grinder. Mix with the salt and turmeric and scatter this mixture all over the lamb, making sure it gets into all the nooks and crannies.

Combine the stock and pomegranate molasses in a jug, then pour this around the sides of the meat. Encase in foil or cover with a lid and place in the oven for about 4–5 hours, or until the meat is tender enough to pull away from the bone with a fork.

Crank up the oven to 200°C/Fan 180°C/Gas 6. Remove the lamb from the oven, drizzle with the extra pomegranate molasses and rub the top with the sugar. Return to the oven, uncovered, for a further 15–20 minutes so that the top of the lamb gets sticky and caramelised.

Assemble the rainbow pickle salad by grouping all the ingredients in a serving bowl. To serve the lamb, remove the onions from the liquid and scatter them over a board or serving plate. Sit the lamb on top, then use two forks to shred some of the meat off the bone – just enough to get started. Sprinkle with the pomegranate seeds. Serve with the flatbreads and miso houmous or yoghurt.

Bavette with radish chimichurri

Bavette steak is huge on flavour and, frankly, infinitely more affordable than fancy sirloin or rib-eye. As it's a hard-working muscle from the flank, it can be tough if overcooked, so it's best served rare, sliced on a big board and served with an acidic, crunchy dressing to stand up to it. I like it with the Crispiest baked potatoes (see page 255) and a simple salad.

To do steak justice there are a few important principles you need to follow for a dark crust and beautiful pink centre. Turn to page 44 for some tips on this. With hard-working cuts, the texture of the flesh is open and fibrous, so it's especially important to slice against the grain for tenderness. The 'grain' is the direction in which the muscle fibres are aligned and it will be easy to identify. *Serves 4 with salad and sides*

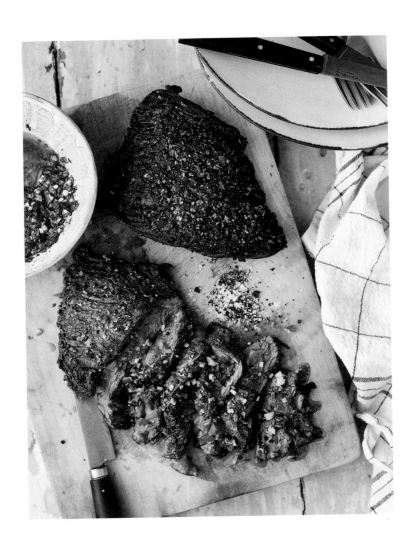

600-700g bavette,
 at least 3-4cm thick,
 at room temperature
3-4 tbsp rapeseed oil
Flaky sea salt and freshly
 ground black pepper

FOR THE CHIMICHURRI
4 tbsp red wine vinegar
1-2 tsp caster sugar, to
 taste
A generous pinch flaky
 sea salt
2 garlic cloves, peeled and
 grated
1-2 green or red chillies,
 finely chopped and
 added to taste
10 radishes, very
 finely diced
20g flat-leaf parsley
 leaves, finely chopped
20g coriander leaves,
 finely chopped
6 tbsp extra virgin olive oil

First make the chimichurri dressing. Put the vinegar into a bowl, add the sugar and salt and stir to dissolve. Add the garlic, chilli (to taste), radishes and herbs, mix together, then stir in the olive oil. Adjust the seasoning if necessary.

Pat the meat dry, then season it all over with salt.

Preheat your heaviest-based frying pan, ideally a well-seasoned cast-iron one, in a hot oven for 10 minutes, or over the hob for at least 5 minutes, until smoking hot. Add the oil, then the steak and cook on both sides over a high heat for about 2 minutes, pressing it down with a fish slice or something heavy to keep it in contact with the pan. A rare steak should still feel soft when you touch it (it will have more resistance if you cook it medium–rare and feel firm if it's well-done). You can also use a meat thermometer to test the internal temperature, pressing it from the side into the centre of the meat. For rare you want it to read about 47°C as during the resting it will carry on cooking, increasing a few degrees to a desired 51°C.

Rest the steak on a plate for at least 5–10 minutes, covered with a little tent of foil.

Once the meat has rested, transfer it to a board and sprinkle with more salt and pepper. Steaks of all kinds have a better serving side, the side that hits the pan first – so flip it that side up. Cut the steak against the grain into 1.5cm slices. Serve at the table on a board, with the dressing on the side or drizzled over the top.

Crispiest baked potatoes

Crispy on the top and soft and buttery underneath, these offer everything you want from a potato bake. They look impressive when served in a large pan at the table, but if anything they are easier to do than perfect roast potatoes and adapt to being made ahead if oven space is an issue.

Eat the potatoes as a meal in themselves, with a little salad, or serve them on the side of some smoked fish, or the pork belly roast on page 246. If you have any potatoes left over the next day (unlikely I'll admit), try reheating them with crispy bacon between the slices, or some melty cheese. *Serves 6*

About 150g salted butter,
 plus a little melted
 butter for brushing
3 onions, peeled and
 finely sliced
2kg floury potatoes
 (Maris Piper or King
 Edward), peeled
3 garlic cloves, peeled
 and sliced
Flaky sea salt and freshly
 ground black pepper
5 fresh rosemary sprigs,
 to garnish

Preheat the oven to 200°C/Fan 180°C/Gas 6.

Melt 2 tablespoons of the butter in a medium frying pan over a medium–low heat. When foaming, add the onions and a pinch of salt. Sweat for 15 minutes, until soft.

Meanwhile, cut the potatoes into 2mm slices (a mandolin with the guard on is best and quickest for this, but you can use a knife). Don't worry if the potatoes aren't cut perfectly evenly – protruding bits will cook more quickly, giving you a gorgeous mix of gold and brown.

Use a little butter to grease a round baking dish about 26cm in diameter. Tip the onions into the dish. Gather the potatoes together in a bundle of slices and stand the slices upright around the sides of the dish, working inwards in concentric circles until you have filled the pan. Sprinkle with the garlic slices, and some salt and pepper, inserting small dollops of butter between the slices as you go.

Arrange the rosemary sprigs on top, then cover with foil and bake for 20 minutes. Remove the foil and cook for a further 50 minutes to 1 hour, or until golden and crispy (the timing will vary, depending on how tightly packed the slices are). Add a little more butter halfway through, to prevent it looking dry. The top should be beautifully golden and the lower part of the slices should be soft if you stab them with a knife. Brush with melted butter before serving, to make the potatoes extra glossy.

Desserts and Baking

Desserts don't need to be complicated to be effective; a perfectly ripe pear or bitter piece of dark chocolate is as good an end to a meal as any. When I'm going that extra mile though, I consider a simple formula that most chefs abide by in the dessert stakes, namely that a successful sweet course relies on a play of textures and flavours, which should complement one another perfectly. Cream, crunch and some kind of contrasting acidity, bitterness or salty edge – these make for the best balance (think Eton mess, lemon meringue pie or apple crumble and custard). The recipes in this chapter bring together some of my favourite techniques and recipe ideas, many of which can be used interchangeably: the praline on the Chocolate mousse would just as elegantly dust the top of the Crunchy caramel apples (see pages 286 and 262), while the lemon curd cream from the Elderflower fritters would sit happily on the side of the Caramelised pineapple (see pages 261 and 280), for example.

Elderflower fritters with lemon curd cream

When elderflower blossoms come out in their full white scented glory, walking the dog in the local park becomes an urban foraging session for me. In this delicate and light dessert, the flowering elderflower heads get veiled in a light batter and gently fried before being dipped into a pale lemon curd cream. If you can get hold of pink elderflower, try mixing up the two colours – I may have pinched the pinks in the picture from my neighbour! *Makes 16*

50g cornflour
50g plain flour
175ml sparkling water
1 litre vegetable or
 sunflower oil
16 elderflower heads, washed
 and thoroughly dried
50g icing sugar, to dust

FOR THE LEMON CURD
Juice and finely grated
 zest of 2 lemons
90g caster sugar
90g unsalted butter
A pinch of fine sea salt
4 egg yolks
100-150ml crème fraîche or
 extra thick Jersey cream

First make the lemon curd. Put the lemon juice and zest into a small saucepan, add the sugar, butter and salt and heat gently until the sugar and butter have melted. Remove from the heat.

Whisk the egg yolks in a bowl, then pour a few tablespoons of the hot butter over them. Whisk vigorously, then pour in the rest, whisking to incorporate. Pour the mixture back into the pan over a very low heat and whisk constantly as the curd starts to thicken – it should take about 4–5 minutes. Don't let it boil, and don't stop whisking or the eggs will curdle. Remove from the heat and pass the curd through a sieve into a bowl. Place cling film directly onto the surface of the curd to prevent a skin forming and chill for at least 1 hour.

For the batter, put the cornflour and plain flour into a bowl and add the sparkling water a few splashes at a time, whisking all the time.

Heat the oil in a deep, heavy-based pan or wok to 170°C (when hot enough, a small drop of batter should sizzle immediately but not brown instantly).

Using one hand, dunk the elderflower heads in the batter, then carefully lower two at a time into the oil and fry for 30–60 seconds, or until the batter is crisp and golden. Drain on kitchen paper. Repeat with the remaining heads.

Stir 100ml of the crème fraîche or cream into the chilled lemon curd, taste and add more if required. Place a large spoonful of curd on each plate and use the back of the spoon to sweep it into a comma shape. Arrange two or three elderflower fritters alongside and dust with plenty of icing sugar. You could also serve the fritters on a platter with a bowl of the curd for dipping.

Crunchy caramel apples

While we all love the humble apple crumble – truly one of the greatest puddings invented – it fails to make the most of the beauty of its star ingredient. This nutty salted caramel dessert shows off the apples as nature intended. Coring them with a melon baller gives a perfectly round crater for pools of caramel to sit in. *Serves 6*

PERFECT ICE CREAM SCOOPS For perfect balls of ice cream (especially useful when making this for a crowd), remove the tub from the freezer and place it in the fridge for 20 minutes. Use an ice cream scoop to dig out six spheres and place them carefully on a tray lined with baking parchment (the tray will need to fit in your freezer). Freeze the scoops until ready to serve.

250ml water

2 tbsp unsalted butter

1 tbsp apple cider vinegar

3 Pink Lady apples, halved
 through the stem and cored
 with a melon baller

Flaky sea salt

500ml vanilla ice cream,
 to serve

FOR THE BUCKWHEAT
AND NUT CRUNCH

100g mixed nuts (I use
 walnuts and pistachios),
 roughly chopped

50g buckwheat groats

½ tbsp vegetable oil

1 tbsp maple syrup or honey

FOR THE CARAMEL SAUCE

150g caster sugar, plus 3-4
 tbsp extra for sprinkling

60g unsalted butter, cubed

90ml double cream

½ tsp fine sea salt

Place the water, butter, vinegar and a pinch of salt in a large, heavy-based pan over a medium–low heat. Bring to a simmer, stirring to melt the butter.

Add the apples in a single layer, cut-side down, and return the liquid to a very gentle simmer. Simmer for about 20 minutes, or until the apples are just tender, turning them halfway through. You want them to hold together and retain their shape. Use a slotted spoon to set them aside on a tray with the cut-side facing up.

To make the buckwheat and nut crunch, preheat the oven to 200°C/Fan 180°C/Gas 6. Mix the nuts and buckwheat together in a baking dish, add the oil and maple syrup or honey and toss together. Season with a pinch of salt, then bake for 20 minutes, stirring after the first 10 minutes, and again 5 minutes later – remove from the oven when golden and crunchy then set aside until needed.

To make the caramel sauce, melt half the sugar in a heavy-based pan over a medium heat without stirring; you can swirl the melting sugar around the pan by tilting it, but stirring it will cause the sugar to crystallise. Add the remaining sugar and heat until it is rich amber in colour, swirling the pan now and then. Remove from the heat and add the butter and cream. Be careful, as it might splutter. Place the pan back on the heat and bubble for a further 3–4 minutes. Sprinkle in the salt, then pour into a heatproof bowl or jar and set aside to cool.

Put the extra caster sugar on a plate and dip the cut-side of the apples in it. Wrap a tiny piece of foil around the stems to protect them, then use a blowtorch to caramelise the sugar until dark amber (or place under a hot grill for a similar effect).

To serve, scoop the ice cream into wide bowls (or if you've followed the tip opposite, remove the pre-frozen balls from your freezer) and place an apple half, caramelised-side up, beside each scoop. Dip a small spoon in the salted caramel and, from a height, drizzle it into and around the apple in a circular motion. Scatter the top with the nut crunch.

Beaujolais-poached pears with chocolate crumbs

Working in the world of food photography, you find yourself examining fruit in a whole new light, admiring their form and physique with as much enthusiasm as you would put into finding the perfect ripeness and flavour. Poaching pears is the best way to show off their elegant figures, so start by picking out fruit with interesting curves (I like a Conference for this recipe). The key is to avoid overly ripe pears – firmer ones will withstand the boozy bathe – and cook them just to the point at which a spoon can slide through the tender flesh. I usually poach the pears the day before serving them as this allows the colour to penetrate.

The chocolate crumbs aren't strictly necessary, but they are satisfyingly crunchy, salty and chocolatey, while also helpfully acting as a perch for the pears. You could also serve the pears with ice cream, or simply with their syrup. *Serves 4*

EXTRA-GLOSSY PEARS I like to double-dip the pears in the syrup just before serving to make them extra glossy. If you wish to serve them hot and have made them ahead, strain the pears from their syrup and leave them at room temperature, then reheat the syrup and dip them back into the hot liquid. You can strain the syrup if you prefer it without the fruity bits.

PRESENTING POACHED PEARS I serve these standing up to show off the curve of each pear, but they don't always behave. If you have a wobbly one, simply slice the base to make it stand upright.

4 firm pears
500ml Beaujolais or other
 fruity red wine
80g caster sugar
170g frozen summer berries
2 bay leaves

FOR THE CHOCOLATE CRUMBS
90g unsalted butter,
 at room temperature
90g caster sugar
90g plain flour
30g cocoa powder
A good pinch of fine sea salt

Peel the pears, removing the calyx but leaving the stem intact. Place the wine, sugar, berries and bay leaves in a pan. Bring to a simmer, then add the pears and cook for 15 minutes, or until a knife slides easily into the flesh. Using a slotted spoon, transfer the pears to a bowl or plastic container. Boil the liquid for a further 15 minutes, or until it thickens to a syrupy consistency. Leave to cool then pour back over the pears. You can do this up to two days ahead and chill in the fridge.

Preheat the oven to 200°C/Fan 180°C/Gas 6. Line a large baking sheet with baking parchment.

To make the chocolate crumbs, put the butter and sugar into a bowl and cream together until pale and fluffy. Sift in the flour, cocoa powder and salt and combine with a wooden spoon. The mixture will be quite dry. Spread it fairly evenly yet sparsely onto the prepared sheet. Bake for about 20 minutes (until crisp), moving the crumbs around at least once during baking so that the ones at the edge do not burn. Set aside to cool.

When the crumbs are completely cold and crisp, bash with a rolling pin to get them to a fairly regular size.

To serve either warm or chilled, scoop the chocolate crumbs onto plates or bowls, dip the pears in their syrup a few times and stand them upright on the crumbs.

265

Orchard lattice pie

This all-American pie encases a warm filling made up of autumn's orchard offerings. Creating the lattice pattern on the top is far easier than it looks (and far easier than it is to describe!), so don't be put off by the long method. Once you've mastered it, you'll be weaving the top of all your pies like a veritable domestic god(dess). *Serves 8–10*

MAKING FLAKY LAYERS Be sure to work relatively quickly and chill the pastry regularly to get the best results. You are aiming to have the odd lump of chilled butter in the dough – those pockets will melt and create flaky layers of pastry.

SPARE PASTRY If you have any pastry left over, cut or stamp out leaf shapes (with a cookie cutter) and arrange them around the crust edge.

550g mixture of apples
 and pears
150g blackberries
Juice of 1 lemon
2 tbsp light brown sugar
1 tbsp cornflour
1 tsp ground cinnamon
1 egg, beaten
1-2 tbsp demerara sugar
Vanilla ice cream or crème
 fraîche, to serve

FOR THE PASTRY
300g plain flour,
 plus extra for dusting
1½ tbsp caster sugar
A generous pinch of fine
 sea salt
300g cold unsalted butter,
 cut into 2cm cubes, plus
 1 tbsp at room temperature
150ml ice-cold water

Grease a round 25cm pie dish that's about 3cm deep.

First make the pastry. Put the flour, sugar and salt into a large bowl. Add the cold butter and toss it in the flour. Using your fingers, press the floury butter cubes, flattening them between your fingers and loosely working them into the flour – there should still be bits of butter visible. Pour the water into the bowl and lightly work it into the mixture to form a rough and scraggly dough. It should still feel quite cool at this point; if not, chill briefly. Generously dust a clean work surface with flour and roll the dough into a rectangle of about 35 × 25cm. Fold the short sides into the centre so that they meet. Now fold the dough over itself from the opposite side, then once more from the first side to create a thick chunk of pastry. Cut in half widthways.

Dust the work surface again if necessary. Roll one piece of dough into a circle about 35cm in diameter and use it to line the pie dish, allowing it to overhang the sides by at least 5cm. Chill for 1 hour. Roll the remaining piece of dough into a circle about 27cm in diameter. Transfer to a piece of baking parchment laid over a board and chill for 1 hour.

For the filling, core the apples and pears and cut into 5mm slices. Place in a bowl and add the berries, lemon juice, brown sugar, cornflour and cinnamon. Set aside. Use a sharp knife to cut the circle of dough into equal strips. They can be thick (3–4cm) or thin (1cm), depending on the look you're going for.

To assemble the pie, brush the top edge of the pastry case with beaten egg. Fill the lined dish with the fruit mixture. As some of the fruit will poke through the lattice, try to position the most attractive bits – especially the smudgy blackberries – on top. Lay five or six of the dough strips across the surface in one direction, leaving about 2–3cm between them. Fold back every alternate strip.

Place one long strip of dough across the centre of the pie, perpendicular to the parallel strips, then unfold the folded strips over it. Now take the parallel strips that are running underneath the perpendicular strip and fold them back over it, as shown in the image above. Lay a second perpendicular strip about 2–3cm from the first strip, then unfold the folded strips over it. Repeat this step with two or three more perpendicular strips, until you have a lattice top.

Trim the edges of the pastry flush with the dish and use a fork to press the pastry down and seal it round the edge. Brush the top and sides with the beaten egg and sprinkle with the demerara sugar. If you have time, chill the pie again for 30 minutes for the best result. If not, preheat the oven to 200°C/Fan 180°C/Gas 6 and bake the pie on the middle shelf for 40–50 minutes, until golden and crisp. Serve with vanilla ice cream or crème fraîche.

Photograph overleaf

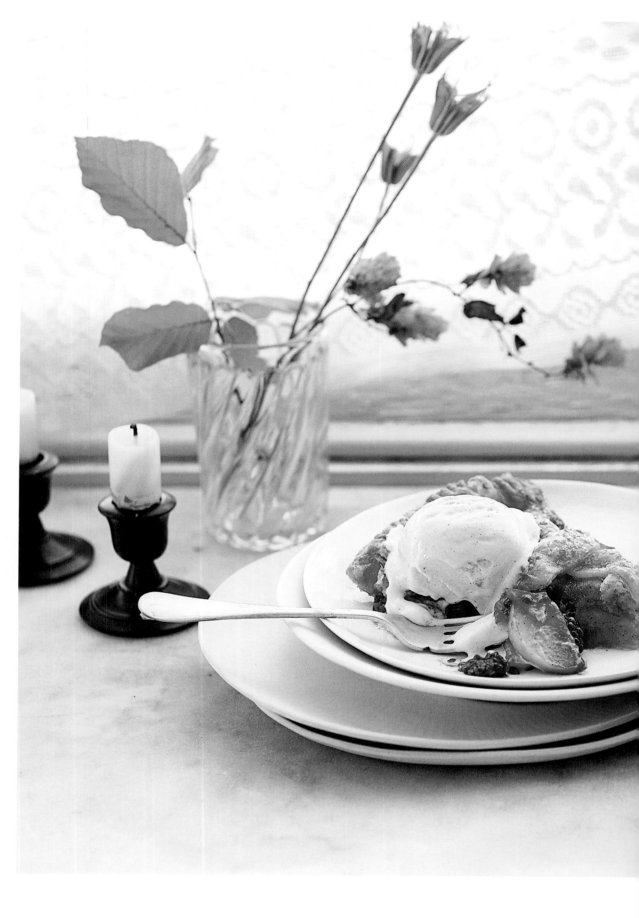

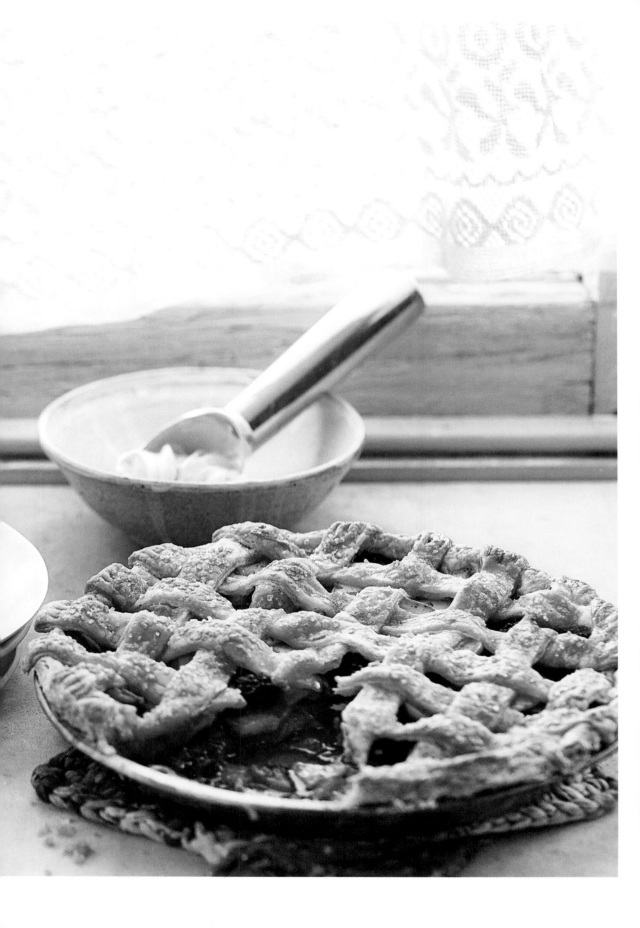

Five-ingredient rhubarb tart

This simple rhubarb tart is here to prove that with just five ingredients and 30 minutes, you can produce a dessert worthy of a Parisian patisserie. The trick is to be precise when trimming the rhubarb and puff pastry to size – I find a metal ruler and a pizza cutter give the greatest accuracy. It might sound a little fiddly, but if you are a fan of geometric precision, you'll find this deeply satisfying. *Serves 6*

EXTRA PUFFY PASTRY Adding a second layer of ready-rolled puff pastry to a tart or pie is something food stylists often do to give extra 'puff'. You can also paint on two layers of egg wash for a really high-gloss finish on the pastry frame.

GLAZING To make the rhubarb extra shiny, brush it with warm honey.

80g shelled pistachios
5 tbsp caster sugar
1 egg
5–7 forced (ideally) rhubarb sticks
320g or 375g ready-rolled all-butter puff pastry

TO SERVE
2 tbsp warmed clear honey (optional)
6 tbsp crème fraîche or ice cream

Preheat the oven to 200°C/Fan 180°C/Gas 6. Line a large baking tray with baking parchment.

Very finely chop the pistachios (I do this by hand to get a more even result than in a food processor). Place in a bowl with the sugar and mix well. In a separate bowl, beat the egg until smooth.

Trim the tough ends and the leaves off the rhubarb, then cut the sticks into 20cm lengths.

Unroll the pastry and lay it on a work surface with the long side nearest you. Trim to a 25cm square. Using the tip of a sharp knife, make a shallow incision all the way around the square about 2.5cm from the outside edge. Do not cut all the way through. The rhubarb will sit within the resulting 'frame'. Transfer to a piece of baking parchment, which will allow you to move it around freely.

Cut four 22.5 × 2.5cm strips out of the remaining pastry. Brush the scored pastry 'frame' with the egg wash, then lay the strips of pastry over it. You don't want the strips to overlap, so place each strip flush against the next and continue all the way around to make a perfect frame. If at any point the pastry feels warm and difficult to work with, chill for about 10 minutes. Brush the strips with more egg wash. Prick the base with a fork, then scatter three quarters of the pistachio sugar over it evenly.

Transfer the pastry to a heavy baking tray and bake for 15 minutes. Remove from the oven and arrange the rhubarb as tightly and neatly as possible in rows inside the frame: I usually fit about nine in a row but this will depend on the width of your rhubarb.

Scatter the remaining pistachio sugar haphazardly over the rhubarb and flick a little water over it, then return to the oven as quickly as possible. Bake for a further 15–20 minutes, or until the pastry is golden, the base crisp and the rhubarb tender (the tip of a knife should slide in without resistance).

To serve, brush the rhubarb with the honey (if using), cut into portions and add a dollop of crème fraîche or ice cream.

A note on cake

As a nation of tea-timers, it's easy for us Brits to overlook the merits of cake at the dinner table. However, with a few small tweaks, a slice of cake can act as a versatile base on which to build a restaurant-worthy dessert.

As far as I'm concerned, less is more when it comes to desserts. Avoid serving a big wedge of cake after a large meal, as a smaller portion will look much more inviting and considerably less intimidating to full bellies. Think outside the box when slicing. Try baking the cake in a square tin and cutting it into squares or small rectangles, or serving a very thin wedge. You could even slice a round cake into diamond-shaped portions to mix things up. For cakes to play around with as desserts, turn to pages 274–7 and 306–11.

Add something smooth or creamy to your cakey dessert: a stroke of crème fraîche smeared across the plate with a palette knife, or spooned into a circle on the centre of the plate with the cake slice jauntily off-centre; or a light flick of Chantilly cream deftly drooping down the side of a slice. A fruity purée might lift a wedge of coconut cake, a quick chocolate ganache (see page 312) will add richness to a nut- or fruit-based cake, and a swirl of salted caramel (see page 263) drizzled from a height always adds a touch of decadence.

Icing sugar and cocoa powder are the food stylist's secret weapons for covering up cracks in pavlovas or the unevenly baked tops of tarts, but they also work brilliantly as a final flourish to harmonise the different elements on a plate. (You didn't hear this from me, but an even cheekier way to use the dusting of icing or cocoa trick is for pulling off a store-bought dessert as your own homemade creation. Just remove it from the packaging and entice a few stray crumbs out so it's looks a bit more rough and ready.) Dust when the cake or dessert is in place on the serving plate for a few light speckles on the plate too. For extra precision, I use a tiny tea strainer so that I can manoeuvre it better. Always wait until the cake is cool before dusting, or the steam will moisten the icing sugar or cocoa and it will dissolve into splodgy speckles.

For some final show-off touches, dried flower petals, crushed praline, rhubarb curls (see page 325), grated blanched pistachio (see page 56) and hibiscus sugar (see page 281) all add textural contrast and colour. Freeze-dried fruits can be ground into a powder or simply crushed in a sandwich bag with a rolling pin and used for dusting. Matcha powder works a dream too for a green hue (as you will see with the Choux buns on page 317), while a light zesting of citrus or subtle grating of chocolate adds understated elegance.

272

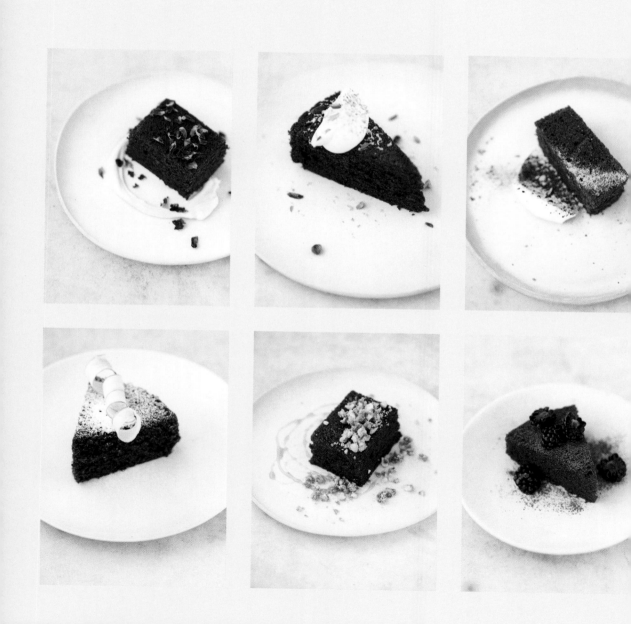

Candied orange and almond polenta cakes

Fruit-studded upside-down cakes are one of the most exciting ways to showcase seasonal fruit, pressing it into the base so that when you flip them over the colours and patterns are exposed in their full glory.

By candying orange slices in a sugar syrup, the rind softens, sweetens and takes on a translucent quality. In winter I use the season's must-have citrus fruit – crimson-fleshed blood oranges – not only for their colour, but also the sweet–sharpness of their tender flesh. During the rest of the year, go for regular oranges. This is an excellent recipe for gluten-free baking. *Makes 8*

200g unsalted butter,
 at room temperature,
 plus extra for greasing
1-2 oranges, ideally
 blood oranges
500g caster sugar
Juice and zest of 2 lemons
½ tsp vanilla extract
A pinch of fine sea salt
3 eggs
2 tbsp natural yoghurt
200g ground almonds
170g fine polenta
1 tsp baking powder

TO SERVE
Whipped cream or yoghurt
A few dried rose petals
 (optional)
A few nibbed pistachios
 (see page 56 for more
 about these; optional)

Grease eight 200ml ramekins or eight holes in a deep muffin tray, and line the bottom of each with baking parchment. A quick way of doing this is to cut around the base of small paper muffin cases; you can cut all eight in one go.

Slice the oranges into 5mm-thick rounds. Place in a small pan with enough cold water to cover them and slowly bring to the boil. Discard the water and refill with enough cold water to cover them once more, taking care not to pour it directly onto the orange flesh as this will ruin the shape of the slices. Bring slowly to the boil again (this removes some of the bitterness from the pith), then carefully drain in a sieve. Finally, add 150ml cold water to the pan, along with 300g of the caster sugar, then gently return the slices to the pan and bring slowly to the boil. Simmer for 8–10 minutes, then use a slotted spoon to transfer the slices to a plate. Add the lemon juice to the syrup and set aside.

Place a slice of orange in the bottom of each ramekin or muffin hole and add 2 teaspoons of the syrup. Remember that the base will become the top of the cake, so put the best-looking side of the slice face down. At this point you can store the ramekins or muffin tray in the fridge overnight if you need to.

Preheat the oven to 180°C/Fan 160°C/Gas 4. Place the butter in the bowl of a stand mixer fitted with the paddle attachment, add the remaining 200g sugar, the vanilla extract, lemon zest and salt and beat until pale and fluffy.

Lightly beat the eggs in a separate bowl, then add them a spoonful at a time to the butter mixture, beating to incorporate. Stir in the yoghurt.

Combine the almonds, polenta and baking powder in a separate bowl, then carefully fold into the egg mixture. Spoon into the prepared ramekins or tray and bake for 25–30 minutes, or until a skewer inserted into the cakes comes out clean.

As soon as the cakes leave the oven, use a skewer to prod a few holes in each one and pour over a teaspoon of the remaining syrup. Leave to cool for 5 minutes, then run a knife lightly around the edges. Line a tray with baking parchment. Turn the cakes out onto the tray and peel off the paper circles to reveal the orange slices. Brush the tops with the syrup to make them extra glossy before serving.

These are delicious served slightly warm with whipped cream or yoghurt and a few dried rose petals and pistachios, or at room temperature just as they come. They keep well for a couple of days in an airtight container.

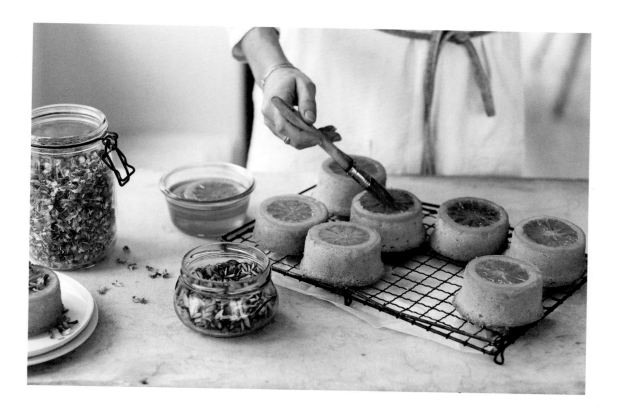

Olive oil, poppy seed and lemon loaf cake

Perhaps it's the simplicity of a well-made loaf cake that explains its enduring appeal. When it comes to icing, depending on the occasion I usually keep it simple with a glossy glaze of sugary syrup, such as a luscious passion fruit glaze, but swirls of lavender-scented buttercream or a rippled yoghurt icing are handy to have up your sleeve.

A slice of loaf cake bundled up in wax paper and tied with butcher's twine makes a sweet lunchbox treat or gift. Thread a piece of lavender or a sprig of rosemary through the knot if you are feeling extra thoughtful. *Makes 1 cake, to serve 10–12*

KNOWING YOUR OVEN The range of time given for baking this cake in the oven may seem broad, but all ovens behave differently (as I know well from using different kitchens on a weekly basis). Get to know your oven and use your intuition, and check your cake by inserting a skewer into the centre - if it comes out clean, the cake is done.

Unsalted butter,
 for greasing
200g plain flour
2 tsp baking powder
A pinch of fine sea salt
200g caster sugar
200g natural yoghurt
120ml light olive oil
2 eggs, beaten
½ tsp vanilla extract
1 tbsp poppy seeds
Finely grated zest
 of 2 lemons

Preheat the oven to 180°C/Fan 160°C/Gas 4. Grease a 2lb/900g loaf tin and line the base and sides with baking parchment.

Sift the flour, baking powder and salt into a bowl. Set aside.

Put the caster sugar into a separate bowl, add the yoghurt, olive oil, eggs, vanilla extract, poppy seeds and lemon zest and whisk vigorously using a balloon whisk or electric whisk, until fully incorporated. Gently fold in the flour mixture in two batches. Pour the batter into the loaf tin and bake for 55–70 minutes on the middle shelf of the oven, or until a skewer inserted into the centre comes out clean. Leave in the tin for 5 minutes then turn the cake out onto a wire rack to cool (unless making the Passion fruit glaze in which case, follow the instructions overleaf).

Toppings overleaf

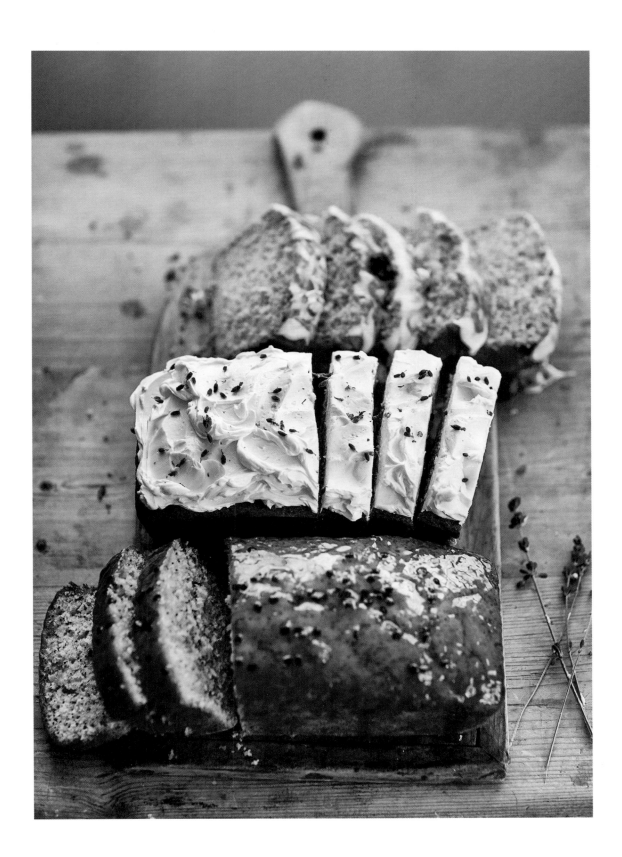

Passion fruit glaze

Pulp of 5 passion fruits
Juice of 2 lemons
90g caster sugar

Towards the end of the cake's cooking time, scoop the pulp out of the passion fruits and place in a pan with the lemon juice and sugar. Simmer for 10 minutes or until thickened to the consistency of single cream. Strain through a sieve into a bowl, using a wooden spoon to push it through, leaving behind the seeds. Return 1 tablespoon of the seeds to the glaze and discard the rest.

When the cake is done, leave it in the tin and use a cocktail stick or skewer to poke holes all over the surface. Brush thoroughly with the glaze and leave for 5 minutes to soak in. At that point, transfer to a wire rack to cool.

Blueberry and yoghurt ripple icing

50g fresh or frozen blueberries
2 tbsp water (if using fresh berries)
1 tbsp caster sugar
175g icing sugar
1 tbsp natural yoghurt

While the cake is cooling, put the blueberries into a pan, adding the water only if they are fresh (none is needed if frozen). Add the caster sugar and cook for 4–5 minutes over a low heat, until the berries break down a little and the juice escapes. Set aside to cool.

Put the icing sugar into a bowl, add the yoghurt and stir to a thick paste. If it's too thick, add only the tiniest more to bring it together (even the smallest amount can thin it too much). Spoon the icing over the top of the cooled cake and dot with some of the berries and juice, using a small spatula or a cocktail stick to make ripples or figure-of-eight patterns over the surface.

Lavender buttercream icing

50ml whole milk
2 tbsp dried culinary lavender flowers,
 plus 1 tsp to sprinkle
200g unsalted butter
200g icing sugar

While the cake is cooling, put the milk and
lavender into a small milk pan and warm over
a low heat to scalding point. Set aside to infuse
for about 30 minutes.

Beat the butter with a wooden spoon or stand
mixer for a good 5 minutes, until incredibly
light. Sift in the icing sugar and continue to
beat until very light. Strain in the infused milk
and beat again.

Using a small palette knife, spread the
buttercream over the cake in waves, then
sprinkle with a little extra lavender.

Caramelised pineapple with hibiscus sugar and mascarpone

This is a lighter spin on the traditional cheesecake. Batons of glazed pineapple are the stars of the show, with creamy quenelles of whipped mascarpone taking a supporting role. I usually present this on individual plates or in shallow bowls, but you could also pop it on a sociable serving plate and let people dig in.

In summer, I like to snack on the pineapple fresh, dipping it in the sherbetty hibiscus sugar – an adult's version of the beloved childhood Dip Dab. For a bit of crunch on top, make the biscuitty crumbs on page 264, leaving out the cocoa powder, and scatter them over. Crushed amaretti biscuits would also work a dream. *Serves 4–6*

COCONUT CURLS Instead of buying coconut curls or chips, food stylists use the nifty method opposite to create elegant and far tastier curls from a fresh coconut; they'll became an essential in your cookery arsenal.

QUENELLES A 'quenelle' is the fancy chef method for neatly presenting scoopable creams—the neater version of a cook's 'dollop'. The key is to start with two similar (or ideally identical) tapered tablespoons with deep curves (vintage spoons are often this shape). Have a bowl of hot water at the ready. Dip the spoons in the water, shake off the excess and scoop up a generous heap of the cream on one spoon, with the other spoon in the opposite hand. Glide the second spoon under the cream, transferring the mixture onto it. Repeat until the sides of the quenelle are smooth and you can ease it off the spoon onto the plate.

250g mascarpone cheese
2 limes
50g icing sugar
250ml double cream
1 medium pineapple
85g dark brown sugar
2 tbsp dried hibiscus
2 tbsp caster sugar
1 coconut

Start the mascarpone cream at least 4 hours in advance, to allow it time to set. Put the mascarpone into a bowl with the zest of one lime and the icing sugar and beat until very smooth. Whip the double cream to soft peaks (I do this by hand, so as not to whip it too far; you don't want it to get grainy, just smooth and light), then fold into the mascarpone. Place in a container, smooth over the top with a palette knife and chill for at least 4 hours.

Preheat the oven to 200°C/Fan 180°C/Gas 6.

Lop the top and base off the pineapple. Sit it upright and carve off the skin, trying not to cut away too much of the flesh. Remove the 'eyes', using a knife to cut them out in a spiral. Cut the pineapple lengthways into 12 wedges and trim away the core. Mix the brown sugar and juice of both limes together in a bowl. Add the pineapple wedges and toss well to coat. Space them out on a foil-lined baking tray and bake for 15–20 minutes, until golden and caramelised on one side. Use tongs to turn the pieces over, then tilt the tray and spoon the juices over the wedges. Return to the oven for 15 minutes or until sticky and golden. Leave the oven on for the coconut.

In a spice grinder or blender, blitz the dried hibiscus and half the caster sugar down to a rough powder (I like to leave a few slightly coarser bits), then combine with the remaining sugar and set aside.

Place the coconut in a heavy-duty plastic bag and use a hammer or rolling pin to crack it in half. Put the cracked coconut on a board and use a spoon or your hands to pry the flesh away from the shell. Starting on one side of a large piece of flesh, use a vegetable peeler to peel off large curls. You'll only need about half the coconut for the dessert, but the toasted curls are great for a snack, or keep some aside to grate over the dessert at the end. Spread the curls in a single layer on a large baking sheet and bake for 3–5 minutes, until lightly toasted.

Scoop a quenelle of the mascarpone mixture (see the method opposite) onto each serving plate and sprinkle with some grated coconut, if using. Place two or three overlapping pineapple wedges beside each quenelle, then add another quenelle, some coconut curls, lime zest and a generous scattering of hibiscus sugar.

Photographs overleaf

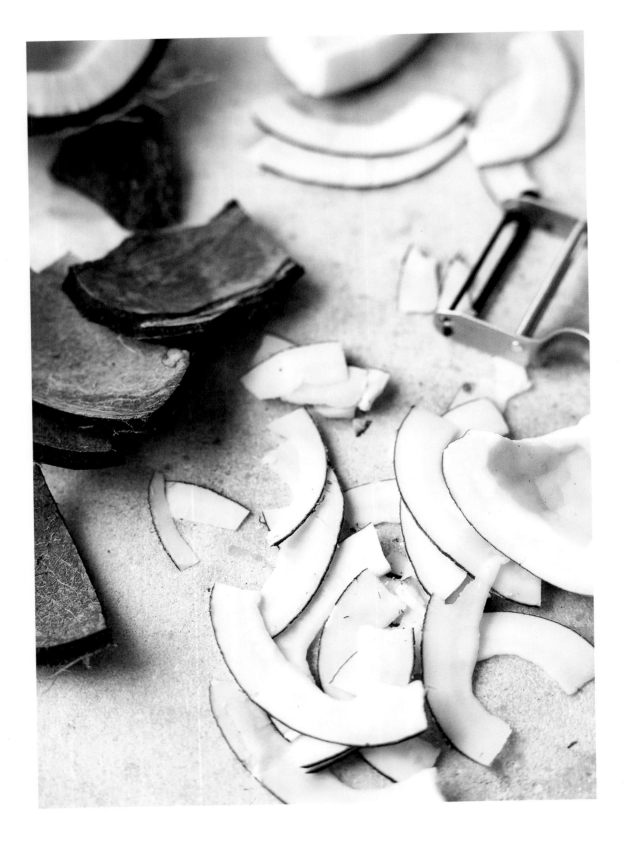

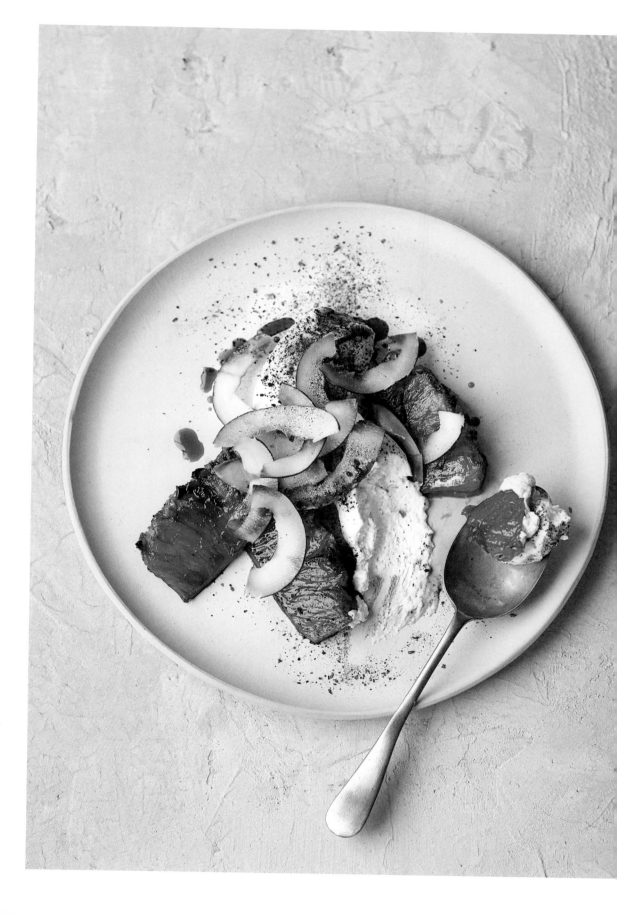

Coconut panna cotta with ginger, lime and lemongrass snow

There's a certain soothing purity in the sight of a delicate panna cotta wobbling on your plate, and in this recipe it is decorated with pale seasonal blossoms, creating a complete rhapsody in white.

Here, coconut is paired with a tangy ginger, lime and lemongrass 'snow' to make a refreshing after-dinner dessert that can be prepared a day ahead. I usually make a double batch of the snow and keep it in the freezer to add a bit of zip to mango sorbet or clotted cream ice cream. Note that the panna cotta needs at least 4 hours to set. *Serves 4*

EDIBLE FLOWERS It's fun to experiment with edible flowers. While I like to keep it all pure and white for this panna cotta, going for super-bold flowers would pop against the white canvas, as would crystallised rose petals (just make sure you buy unsprayed, edible petals). Turn to page 23 for more on crystallising.

250ml double cream
300ml whole milk
30g caster sugar
60g desiccated coconut
3 gelatine leaves
Cherry blossom, other edible
 flowers or sugared white
 currants, to decorate

FOR THE SNOW
125ml water
40g caster sugar
2 lemongrass sticks, bashed
 and broken in half
5cm piece fresh root ginger,
 thinly sliced
Juice of 1 lime

Put the cream, milk, sugar and coconut into a small saucepan and slowly bring to a simmer. Continue simmering over a medium heat for about 5 minutes to dissolve the sugar, then turn off the heat and leave to infuse for 30 minutes.

Strain the infused cream through a sieve, pressing the coconut down to get all the cream through. Discard the coconut.

Soak the gelatine leaves in a bowl of cold water for 5 minutes to soften, then return the cream to the pan and warm it back up. Squeeze the gelatine sheets dry before stirring them through the cream to dissolve.

Divide the mixture between four 120ml ramekins or moulds, and leave to set in the fridge for at least 4 hours.

To make the snow, put the water, sugar, lemongrass and ginger into a small pan and slowly bring to a simmer. Continue simmering for 7 minutes to fully dissolve the sugar and release the flavours. Take off the heat, add the lime juice and leave to infuse and cool for 30 minutes. Strain the cooled liquid through a fine sieve into an airtight plastic container and freeze for 4 hours.

Remove from the freezer and use a fork to scrape the frozen mixture into 'snow'. Return to the freezer until needed, and place four serving plates in the fridge.

When you are ready to serve, take your plates out of the fridge and fill a deep heatproof bowl with hot water from the tap. Dip one ramekin at a time in the hot water, wipe dry, then invert a chilled plate on top and flip both over. Slightly shake the ramekin to release the panna cotta. Turn the others out in the same way. Take the snow from the freezer and scrape it up again with a fork. Sprinkle it daintily over each panna cotta in a straight line. Decorate with flowers or sugared white currants.

Chocolate mousse with crushed praline and raspberry cream

There's an adorable little restaurant in Paris called Chez Janou that prides itself on a 50-strong list of pastis, a leafy terrace and one of the most memorable desserts I've ever been served. One of the things that makes their mousse stand out is the way it is presented: a massive earthenware tureen is plonked on the table, along with a spoon for you to help yourself. Wanting to emulate this relaxed style of hospitality, I have had to come up with my own version. Both velvety soft and airy, this is the perfect indulgence to punctuate a dinner. Put the bowl on the table with raspberry cream and crunchy praline alongside for accessorising. If you don't have time to make the praline as well, simply grate over a generous amount of chocolate, or add some chocolate curls (see page 289). *Serves 6–8*

RESCUING SEIZED CHOCOLATE To rescue melting chocolate that has seized up (gone firm and grainy), vigorously whisk in some warm water 1 tablespoon at a time, until smooth, then proceed as per the recipe.

CLEANING UP CARAMEL To clean up your caramel pan and utensils, simply add water and simmer over a low heat until the caramel remnants dissolve.

250g chocolate (70 per
cent cocoa solids),
broken into small pieces
140ml water
¼ tsp ground green
cardamom (optional)
A pinch of flaky sea salt
5 eggs, at room temperature
3 tbsp caster sugar

FOR THE PRALINE
100g blanched hazelnuts
150g caster sugar

TO SERVE
125g raspberries,
roughly torn
300ml whipping cream
whipped with 4 tbsp
sifted icing sugar

Place the chocolate in a large heatproof bowl with the water, cardamom (if using) and salt, and set over a pan of simmering water – don't allow the base of the bowl to touch the water. Meanwhile, separate the eggs, placing the whites in a large bowl and the yolks in a small one.

Once the chocolate has mostly melted, turn off the heat and allow it to melt fully, stirring regularly. Take the bowl off the pan and set aside to cool for a few minutes.

Stir one of the egg yolks into the slightly cooled chocolate until combined. Follow with the remaining yolks and stir until smooth.

Whisk the egg whites in a bowl with a balloon whisk or in a stand mixer, until it forms soft peaks, then add 1 tablespoon of sugar at a time until fully incorporated and you have glossy stiff peaks. Stir one third of the whites into the chocolate mixture, then gently fold in the remainder. The lighter you fold, the lighter your mousse will be. Pour or spoon the mixture into a big serving bowl (at least 900ml capacity). Chill for 3–4 hours.

For the praline, preheat the oven to 200°C/Fan 180°C/Gas 6.

Place the hazelnuts on a tray and roast for 10 minutes, or until golden. If I am feeling pedantic I then use a sharp knife to slice three quarters of them in half, to reveal the hole in the centre (which looks extra pretty), and roughly chop the rest. Line a baking tray with baking parchment. Sprinkle about half the caster sugar into a heavy-based pan and place over a medium heat. Once it starts to melt, sprinkle over the remaining sugar and melt again to a dark golden brown: you can swirl the pan around, but do not stir it. Whatever you do, don't be tempted to dip your finger in because it is burning hot. Add the hazelnuts to the caramel, stirring to coat. Quickly pour the mixture onto the baking tray, spreading it out a little with a spatula before it fully sets, and leave to cool completely before roughly bashing it up with a rolling pin. Place half in a food processor and blitz to a powder; keep the other half in rough chunks.

Roughly mix the raspberries through the cream to leave bright smudges. Serve the cream, crushed praline and praline powder in separate bowls alongside the mousse, allowing guests to help themselves to each.

Chocolate and blackberry frozen parfait

Even as a youngster I was a bit of a dessert snob, preferring my granny's bakes over anything that might emerge from a packet. That's until I discovered the soft creamy ripples and crisp chocolate layers of a Viennetta. This frozen parfait – a nod to my childhood predilection – is delicate and creamy, with fine layers of chocolate to crack your spoon through. I like to decorate it with blackberries and some chocolate curls. *Serves 10–12*

USING A 2LB TIN I make this in a 3lb/1.3kg loaf tin, but if you only have a 2lb/900g loaf tin, any remaining parfait mixture can simply be frozen in an airtight plastic container then scooped and served as you would ice cream. Or reduce the quantity by a third.

PRESENTING A FROZEN DESSERT If you return the parfait to the freezer once it's decorated with the blackberries and chocolate curls, they will have a frosted look and the dessert will hold up longer. A marble serving plate works really well – place it in the freezer and it will keep the parfait chilled for longer.

200g dark chocolate (70 per
 cent cocoa solids), broken
 into small pieces
3 eggs, plus 2 egg yolks
Seeds scraped from
 ½ vanilla pod
200g caster sugar
500ml whipping cream
150g blackberries
5-6 thin wafer biscuits
 or butter crisps

Melt the chocolate in a heatproof bowl set over a pan of simmering water. Make sure the bowl does not touch the water. Line a baking tray (one that fits in your fridge) with baking parchment.

Once the chocolate has melted, use an offset spatula to spread just under half of it very thinly (about 1mm thick) over the parchment until it measures about 15 × 30cm (the equivalent of twice the base of your loaf tin). Place in the fridge to harden. Spread the remaining chocolate over a small overturned flat tray to 2mm thick. Place in the fridge for 5–10 minutes, until just set but not solid (this might take a little experimentation). Remove from the fridge and run a knife or metal dough scraper along the top of the chocolate at a 45-degree angle to scrape up curls of chocolate. Place the curls in a container in the fridge.

To make the parfait, place the eggs, extra yolks, vanilla seeds and sugar in a large heatproof bowl set over a pan of simmering water, again ensuring it does not touch the water. Whisk continuously for 6–8 minutes (an electric whisk is ideal for this), until the mixture becomes very thick and pale and doubles in volume. The whisk should leave a trail of ribbons on the surface when lifted. Remove from the heat and allow to cool. In a separate bowl, whip the cream until soft peaks form. Lightly fold it through the cooled egg mixture a spoonful at a time until well combined. At this point, measure out 350g of the mixture and place in a separate bowl. Purée 50g of the blackberries in a blender or food processor and fold through this batch. Leave both parfait mixtures to cool fully.

Line a 3lb/1.3kg loaf tin with cling film, leaving about 7.5cm overhanging the long sides. Pour in half of the pale parfait mixture and even the surface with a small palette knife. Cut the chilled chocolate sheet into two rectangular lengths just slightly smaller than the loaf tin and lay one over the parfait layer. Add the remaining pale mixture, followed by the second chocolate length. Pour over the blackberry mixture, smooth it down and press the biscuits lightly over the top. Fold the overhanging cling film over the biscuits and freeze overnight, or for at least 6 hours.

Turn the frozen parfait out onto a chilled serving platter. Cut the remaining blackberries in half. Arrange the berries and chocolate curls on the parfait and serve in thick slices. (Return the dessert to the freezer before serving, if you want a frosted look.)

Eton mess ice cream sandwiches

These ice cream sandwich bars, with their meringue, cream and summer berry combo, can be whipped out of the freezer at a moment's notice, making them a nifty make-ahead dessert for a midsummer barbecue. Slicing evenly-sized biscuits is best done with a metal ruler and a sharp knife or pizza cutter. *Makes 8*

FREEZING FLAT We all have a habit of playing freezer Tetris, squeezing and slotting things into tricky spaces. Resist the urge to do this when freezing the filling for these ice cream bars. Leave it to set on a flat surface, not precariously perched on top of a bag of frozen peas or the bars will end up different thicknesses.

COOLING QUICKLY To cool things quickly, metal trays are useful because they conduct the cold. Place a tray in the freezer for 10 minutes then transfer anything you need to cool (in this case the heated berries) onto it.

1 litre good-quality
 vanilla ice cream
300g frozen summer berries
50g caster sugar
6 ready-made meringue
 nests or equivalent
 (75g meringue)

FOR THE SANDWICH BISCUITS
150g unsalted butter,
 at room temperature
100g caster sugar
1 egg
160g plain flour, plus
 extra for dusting
40g cocoa powder
A good pinch of fine sea salt

Place the ice cream in the fridge to soften slightly. Meanwhile, tip the frozen berries into a pan with the sugar and pop the lid on. Place over a low heat for 4–5 minutes, just long enough to defrost them and release their juices but not turn them to mush as you want them to hold their shape. Set aside to cool fully.

Decant the softened ice cream into a large bowl and lightly stir in the berries and their juices. Crumble in the meringue nests and stir. Line a 23 × 23cm baking tray or cake tin that's at least 4cm deep with plenty of cling film. Pour in the ice cream and use a spatula to smooth the top so it is even. Cover the top with cling film and return to the freezer for 5–6 hours to set.

For the biscuits, preheat the oven to 190ºC/Fan 170ºC/Gas 5. Line one or two large baking sheets with baking parchment.

Put the butter and sugar into a bowl or stand mixer and beat until pale and fluffy. Add the egg and mix well. Stir in the flour, cocoa powder and salt to form a ball of dough. Cut in half, then dust each piece with flour on both sides and roll out between two sheets of baking parchment into rectangles 3mm thick. Place these in the freezer for about 15 minutes to firm up – this makes it much easier to cut accurately.

Cut the chilled dough into 16 rectangles measuring 5 × 9cm. Use a fork to prick the top of the biscuits. Transfer to the prepared baking sheets and bake for about 12 minutes or until firm. Transfer to a wire rack to cool.

When the ice cream filling is fully set, flip it out of its tin onto a board and cut it into rectangles the same size as the biscuits. Sandwich together as many bars as you wish to serve immediately. Store any unused biscuits in an airtight container for up to 1 week, and sandwich them together with the ice cream filling as and when you want. Best served with a paper napkin on a hot day.

Two-tone strawberry and rose ice lollies

Whether it's because of the heart-shaped strawberry slices or simply nostalgia, my homemade yoghurt ice lollies get a lot of love from adults and children alike so they are a mighty handy snack to have in the freezer.

You will need eight lolly moulds (of 80ml capacity) and sticks for these. *Makes 8*

BUILDING ICE LOLLIES In order not to mix the layers of colour when building these lollies, I place a spoon vertically just above the surface of the previous, frozen layer and pour the mixture for the new layer down it, as bartenders do for cocktails. If you push a strawberry slice down the side of the mould, it will stick neatly to the side. This way you'll see a strawberry heart on the outside when the lolly is removed from its mould.

UNMOULDING ICE LOLLIES While a little meltiness can have its own visual appeal, stylists try to control it as much as we can, so unmoulding homemade ice lollies ahead of time then refreezing them is essential for preventing this. As soon as your lollies have set, remove them from their moulds. Fill a mug with boiling water and slot the lolly mould in, leave it for a couple of seconds, then pull it out. Store your unmoulded lollies in a Tupperware box with baking parchment layered between them to stop them sticking. This is also a good way to have the lollies ready to serve at the same time.

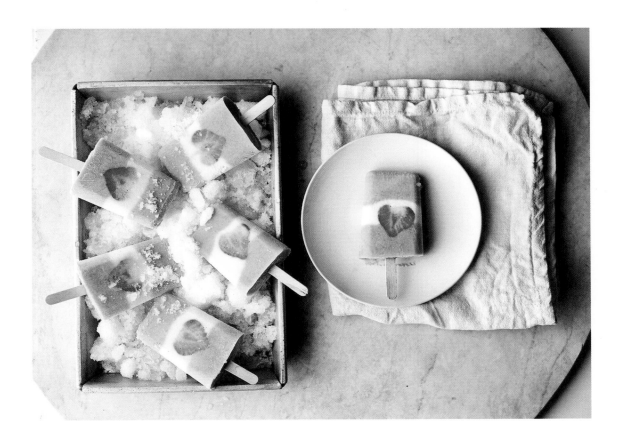

250g strawberries, hulled
500g Greek yoghurt
100g caster sugar
½ tsp rose water
Juice of 1 lemon
½ tsp vanilla bean paste

Set aside four of the prettiest strawberries. Put the remaining berries in a blender with 250g of the yoghurt, 60g of the sugar, the rose water and the lemon juice and whizz until completely smooth.

In a separate bowl, beat the remaining yoghurt and sugar and the vanilla paste. Although not strictly necessary, I whizz this in the blender too, to achieve a pourable consistency which is easier for pouring into the lolly moulds.

Put both mixtures into jugs with spouts. Slice your reserved strawberries into 2mm slices with the tip of your knife.

Pour about a 2cm layer of the pink mixture into the bottom of each lolly mould and leave to set for 15 minutes in the freezer.

Divide the white mixture between the moulds on top of the set pink layer. Slide a strawberry slice down either side of each mould. Freeze for 15 minutes more, then top up with the remaining pink mixture. Freeze the lollies for 2–3 hours, or until fully set.

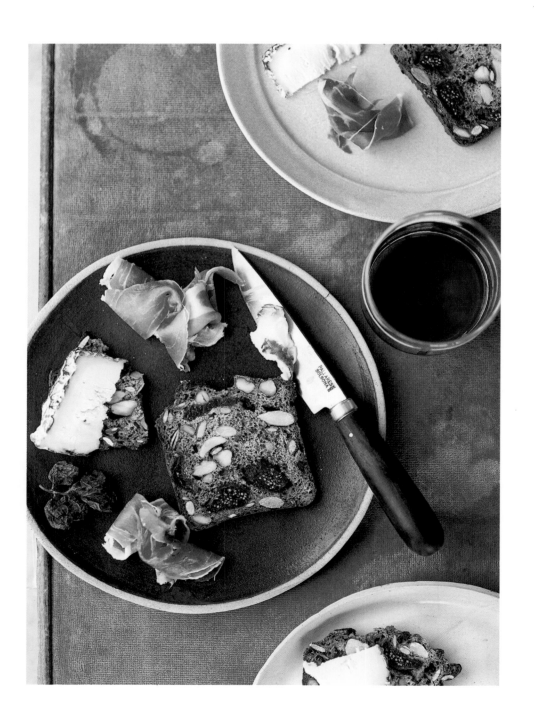

Fruit and nut toasts

These fruit and nut toasts are designed to be loaded with Stilton while you sip Sauternes on a cosy candlelit evening. Studded with dense dried apricots, figs and cranberries and packed with nuts, a quick soda bread gets sliced and re-baked to make an impressive home-made addition to the cheeseboard. These can be made a week or two in advance and stored in an airtight container; they also make an excellent gift. *Makes about 25*

CHOOSING DRIED FRUIT AND NUTS I leave all the fruit and nuts whole for this recipe, so that when you cut through, each slice will be studded with different colours. As with the granola (see page 75), brighter dried fruits, and nuts such as pistachios or hazelnuts, work best.

SUBSTITUTING BUTTERMILK If you can't find buttermilk, use a 50:50 mixture of milk and Greek yoghurt.

Unsalted butter,
 for greasing
100g rye flour
100g plain flour
½ tsp bicarbonate of soda
½ tsp fine sea salt
70g pumpkin seeds
120g dried apricots,
 figs and cranberries
120g hazelnuts, pistachios
 and almonds
75g clear honey
1 × 284ml carton buttermilk

Preheat the oven to 200°C/Fan 180°C/Gas 6. Grease a 1lb/450g loaf tin and line it with baking parchment.

Put the two flours into a medium bowl and add the bicarbonate of soda and salt. In a separate bowl, combine the seeds, dried fruit, nuts and honey.

Make a well in the centre of the flours and pour in the buttermilk. Mix to form a dough, then incorporate the dried fruit mixture. Place the dough in the prepared tin, then bake for 1 hour, or until a skewer inserted in the loaf comes out clean. Transfer to a wire rack to cool, then place in the fridge until completely cold; this is important as it will enable you to keep your slices neat.

Preheat the oven to 140°C/Fan 120°C/Gas 1 and line two baking sheets with baking parchment. Place the cold loaf on a board and use your sharpest knife (again, this is important!) to cut it into very thin (3mm) slices. Spread them out on the lined baking sheets and place in the oven for around 1 hour or just over that, or until the slices have dried out fully.

Store in an airtight plastic container before bundling up as a gift or serving on the side of a cheeseboard.

Garlic and Cheddar bread wreath

With layers of herby garlic butter and Cheddar cheese running all the way through it, this crunchy, buttery bread wreath is the ultimate tear and share centrepiece. I use a similar method to making babka, whereby you roll up the dough and cut it down the centre to reveal the garlicky green layers. The Cheddar was a late addition to the recipe, and now I can't imagine it any other way. *Serves about 12 as a snack or side*

500g strong white bread
 flour, plus extra
 for dusting
2 tsp fine sea salt
1 tsp caster sugar
4 tsp fast-action
 dried yeast
250-300ml warm whole milk
2 eggs, at room temperature
50g unsalted butter, at
 room temperature, cubed,
 plus extra for brushing
½ tbsp sunflower oil,
 plus extra for greasing
150g mature Cheddar, grated

FOR THE GARLIC BUTTER
100g salted butter,
 at room temperature
30g flat-leaf parsley
 leaves, roughly chopped
6 plump garlic cloves,
 peeled and halved

Put the flour into the bowl of a food mixer, adding the salt to one side and the sugar and yeast to the other (salt can inhibit the growth of the yeast). Make a well in the centre and add 250ml of the warm milk and one of the eggs. Fit the dough hook and mix at a low–medium speed until it starts to come together. Add more milk if required. Increase the speed and knead for 4–5 minutes, until the dough is well combined and pulls away from the sides of the bowl. It will be quite sticky. Add the butter one cube at a time and keep kneading for a further 5 minutes, until it comes together into a springy dough. Shape the dough into a ball with your hands, drizzle over the oil and turn the ball in the oil, still in the bowl, to coat it very lightly. Cover the bowl with cling film and set aside in a warm place for 1–2 hours or until the dough has doubled in size.

Meanwhile, make the garlic butter. Put the butter into a blender with the parsley and garlic and pulse until well combined, then set aside.

Dust a work surface with flour and use a dough scraper to scoop the dough onto it. Lightly flour the top of the dough and your rolling pin, then stretch and roll into a rectangle of 60 × 40cm.

Use an angled palette knife to spread the garlic butter evenly across the dough, right to the edges. Sprinkle with the cheese.

Starting from a long side, roll the dough up into a fairly tight sausage shape, tucking the seam underneath. Using a very sharp, long knife, slice it equally in half lengthways. With the layers facing upwards, press the ends furthest away from you together, then start overlapping the pieces, as if you were plaiting them, stretching them slightly as you go and trying to keep the layers facing upwards. Try to do this as uniformly as possible because any unevenness will be more visible once the bread has been proved and baked.

Line a baking sheet with baking parchment and place the plait on it. Curve the ends around to meet and make a wreath, then squeeze them together to join firmly but as neatly as you can. Gently shape the dough so that the inner circle is about 20cm in diameter. Grease the outside of a 20cm cake tin with oil and place it inside the circle (this isn't strictly necessary, but it creates a more regular shape). Leave to prove for a further 20–30 minutes in a warm place.

Preheat the oven to 220°C/Fan 200°C/Gas 7. Beat the remaining egg in a shallow bowl.

Brush the wreath with the beaten egg and bake for 20–30 minutes (the time depends on the thickness of the dough), or until golden and the base sounds hollow when tapped. If it looks as though it might be browning too quickly, turn the oven down to 200°C/Fan 180°C/Gas 6. Leave to cool on a wire rack, then brush with extra butter before serving to make it enticingly glossy.

A beautiful cheeseboard

My mum used to tell me off for plucking individual grapes off the bunch. Mum, I get it now; I'm sorry. When you have put thought into styling a display of cheeses and fruit, the last thing you want is someone leaving scrappy grape skeletons on display. Here are my tips for creating a cheeseboard just as pretty as my mum's...

The basis of a good cheeseboard is good cheese. Store your cheese in waxed paper, ideally the paper you bought it in. Don't switch between papers when you wrap them back up, you don't want the smells to transfer.

Think about the shape of the cheeses you are buying because mixing it up makes all the difference to the overall look of the board. For example, buy small rounds of soft goat's cheese and try sprinkling them with your own flavouring – pink peppercorns, dried cranberries or fresh herbs. Alongside that you could offer chunks of Lincolnshire Poacher, a slice of soft Brie, some crumbled Parmesan... whatever takes your fancy.

Remember to get your cheese to room temperature before serving, so think about taking it out of the fridge before your guests arrive. A really gooey ripe cheese might need to be pulled out only at the last minute. When positioning the cheeses on a board, take a leaf out of the French book and consider the order in which you want your guests to eat them with care, starting with the mildest. Position a separate knife near each cheese so you won't get bits of one 'contaminating' another.

Figs, apples and pears all add colour, acidity, freshness and texture. I like to slice Braeburn apples into rounds and serve them as 'crackers' for mature cheese. You could do the same with pears and Gorgonzola. In both cases, rub the fruit slices with a little lemon juice to stop them browning.

Grapes (with a pair of scissors alongside to snip them off) are always a good-looking addition to the board.

Dried fruit and nuts also add extra textural interest. If you can get unshelled nuts, pop them on the board with a nutcracker, breaking a few to get started, and scattering some shells about.

Fresh honeycomb goes beautifully with blue cheese.

When it comes to crackers, think in terms of shapes and textures, from oatcakes and water biscuits to charcoal biscuits and Bath Olivers, or my Fruit and nut toasts (see page 295).

A large wooden board is a great investment for serving a beautiful display of cheese. If you don't have one, you could opt for a selection of plates and match every cheese with its accompaniment on each one: figs with goat's cheese, honeycomb with blue cheese, apples with Cheddar or Poacher.

Cutting cheese

Here are the best methods for ensuring everyone has a decent
slice of cheese:

Round or square cheeses can be cut like a cake. Log cheeses
should be cut into rounds.

Cut Brie wedges at a diagonal from the tip, alternating sides.
Once halfway into the piece, cut from the rind end inwards.
Blue cheeses, such as Stilton, should be cut in the same way
so that everyone gets a bit of the bluest part at the centre.

Rectangular cheeses, such as Comté or Gruyère, can be cut
into batons widthways, towards the rind, until halfway through,
then perpendicular the other way to even out the distribution
of the rind.

Very hard cheeses (like Parmesan or mimolette) work best if
crumbled or shaved. With Parmesan, poke the tip of a knife
into the wedge, then twist like a screwdriver so that chunks
break off haphazardly.

For super-soft cheeses, use a spoon to scoop them.

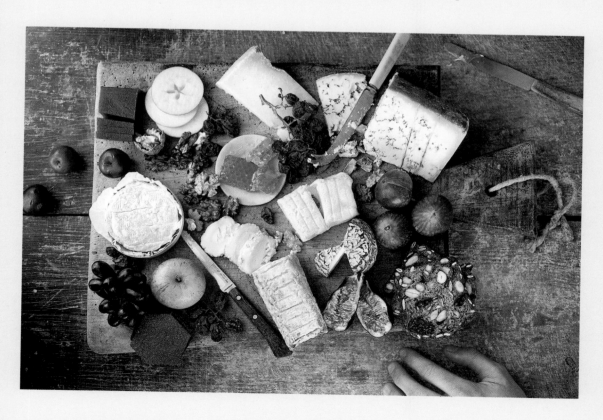

Griddled pears with Gorgonzola and rye caraway crisps

Time spent in Sweden has fostered my love for their ubiquitous crisp flatbreads, knäckebröd, which are served at every mealtime. While they are endlessly versatile, my favourite combination has to be this: the union of a juicy ripe pear, a peppery piece of Gorgonzola and a caraway-spiked thin rye crisp. This humble recipe is an exceedingly satisfying yet simple end to a meal. I am quite fussy when it comes to pears, preferring none at all to a bad one. For this recipe it needs to be a perfectly ripe Red Anjou or Comice, just at the point of juiciness, but still firm enough to withstand searing on a smoking hot griddle. *Serves 6 as a cheese course*

RUSTIC APPEAL Don't worry about perfectly formed crisps - embrace their homemade nature and keep them rustic; you made your own crisps after all, so you might as well celebrate that!

3 ripe pears (Red Anjou
 or Comice)
200g good-quality
 Gorgonzola or dolcelatte

FOR THE CRISPS
3 tsp caraway seeds
200g wholegrain rye flour,
 plus extra for dusting
1 tbsp caster sugar
¼ tsp fine sea salt
120ml water
Flaky sea salt

Preheat the oven to 220°C/Fan 200°C/Gas 7. Line a large, heavy baking tray with baking parchment and place in the oven to heat.

Start by making the crisps. Toast 2 teaspoons of the caraway seeds in a dry pan over a medium heat, until fragrant. Using a spice grinder or pestle and mortar, grind to a powder. Transfer to a large bowl and add the flour, sugar and fine salt. Pour in the water and beat with a wooden spoon until a dough forms.

Flour a work surface, tip the dough onto it and knead for a few minutes until you get a smooth ball. Divide the ball into 16. Starting with about four to six balls (depending on how much oven space you have), use a rolling pin dusted with flour to roll them out to about 12 × 7cm and 1mm thick. Spray them with water, or flick water over if you don't have a spray. Sprinkle each crisp with a few caraway seeds and some flaky salt, then transfer them to the hot tray and bake for 7–10 minutes, or until crisp but not dark. Cool on a wire rack and repeat with the remaining dough.

Place a griddle pan over a high heat. Cut the pears in half through the stem. Use a melon baller to scoop out the core in a neat semicircle. Put the pears into the hot pan, cut-side down, and cook without moving for 3–4 minutes, or until they caramelise and smell a bit burnt. Transfer to six serving plates, placing a rye crisp beside them and a slice of cheese on the crisp. Keep any leftover crisps in an airtight container for up to 1 week.

Celebrations

Creating a successful gathering goes far beyond the food, as anyone who has cremated a roast dinner while engrossed in conversation will know well. Celebrating is about the atmosphere, the mood, the mingling with friends...

I won't deny some of the best times are spontaneous, but a sure-fire shortcut to creating a special occasion is to think about the setting and be conscious of the context, whether that's through cosy candlelight, pulling out a cracking playlist or simply setting the table stylishly. The recipes in this chapter are 'good-time enablers': the Spiced Bundt cake (page 306) is heady with festive spices, while French 75 with a rhubarb cordial (page 328) is a great New Year's Eve tipple, guaranteed to get you in the celebratory spirit.

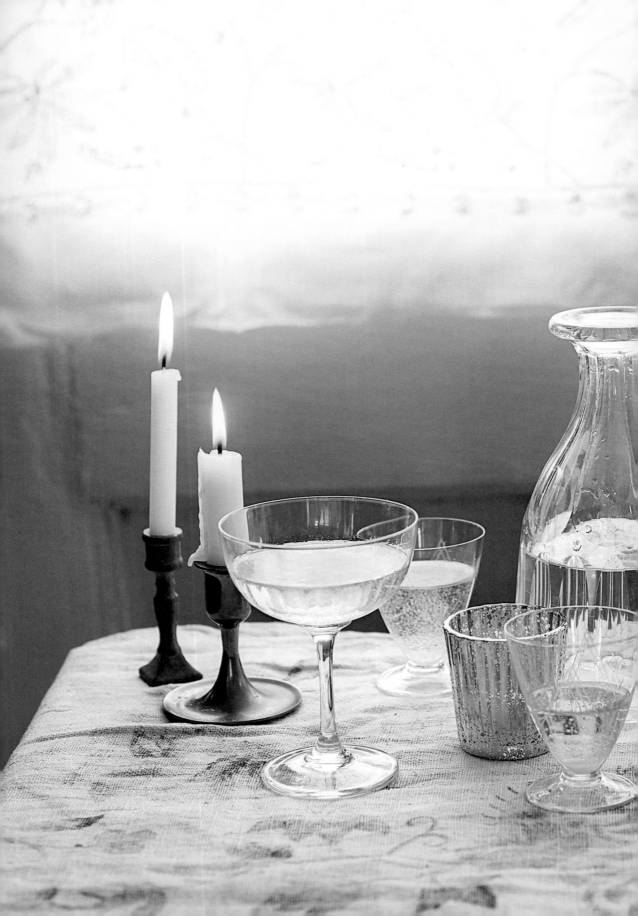

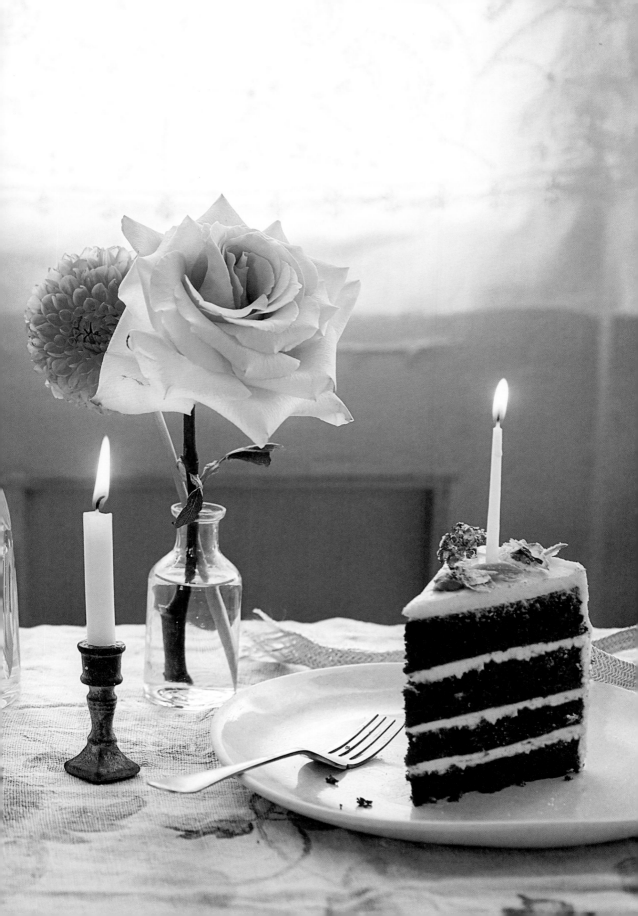

Spiced Bundt cake with ginger caramel icing

This lightly spiced Bundt looks quite the part for an autumn or Christmas occasion with its drippy icing and studs of crystallised ginger. The method for making the cake batter, which involves heating the butter and sweet ingredients together rather than creaming them, produces a lovely moist crumb. Note that you will need a 10-cup/2.4-litre Bundt tin for this recipe. *Serves 10–12*

```
DRIPPY ICING  Getting icing to drip as you want it to
takes a little bit of practice and this technique will
help. Just before decorating, place the bowl of icing
over a pan of simmering water - the heat will give it a
glossy consistency. To thin it, add more cream (or the
liquid you originally used); to thicken, add more icing
sugar. For this cake I opt for a slow-moving glaze, thick
enough to leave suspended drips down the side.
```

250g unsalted butter,
 plus extra for greasing
250g soft light brown sugar
150g golden syrup
300ml whole milk
360g plain flour
2 tsp ground ginger
2 tsp ground cinnamon
2 tsp bicarbonate of soda
2 eggs

FOR THE ICING
100g icing sugar
65g unsalted butter
85g dark brown sugar
3 tbsp double cream
2 tsp fresh root ginger,
 grated
½ tsp flaky sea salt
50g crystallised ginger,
 roughly chopped into
 small pieces

Preheat the oven to 180°C/Fan 160°C/Gas 4. Grease a 10-cup/2.4-litre Bundt tin very thoroughly.

Place the butter, brown sugar and golden syrup in a saucepan and melt together over a low–medium heat. Remove from the heat and stir in the milk. Set aside until lukewarm.

Sift the flour, spices and bicarbonate of soda into a large bowl. Make a well in the middle, crack in the eggs and stir to incorporate. Gradually add the melted butter mixture, stirring all the time, until you have a smooth batter. Whisk lightly to remove any lumps. Use a ladle to pour the batter into the greased tin, filling it to 1.5cm below the top. Bake for 20–25 minutes, or until a skewer inserted in the cake comes out clean. Leave in the tin for 5 minutes, then turn out onto a wire rack to cool.

For the icing, sift the icing sugar into a heatproof bowl. Melt the butter and brown sugar in a small pan over a medium heat until they start to bubble and there are no lumps. Remove from the heat, carefully add the cream (it may splutter), then stir a few times over the heat to combine. Add the fresh ginger and salt. Pour the liquid over the icing sugar and stir until smooth. Use a spoon to drizzle the icing down the sides of the cake, then transfer it to a cake stand or serving plate and top with the crystallised ginger.

Panettone torrone Alaska

This snowy white showpiece is a child-friendly alternative to Christmas cake; a hybrid of festive flavours. A traditional panettone gets filled with a frozen *torrone* centre (nougat to the Francophiles), then topped with glossy meringue swirls and torched like a baked Alaska. The frozen centre can be made a week or two ahead, then you simply make the meringue icing to serve. *Serves 8–10*

MERINGUE SWIRLS I like to use a palette knife to freestyle the swirls on the top of this cake; little flicks of meringue will catch beautifully when torched. Alternatively, you can create a more precise finish using a star-shaped piping nozzle.

FOR THE FILLING
5 eggs, 3 whole and
 2 separated
150g caster sugar
50g good-quality
 clear honey
500ml double cream
50g candied orange peel
 (see page 40), chopped
50g pistachios (I use nibbed
 Iranian pistachios)
100g torrone or nougat,
 finely chopped
750g Panettone (available
 from most Italian delis
 and large supermarkets)

FOR THE MERINGUE TOPPING
220g caster sugar
2 egg whites

Place the three whole eggs and two egg yolks, the sugar and honey in a large heatproof bowl set over a pan of simmering water, ensuring it does not touch the water. Whisk continuously for 6–8 minutes with an electric whisk until the mixture becomes very thick and pale and doubles in volume. The whisk should leave a ribbon trail on the surface when lifted. Remove from the heat and allow to cool slightly.

In a separate bowl, lightly whip the double cream with a balloon whisk or electric whisk until you have soft floppy peaks. Lightly fold this through the cooled egg mixture a spoonful at a time until well combined, then fold through the candied orange, pistachios and torrone.

Turn the panettone upside down and fit it snugly inside a bowl lined with cling film. To hollow out the panettone, use a small sharp knife to cut a 2cm-deep circle inside the base – leave a 2cm margin around the edge. Carefully pull the base out, trying to keep it in one piece. Use your hands to pull out the fluffy inside. Pour or ladle the custard inside, leaving a gap of 2cm at the top. Slot the base of the panettone back into place, then freeze until solid, about 12 hours.

When ready to serve, preheat the oven to 200°C/Fan 180°C/Gas 6.

To make the meringue, spread the caster sugar out on a baking tray and place in the oven for 10 minutes. Heating the sugar in this way will help stabilise the egg whites. Next, put the egg whites, plus the two reserved whites from the filling mixture into a stand mixer and whisk until very frothy.

With the mixer on a medium speed whisk in the warmed sugar a spoonful at a time until stiff peaks form. Keep whisking for 5 minutes, until the meringue is glossy.

Remove the panettone from the freezer and place it the right way up on a serving plate or cake stand. Dollop the meringue randomly over it, then use a palette knife to spread it around and cover the whole thing. Now sweep the palette knife over it to create soft waves. Use a blowtorch to lightly colour the meringue, holding it about 15cm from the panettone. If you don't have a blowtorch, you can serve the panettone without brûléeing it.

Serve in wedges immediately. When cutting slices, have a deep jug of boiling water next to you. Dip your knife in it, then wipe dry and cut. Repeat this between slices for pristine cuts.

Ultimate chocolate cake

The base for this decadent chocolate cake recipe was passed to me by my boyfriend Robin's mum, an experienced celebration cake maker. The crumb is lovely and moist, which is an essential attribute for a cake you want to make ahead of a special occasion.

Often I decorate the cake in as kitsch a way as I can. Alternatively, adding a few fresh flowers is an elegant choice which works wonderfully for a wedding cake (see page 312). I bake this using two 18cm cake tins to make a towering two-layer cake, but if you want one that's less tall, the full batter quantity will fit in one 23cm cake tin (just allow a few minutes longer to cook). *Serves 10–12*

FILLING YOUR CAKE To fill the cake, you can dollop on a hefty layer of the buttercream and use a palette knife to glide it to the edge with a graceful swoop, which will be visible when you are looking at the cake side on. Alternatively, if you prefer less of a wave effect and a neater finish, pipe the buttercream with a 1cm round nozzle in a circle starting from the edge of the cake and continuing in spirals into the centre.

EQUAL-SIZED CAKES To get perfectly even-sized cakes, weigh the batter and divide it by two.

FOR THE CAKE BATTER

175g unsalted butter,
 at room temperature,
 plus extra for greasing
100g dark chocolate
 (70 per cent cocoa solids)
3 tbsp cocoa powder
100ml freshly boiled water
250g caster sugar
3 eggs
200ml natural yoghurt
250g self-raising flour
1 tsp bicarbonate of soda
A good pinch of fine
 sea salt

FOR THE RASPBERRY BUTTERCREAM

100g raspberries
250g icing sugar, plus 3 tbsp
 for the raspberries
225g soft unsalted butter

TO DECORATE

120g raspberry jam
1 tbsp freeze-dried
 raspberry powder
 (optional)

Preheat the oven to 180°C/Fan 160°C/Gas 4. Grease two 18cm cake tins, at least 6cm deep, and line them with baking parchment.

Break the chocolate into a small heatproof bowl and add the cocoa. Pour over the hot water (making sure the chocolate is submerged). Leave for 1 minute, before stirring until the mixture is smooth. Set aside.

Put the butter and sugar into a large bowl or stand mixer and beat together with a wooden spoon or using the paddle attachment, until pale and light. Beat the eggs in a separate small bowl, then add them to the butter and sugar mixture bit by bit, beating until really smooth. Spoon in the yoghurt then pour in the melted chocolate and mix well.

Sift the flour, bicarbonate of soda and salt into a separate bowl, whisk together to combine, then lightly fold into the batter. Spoon the mixture into the prepared tins, then use a spatula to even the top. Bake for 40–50 minutes, or until a skewer inserted into the centre comes out clean. Allow to rest in the tin for 5 minutes, then carefully turn the cakes out onto a wire rack and leave to cool.

Make the buttercream while the cakes are cooling. Purée the raspberries with the 3 tablespoons of icing sugar, then strain through a sieve. Beat the butter in a stand mixer for 5 minutes, until very light and fluffy. Sift in the remaining icing sugar. Beat for a further 5 minutes until soft and creamy, adding small amounts of the berry purée at a time until you have your desired colour.

Transfer one of the cakes to a serving plate or cake stand, trim the tops off the chocolate cakes to make straight surfaces. Using a palette knife, spread the surface of this cake with the jam, then follow with a voluptuous layer of buttercream. Glide the icing to the sides with a palette knife and sandwich the second cake over the top. Place the remaining icing in a piping bag fitted with a wide star-tipped nozzle, and pipe small dollops of the buttercream in quick upwards motions across the top of the cake. Dust with raspberry powder, if using.

A wedding cake with salted caramel and fresh flowers

I made this mammoth three-tiered cake for my best friend's wedding, decorating it with the herbs and flowers that matched her beautiful bouquet. Juggling the building of a cake to feed 150 in unseasonably sweltering heat with bridesmaid duties was quite the challenge, so I used a simple buttercream to cover the cake, then sandwiched the layers with a glossy salted caramel and a rich chocolate ganache. *Serves 65*

CLEAN LAYERS Cut whole cakes into layers when cold. I sometimes put them in the fridge first, then use a bread knife to make an even mark around the edge, before slicing all the way through. When cutting ahead (which I would recommend so that you aren't rushed and can concentrate), store the layers between parchment and wrap in cling film. They'll keep for up to 2 days in the fridge; longer in the freezer.

SMOOTH BUTTERCREAM To get a really smooth finish when spreading buttercream, dip the palette knife regularly in hot water, then dry it before continuing. A turntable also helps a great deal if you have one.

Unsalted butter,
 for greasing
2 quantities Ultimate
 chocolate cake batter
 (see page 311)
1 quantity Caramel sauce
 (see page 263)
Fresh unsprayed flowers,
 to decorate (see Stockists,
 page 333)

FOR THE BUTTERCREAM ICING
750g soft unsalted butter
750g icing sugar
4 tbsp milk

FOR THE GANACHE
200g dark chocolate
 (70 per cent cocoa solids)
200ml double cream

Preheat the oven to 180°C/Fan 160°C/Gas 4. Grease two deep cake tins (at least 6cm deep), one 26cm in diameter and the other 20cm. Line them both with baking parchment.

Prepare the first batch of cake mixture, following the instructions on page 311. Do not be tempted to make both batches at once, as the quantity will be too large to fold. Weigh the batter (putting the bowl on the scales before you start), then pour two thirds into the big tin and the remaining third into the small tin. Bake for about 40 minutes to 1 hour (the two cakes will vary in cooking time, so check each one after 40 minutes), until a skewer inserted in the middle comes out clean. Allow to rest in the tin for 5 minutes, then turn out onto a wire rack and leave to cool. Repeat the process to make two more cakes, one of each size. When the cakes are cool, slice each of them in half horizontally, ending up with four layers of both sizes. Make sure you have lots of space to lay them out if you are icing them straight away. You can easily do this a day ahead, as they keep well, or even freeze them (see note on clean layers above).

To make the buttercream icing, put the butter into the bowl of a stand mixer fitted with the paddle attachment and beat for 5 minutes, until extremely creamy. Sift in the icing sugar in three batches, beating well after each addition, then beat for a further 5 minutes until very smooth. Add the milk a tablespoon at a time, again beating between each addition. Set aside at room temperature.

To make the ganache, chop the chocolate into small pieces and place in a small heatproof bowl. Heat the cream in a small pan to just below boiling point, then pour it over the chocolate. Leave to sit for 2 minutes, then whisk using a balloon whisk until very smooth.

Assemble the large and small cakes separately. Using a palette knife, spread a tablespoon of the caramel sauce over three of the big layers, then spread a tablespoon of ganache over that, and follow with a dollop of the buttercream, smoothed over the top. Sandwich them together, and put the plain layer on top (be sure to use the flat smooth side of the cake as the top). Repeat this process with the smaller cake. Place the big cake on a 26cm board and the smaller one on a 20cm board.

Once the cakes are assembled, smooth a layer of buttercream all over them. This doesn't need to be neat, because it's the 'crumb layer', which acts like glue to keep the crumbs on the cake and not in the icing. Chill until set, then spread another layer of buttercream all over the cakes, smoothing neatly with a palette knife.

Gently lower the small cake onto the big cake, taking care to centre it. Tidy up the icing on the sides, then decorate with the flowers.

Photograph overleaf

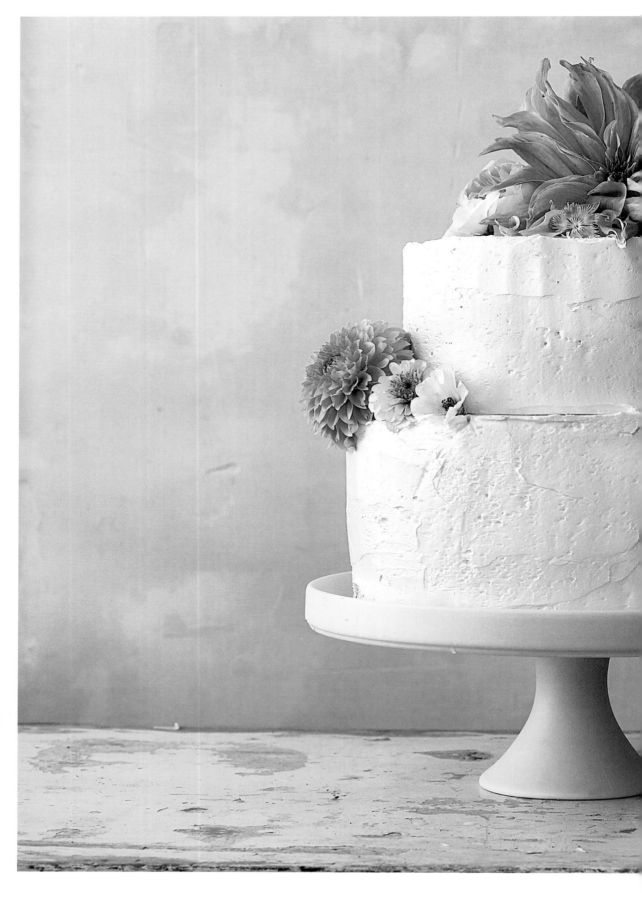

Choux buns

Ever since I learned to make choux at Le Cordon Bleu in Paris, it's been one of my favourite pastries, the base for not only these dainty buns, but elegant éclairs, decadent chocolatey profiteroles, or even the impressive structure that makes up the French answer to wedding cake, a caramel *croquembouche*.

While it's not strictly necessary, there's a secret trick that pâtissiers use to create the perfectly round dome on top of choux buns before they're decorated with icing: it's called 'craquelin'. A simple sweet dough, the craquelin not only guarantess that picture-perfect, smooth top, it also adds a wonderful crunchy coating.

You can keep the buns simple and serve them sliced in half with some Chantilly cream piped into the centre and a dusting of icing sugar, or follow the method overleaf for crème patissière and icing. *Makes about 40*

EVENLY-SIZED BUNS For perfectly even-sized choux buns, use a pencil and a small cookie cutter to mark out 3cm circles on your baking parchment, spacing them 2cm apart. Flip the paper over before you pipe so you don't have pencil marks in the choux (I found this out the hard way), then use as a guide.

CHOOSING FOOD COLOURING When it comes to food colourings, look for paste or gels. These are less runny than traditional liquid food colourings, meaning that they don't affect the consistency of your icing.

FOR THE CRAQUELIN
75g unsalted butter,
 at room temperature
75g caster sugar
75g plain flour

FOR THE CHOUX PASTRY
100ml whole milk
150ml water
100g unsalted butter,
 finely cubed
1 tsp caster sugar
A good pinch of fine
 sea salt
150g plain flour
3-4 eggs

FOR THE CRÈME PATISSIÈRE
500ml whole milk
Flavouring options:
 1 tbsp dried lavender
 or 1 split vanilla pod
 or 1 tbsp matcha powder
5 egg yolks
120g caster sugar
50g cornflour

TO DECORATE
200g icing sugar, sifted
5-7 tsp lemon juice or water
A few drops food colouring
 gel or paste (optional)
Small edible flowers, some
 crushed praline (see page
 287) and/or a dusting of
 matcha powder (optional)

Preheat the oven to 200°C/Fan 180°C/Gas 6.

First make the craquelin. Put the butter, sugar and flour into a bowl or a stand mixer and beat using a wooden spoon or the paddle attachment until smooth. Place the mixture between two sheets of baking parchment and roll out to a thickness of 3–4mm. Transfer to a board or baking tray and place in the freezer for about 10 minutes. You want it to be very firm before cutting.

To make the choux pastry, place the milk, water, butter, sugar and salt in a pan over a low heat, stirring to melt the butter. Sift the flour into a separate bowl.

Turn up the heat and once the liquid has come to the boil, pour the flour into the pan, remove it from the heat and start beating it hard with a wooden spoon. Put it back over a low heat and continue beating really hard until a solid dough forms and some of the steam has escaped. Transfer to a bowl and continue beating, either by hand or with the paddle attachment in a stand mixer – this allows it to cool. Crack in the first egg and beat until incorporated (it may look like mashed potato, but fear not). Beat in the second egg, then the third; you might not need the fourth or you may only need half of it so beat it in a separate bowl and add it a little at a time. The mixture should be the consistency of very thick Greek yoghurt – not runny but firm enough for piping.

Transfer the mixture to a piping bag fitted with a 1–2cm nozzle (I find the larger size easier to work with). This is most easily done by placing the bag in a vase or jug and folding it open over the rim, then you can use both hands to dollop in the mixture. Draw 3cm circles on two sheets of baking parchment (see the tip about evenly-sized buns on page 317) and use to line two baking trays. Dab a little dough under each corner of the parchment to hold it down, then pipe a neat dollop inside each circle.

Use a 3cm cookie cutter to stamp out circles from the frozen craquelin and perch them on top of the piped choux.

Place the choux in the oven and bake for 20–25 minutes, or until lightly golden and puffed up, and they sound hollow when tapped on the bottom. Transfer to a wire rack to cool.

While the choux are baking, make the crème patissière. In a small saucepan, bring the milk to the boil with your chosen flavouring.

Put the egg yolks into a bowl with the caster sugar and cornflour and beat with a wooden spoon until very smooth, pale and light. Pour a small amount of the hot milk over the mixture, beat well, then add the remaining milk and beat again. Strain the mixture if you have used lavender or a vanilla pod, then return to the pan and whisk continuously over a low heat until it thickens and releases a couple of bubbles, 5–10 minutes. Decant into a plastic container and place a sheet of cling film directly on the surface so it doesn't develop a skin. Set aside to cool, then chill thoroughly.

Put the cold crème patissière into a piping bag fitted with a 5mm round nozzle and twist the end of the bag closed. It is easier to work with when less full, so pipe in two batches if necessary. Pierce a hole in the base of each bun and pipe in the cream until the buns feel full (don't let it go too far or they may burst).

Put the icing sugar into a bowl and stir in 1 teaspoon of the lemon juice or water at a time until you reach a stiff consistency – you don't want it to run. Add a few drops of food colouring (if using) to create the desired colour. Use a teaspoon to spread a little icing on each bun, then decorate with a dusting of matcha or crushed praline, or leave the buns simple, perhaps with just a single edible flower on top.

Every occasion lemon biscuits

This simple buttery biscuit dough is so foolproof that you can multitask a million things while making it, which is generally the situation I find myself in in the lead up to Christmas or other big celebrations.

This is your chance to revel in a little DIY decorating. In spring or summer, go to town with edible dried flowers, crystallised herbs and candied citrus to make bejewelled beauties for wedding favours or a box of birthday biscuits. When Christmas comes around, make them as edible present labels or transform them into snowflakes to hang from the tree. You'll need a plastic piping bag to write with the icing, or use a normal piping bag with a tiny decorating nozzle. *Makes about 1.2kg dough, about 40 biscuits depending on the size of your cutters*

FOOD COLOURING Do add food colouring to the royal icing if you want to liven things up, though I like to keep the palette quite pale and let the other adornments do the work. Use paste or gel food colouring rather than liquid so as not to dilute the icing.

FREEZING AHEAD This dough freezes well. I'd recommend making the full quantity, then dividing it into three batches, wrapping them individually in cling film and freezing for up to 2 months. Defrost at room temperature until cool enough to roll out.

300g unsalted butter,
 at room temperature
225g caster sugar
3 eggs
1 tsp lemon extract
500g plain flour,
 plus extra for dusting
1 tsp baking powder
1 tsp fine sea salt

FOR THE ROYAL ICING
enough to decorate about
one third of the dough
1 egg white
250g icing sugar, sifted
About 2 tbsp lemon juice

Put the butter and sugar into a bowl or stand mixer and beat together with a wooden spoon or using the paddle attachment on the mixer until really smooth. Beat in one egg at a time, then add the lemon extract. Add the flour, baking powder and salt and beat again until a dough forms. Shape it into a ball, wrap in cling film and chill for 30 minutes.

Preheat the oven to 180°C/Fan 160°C/Gas 4. Line a large baking sheet with baking parchment.

Divide the chilled dough into three equal pieces, wrap them individually in cling film and freeze the ones you don't need.

Flour a piece of baking parchment, and roll out the dough to a thickness of 5mm. Transfer to the freezer on the board or a tray for 15 minutes so that the dough is as firm as possible for cutting.

Using whatever cutter shape takes your fancy, stamp out the biscuits. If you want to make edible gift tags, use a straw or the tip of a 5mm piping nozzle to make a hole for the ribbon about 1cm from the edge.

Transfer your shapes to the lined baking sheet and bake for 10–12 minutes, until they are firm but still pale. Keep your eye on them as some may bake more quickly than others, depending on your oven. Using a fish slice or palette knife, transfer the biscuits to a wire rack to cool.

Meanwhile, get on with the icing. Put the egg white into a bowl and gradually beat in the sugar using a wooden spoon. Add the lemon juice a little at a time until you have a thick, creamy icing that will pipe easily but not run off the biscuits. Fit a piping bag with a fine nozzle and fill it with the icing (you can fill the bag more easily by placing it in a vase or jug and folding it open over the rim – don't overfill it, and twist the end shut). Any unused icing must be kept covered or it will go hard.

IDEAS FOR DECORATING
Crystallised herbs, flowers
 or fruits (see page 23)
Freeze-dried fruits,
 whole or crushed
Dried rose petals,
 cornflowers or
 lavender sprigs
Sugared nuts
Edible gold lustre

To decorate the biscuits, get creative – but be speedy, as the icing will set quickly. If you want to try piping names for tags or the tree, snip the end off a plastic piping bag to create the tiniest opening (under 1mm, or use a normal bag fitted with a tiny nozzle). I find writing is easiest done by holding the end of the piping bag about 4cm from the biscuit and very slowly and steadily guiding the tip from a height.

Another idea is to 'flood fill' the shapes with icing. Take your piping bag and pipe around the very edges of each biscuit to create a barrier. Next take a teaspoon of the icing and mix it with a tiny amount of water to make it a little thinner. Spoon a small amount into the centre of each biscuit and let it flood the frame. You can help spread it out with a cocktail stick, by dragging it towards the frame. If you make any mistakes, simply clean them up with a cocktail stick. Just a few things to remember: go carefully, do not put too much icing on each biscuit and do not over-dilute the icing for the 'flood'. Once you have finished, add the decorations of your choice before the icing sets.

Leave the biscuits for 2–3 hours to set properly before stacking them in an airtight container to store.

If using edible gold lustre, flood the icing and then leave to dry for 2–3 hours before using a small brush to paint a design on them.

The art of serving drinks

I take after my father in the belief that, when I am the host,
the most important thing is to get a drink in someone's hand
as soon as they have walked through the door – alcoholic or soft,
either will do. Guests always know they're in for a good night
if a pre-dinner aperitif outside of the norm has been considered,
so it's well worth having a couple of favourite cocktail recipes
up your sleeve to kick off the evening. See page 13 for some
tips about which glasses to choose for serving them.

Garnishes

Adding a simple garnish, whether it's a twist of citrus or a spiral of cucumber, is an easy way to elevate a drink. You can mix and match garnishes for the recipes that follow on pages 328–9.

CRYSTALLISED FLOWERS OR HERBS
These look dainty and chic floating on the top of a delicate cocktail, particularly in a coupe where they won't compete with ice for attention. Stick to just one perfect one, for understated elegance (see page 23 for instructions on crystallising herbs and edible flowers).

CITRUS TWISTS Despite being easy to make, a citrus twist never fails to impress - disproportionately so I think - when done properly. Use a peeler to peel a clean circular spiral of zest around a lemon or orange. With a sharp knife, trim lengthways for a clean edge, then cut both ends at an angle in opposite directions. Curl the strip around your finger to bend it into shape and hold it for a few seconds to encourage the spiral to stay in place. This also releases the skin's essential oils. Pop the curled citrus into a glass, on top of ice.

CITRUS CRISPS Citrus crisps are a bartender's favourite and surprisingly easy to recreate at home. Follow the recipe for candied citrus on page 40 and dry them out in the oven until very crisp (this can take an extra 45 minutes). Use the crisps for garnishing long or short cocktails.

CANDIED RHUBARB CURLS

150g caster sugar
150ml water
2 rhubarb sticks

Preheat the oven to 120°C/Fan 100°C/Gas ½. Line a baking tray with baking parchment. Combine the sugar and water in a pan and bring to a simmer. Continue simmering until the sugar has just dissolved and a light syrup has formed. Pour into a bowl to cool slightly.

Meanwhile, use a vegetable peeler to peel ribbons of rhubarb down the length of the stick.

Dip the strips in the syrup, spread out on the baking tray and place in the oven for about 1 hour, turning them over halfway through. You want them dry but still soft enough so that they won't crack when twisted. Twist them around the handle of a wooden spoon and leave to dry in a warm place for about 30 minutes - they should then hold their shape. Store in an airtight container and serve floating on the surface of the drink.

Ice

Ice is rarely an afterthought on a photo shoot. We rifle through pre-bought bags of ice in search of the perfect shape, size and style for the drink, just to make it look that extra bit more special. Here are a few ways to consider using your ice at home:

CRUSHED OR CUBED ICE To crush ice, simply place normal ice cubes in a blender and whizz. I do this in small batches, returning the crushed ice to the freezer in bags between batches. You'll want to do this ahead of time so the crushed ice has time to refreeze before serving.

Alternatively, for a rougher crush, smash the ice cubes in a tough sandwich bag using a rolling pin. UV-filtered ice gives you a clearer ice cube than anything you can achieve at home and is worth buying online for special occasions.

If using whole ice cubes, I opt for larger ones which won't dilute the drink as quickly (see Stockists, page 333); they're perfect for whiskey. For an extra-special occasion, sculptural clear ice blocks can be bought from specialist ice makers, and then chipped and chiselled down (with care!) to create rugged ice chunks.

EDIBLE FLOWER ICE CUBES As small flowers tend to float to the top of ice cubes when you make them, first you have to suspend them in a small amount of water. Fill an ice-cube tray a quarter of the way with water, then add flowers facing down or to the side, and freeze. Once the first layer is frozen, add more water to fill halfway, then freeze. Fill to the top, and freeze again. At this point the ice is ready to be used. Be sure to use edible flowers only.

FRESH FRUIT ICE CUBES If you are making a fruit-based drink, try freezing some of the fruit in the freezer and then using it as ice cubes. As it defrosts it won't dilute your Pimm's in the way that ice will when it defrosts, and it adds a pop of colour. This works well with cubes of melon (or use a melon baller for perfect spheres), slices of cucumber and summer berries.

Alternatively, try chopping small pieces of fruit and herbs and adding them to ice-cube trays; top them up with water and freeze until solid (small berries have a tendency to float to the surface, while heavier fruits like apples will sink – use the same method as for edible flower cubes, if necessary).

Party drinks

When it comes to drinks, a little careful consideration can go a long way towards transforming a casual get-together into an elegant soirée. Being organised and getting ahead is the key to seemingly effortless hosting. A separate drinks station is an easy way to divert the congregation zone away from the cooking area and an ice bucket or two does away with the need for anyone to go back and forth to the fridge.

Squeeze your limes in advance, place any garnishes into pretty vessels so that you have them to hand, decant sugar syrup into a jug and have polished glasses at the ready.

The drinks recipes here make a single serving, but each could just as easily be scaled up and prepped ahead in a larger batch, holding back the champagne or the soda water till the last minute for the French 75 and the Elderflower and lime Collins.

A cocktail shaker and strainer, and a jigger or other measure are my bar station essentials, and you will need them to hand for these drinks – three party favourites.

French 75 with rhubarb cordial

This elegant cocktail has become a New Year's Eve fixture in my house. Obviously the rhubarb cordial need not be exclusively served on champagne (although I strongly suggest you do), make a batch and dilute with about three parts water or sparkling water (or to taste) for a soft drink. Store in the fridge for 3–4 days. *Serves 1*

25ml gin
15ml Rhubarb cordial
A generous squeeze lemon juice (about 10ml)
Ice cubes
About 75ml champagne, to top up
Lemon twist or rhubarb curl (see page 325),
 to garnish

FOR THE RHUBARB CORDIAL
makes about 1.2 litres
1kg rhubarb, chopped into chunks
350g caster sugar
1 litre water
Juice of 1 lemon

To make the cordial, put all the ingredients into a pan and bring to the boil. Simmer for 20 minutes over a medium–low heat, until the rhubarb has broken down. Set aside to cool.

Strain the cooled mixture through a fine sieve or one lined with muslin, and allow it to drip without forcing it through (or the cordial will be cloudy). Transfer to a bottle, then store in the fridge and use within 5 days.

To make the cocktail, measure the gin, cordial and lemon juice into a shaker, top up with ice and shake well. Strain into a coupe and add the champagne then your chosen garnish.

Elderflower and lime Collins

You can serve this one as long or as short as you fancy by adjusting the amount of sparkling water – short and strong always wins for me. This is a refreshing and quick-to-put-together cocktail, so a good one to make for a crowd. I get an efficient mise en place set up, with a big batch of juiced limes on the go, ice at the ready and plenty of polished glasses to hand and shake to order. *Serves 1*

15ml concentrated elderflower cordial
25ml gin
20ml lime juice
Ice cubes
About 50ml sparkling or soda water
Edible flower, lemon twist or sprig of
 crystallised rosemary (see pages 325
 and 23), to garnish

Put the cordial, gin and lime juice into a shaker, top up with ice cubes and shake well.

Strain into a highball or tumbler and top up with sparkling or soda water. Add your chosen garnish and serve.

Frozen hibiscus margarita

Agua de Jamaica is a Mexican infusion of hibiscus, water and sugar, served chilled. With its cranberry-like tartness, when sweetened and spiked with a little lime juice, you have yourself a refreshing drink.

This spin on a classic margarita gets a generous slosh of tequila. It's a perfect tipple to serve over plenty of crushed ice, to accompany the pulled salmon tacos on page 239. When serving a crowd, up the quantities and pour from a big pitcher with plenty of crushed ice. *Serves 1*

Ice cubes
50ml tequila
25ml lime juice
25ml hibiscus syrup
20ml Cointreau
1 lime slice
Hibiscus salt or sugar (see page 281)
Lots of crushed ice (see page 326)

FOR THE HIBISCUS SYRUP
10g dried hibiscus flowers
50g caster sugar
200ml water

Start by making the hibiscus syrup. Put all the ingredients into a pan, bring to a simmer, then bubble for 2 minutes, until the sugar has dissolved. Cool to room temperature, then strain, discard the flowers, and chill before using.

To make the margarita, half fill a shaker with ice cubes, then measure the tequila, lime juice, hibiscus syrup and Cointreau over the top. Shake well and adjust the amount of syrup.

I usually serve this in a low tumbler. Grab a slice of lime and run it around the rim of the glass. Put the hibiscus salt or sugar onto a plate and dip the rim of the glass in it. Fill the glass with crushed ice and strain the margarita over the top.

Stockists

One of the less discussed parts of the job of a stylist is the sourcing of picture-perfect produce and interesting tableware. It's a process that can range from the frantic (trying to get hold of just-picked tea leaves the day before an advertising shoot) to the calm and considered (tracking down unique pieces for a new project). Whether on holiday or at home, I trundle around antiques markets and charity shops at any given chance looking for vintage glasses or weathered chopping boards, as these are some of the best places to find affordable long-loved treasures. The list below is by no means exhaustive, but these are a few of my favourite places to turn to for inspiration, for filling my toolkit or for sourcing supplies for photo shoots.

For the table

Stylists are always on the hunt for one-off textiles, plates and boards to present their food, and we are extremely well served by the number of artisans crafting handmade pieces.

TURNING EARTH (e2.turningearth.uk) is a ceramics studio in East London for professional and hobbyist potters. Each season they open their doors for the public to buy unique pieces direct from the maker. Look out for Marios Patriotis, Lazy Eye Ceramics, Lisa Ommanney and Volkiln.

While you don't get to enjoy the tactile nature of their products this way, many of my favourite independent makers sell online: Jane Sarre (janesarre.co.uk); Jess Jos (jessjos.com); Owen Wall (owenwall.co.uk); Brickett Davda (brickettdavda.com).

For hand-crafted wooden utensils and boards, turn to GRAIN & KNOT (grainandknot.com) or BARN THE SPOON (barnthespoon.com).

For rustic French breadboards, have a virtual rummage through Etsy.com, which is a useful resource for tracking down all sorts of second-hand finds.

Many of the tablecloths and napkins peppered throughout this book are from LINENME (linenme.com), a Lithuanian company specialising in stunning stonewashed linens.

THE CLOTH SHOP (290 Portobello Rd, London W10 5TE) and CLOTH HOUSE (47 Berwick Street, London W1F 8SJ) stock a carefully curated range of textiles by the metre, as well as brass buttons, vintage Indian trimmings, velvet ribbons, lace and cute tassels. They're veritable Aladdin's caves for stylists.

Stocking a range of glassware, cutlery and linens, THE CONRAN SHOP (conranshop.co.uk) in West London is a must-visit for lovers of modern tabletop design.

For chic cutlery and crockery, and a _très_ on-trend palette of linens for the table and bedroom, MERCI PARIS (merci-merci.com), a Paris-based design boutique, now ships its coveted stock internationally.

For party supplies look no further than MERI MERI (shopmerimeri.co.uk), an emporium of accessories from giant confetti balloons to pretty paper party napkins and place cards.

For classy Christmas decorations, twinkly lights (like the ones on page 309) and other atmosphere enhancers for the home, the online store ROWEN & WREN (rowanandwren.co.uk) has a small but perfectly formed selection.

An emporium of good taste, PETERSHAM NURSERIES (petershamnurseries.com) offers a range of homeware stretching from the beautiful Astier de Villatte through to more affordable glassware and linens.

For the kitchen

With three London stores as well as an online store, I never leave BOROUGH KITCHEN (boroughkitchen.com) without a new trusty utensil or treat. As well as an excellent selection of pans and knives, they also stock all manner of tools, from julienne peelers through to chef's tweezers and ice-cube trays.

Cast-iron pans are one of my favourite kitchen luxuries; not only will they last a lifetime, they transfer elegantly from hob to table for effortless entertaining. STAUB (staub-online. com) are my favourite thanks to their durability and timelessly elegant design.

For cake decorating tools and tins, LAKELAND (lakeland.co.uk) is a brilliant nationwide and online resource for turntables, piping bags and cake boards, as well as other useful household necessities.

Catering suppliers NISBETS (nisbets.co.uk) stock practical kit for kitchens, from colour-coded chopping boards to inexpensive mixing bowls and other kitchen essentials.

Purveyors of well-designed hardware in London's East End since 2000, LABOUR AND WAIT (labourandwait.co.uk) is a small store selling sensible but stylish enamelware, preserving jars for the pantry and utensils. They also somehow make cleaning supplies covetable.

For specialist ingredients

SOUSCHEF (souschef.co.uk) is an online store that has got me out of innumerable pickles when I've been sourcing harder-to-find ingredients, from Malaysian candlenuts to Iranian pistachios and even edible insects. It is a one-stop-shop for specialist ingredients and cheffy tools.

For edible and unsprayed blooms sent from their farm in Devon, GREENS OF DEVON (greensofdevon.com) are my go-to suppliers.

When it comes to seasonal produce, NATOORA (natoora.co.uk) is one of the most exciting greengrocers in London. When citrus and bitter leaf season are in full swing, I like to banish the winter blues at their Spa Terminus store in Bermondsey (they're also stocked on ocado.com).

NEAL'S YARD DAIRY (nealsyarddairy.co.uk) sells the finest cheeses from the British Isles. Their Borough Market store is my favourite, with exceptionally well-trained staff more passionate about cheese than I am (which is saying a lot); I never leave without a new dairy discovery.

Index

Acknowledgements

None of this would have happened had it not been for the amazing team at Bloomsbury. I still have to pinch myself each time I visit Bedford Square – what a dream come true it is to be counted among your authors. To Richard Atkinson and Natalie Bellos, thank you for believing in this book (although maybe not the original title!) and enabling it to become something I am really proud of. To Xa Shaw Stewart and Lisa Pendreigh, for guiding it through the process and coming up with such an elegant title. Thank you both for your faithful support, sound knowledge and for trusting in Kristin and me throughout the photo shoot.

Kristin Perers, not only are you the most gracious collaborator, but you poured so much of your spirit and time into this project – I feel so lucky to have worked with you on this. Thank you for being an endless source of inspiration. Thank you to Sam Harris, for being a stellar assistant to Kristin and being an overall joy to work with, and to Ben Perers Cook for all his help on shoot days.

I never thought I'd be able to trust someone who doesn't like cheese until I met you Charlotte O'Connell; your up-for-everything attitude, speed and skill were critical in making our shoot days come together. Thank you also for your time in the kitchen testing recipes, and to Sophie Mackinnon. Many thanks to Hedvig Billengren Lindenbaum, who travelled all the way from Stockholm for the shoot, and Jess Dennison, for your assistance in the kitchen on our final, and rather hectic, shoot days. We are very fortunate we get to call messing around in the kitchen together work, and I am especially lucky I get to do it with you brilliant people.

A Practice for Everyday Life, I couldn't ask for more from the pages you have created. The thoughtful design looks effortless, which is a testament to your incredible skills.

Imogen Fortes, editor extraordinaire and fellow Francophile, thank you for your positive affirmations when I was losing the plot and for making sense of what the book is about with your gentle and thorough touch. Now let's go drink Martinis and talk about Paris.

Harriet Moore, my thoughtful agent, thanks for your constant encouragement and support. Rachel Khoo, for introducing us, but more importantly for being such an inspiration and source of advice over the years, someone I am fortunate enough to call a dear friend too.

A huge thank you to Jess and Ally of Aesme Flowers for the beautiful Old Man's Beard installation that graces these pages. Thank you to Michael Robbins at Staub, LinenMe, Rowen and Wren, Greens of Devon, Jess Joslin and Owen Wall for their generosity with their beautiful things, as well as Danny at Fin and Flounder for always bringing banter to the fish-buying process. A big thanks to talented treasure hunters Lucy Attwater and Vic Allen, whose beautiful props feature extensively here.

To my amazing friends, who have listened to me witter on for coming up to two years about this – in particular Louise, Kate, Camilla and Carly – you have suffered the worst of it. I love you all dearly and will shut up now.

To Robin, my absolute favourite person to cook with, for his unwavering support and love through the ups and downs. Kudos to him for (mostly) happily eating version after version of the same dishes for over a year. Thanks to Hilary, for kindly sharing her chocolate cake recipe and always indulging me in a good old discussion about what's for dinner.

And finally, thanks to my funny little family. My sister Lukey, for supporting from afar, and sending Sheryl Sandberg quotes at the opportune moments, and Dad, whose entrepreneurial spirit and optimism is a huge inspiration. Mum, not only for fostering my love of food in the first place, but selflessly giving up your time to make my life easier through the whole process, whether it was crossing London to source salad leaves for the photography or giving me feedback on yet another recipe test. I couldn't have done it without you all.

BLOOMSBURY PUBLISHING
Bloomsbury Publishing Plc
50 Bedford Square, London, WC1B 3DP, UK

BLOOMSBURY, BLOOMSBURY PUBLISHING and the Diana
logo are trademarks of Bloomsbury Publishing Plc

First published in Great Britain 2018

A catalogue record for this book is available
from the British Library

ISBN: HB: 978-1-4088-8673-1

10 9 8 7 6 5 4 3 2 1

Designer: A Practice for Everyday Life
Photographer: Kristin Perers
Food and Prop Stylist: Frankie Unsworth
Indexer: Hilary Bird

Printed and bound in China by RR Donnelley Asia
Printing Solutions Ltd

Bloomsbury Publishing Plc makes every effort
to ensure that the papers used in the manufacture
of our books are natural, recyclable products
made from wood grown in well-managed forests.
Our manufacturing processes conform to the
environmental regulations of the country
of origin

To find out more about our authors and books visit
www.bloomsbury.com and sign up for our newsletters